# Digital Photography

## How to capture, manipulate and output images

Alastair Fuad-Luke

A comprehensive handbook
for getting the most out of
the technology that is
revolutionising the
imaging industry

*A* Guardian Book

Published in Great Britain by:
Fourth Estate Ltd
6 Salem Road
London W2 4BU

Copyright 1998 Guardian News Services Limited and Alastair Fuad-Luke.
A catalogue record for this book is available from the British Library
ISBN 1 84115 0517

Design by Gary Phillips using Quark XPress, copy editing by Paul Fisher and layout
by Alastair Fuad-Luke using Apple Macintosh computers.

Set in Scala and DIN-Bold.
Printed in Wales by WBC Book Manufacturers Ltd, Bridgend.

## Acknowledgements

The author would like to extend his warm thanks to the following individuals and organisations who have made this project possible: Paul Fisher for his encouragement and clarity of editing; Gerald Knight of Guardian Books for commissioning the project; Judith Caul at the Observer Photo Archive; Felicity Harvey at the Bridgeman Art Library; Alain Rochecouste at Sky Photographic Ltd, London for scanning images to PhotoCD; Mary Cowan of Epson UK for loan of an Epson PhotoPC600, FilmScan 200 and Photo Stylus printer; and the following companies who provided software and illustrations - Adobe Systems UK, MetaTools, Microsoft Corporation, The Digital Camera Company, Micrografx, Keybase Systems, Image Resource, Digital Arts & Sciences, Computers Unlimited, Different Angle, Sony Corporation, Canon, Kodak Digital Sciences, Apple Computers, Casio, Hasselblad, Logitech, Fujifilm, Olympus, Impact Peripherals, Epson, Nikon, Scitex, Metro Imaging, Sky Photographic, Iomega, Bannerbridge, IQ Videograpics, the Bridgeman Art Library, the Observer Photo Archive, Digimarc Corporation, Corel Corporation, and PhotoDisc.

# Contents

# Point

## & shoot
## & retouch
## & edit
## & print
## & e-mail
## & file

& that's by no means the end of it. Once captured on the PowerShot A5 digital camera and downloaded to your PC or Mac, images are infinitely adjustable. You can then incorporate them into your business documents quickly and easily. It's ultra compact, lightweight and allows you to store up to 236 images, which you can then view on the camera screen or your PC. And it comes with all the software and accessories you need. For more information and a demonstration CD ROM, freephone 0500 246 246 or visit www.canon.co.uk & don't delay.

**YOU AND CANON CAN.**

**Canon** *PowerShot*

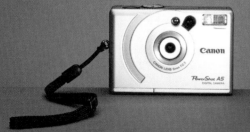

## Preface

In this book digital photography is defined as the process of creating still - as opposed to moving - electronic or digital images. A digital image is a file of data which is stored in a camera, a computer or special media. The image can't be seen until it is converted into a picture on a screen, such as a monitor or television, or made into a print. Digital photography hardware and software - once the preserve of scientists, technologists, and professional photographers - is now available to consumers. This has been achieved by the coalescence of several factors. The equipment required for digital photography - personal computers (PCs), digital cameras, scanners and printers - has become affordable. PCs have become more powerful and can process larger image files. New media, such as CD-ROMs, the Internet and World Wide Web (WWW), need photographs to be converted into digital images. Software developers have responded by creating new applications to manipulate, store and distribute digital images online or via transfer media.

The objectives of this book are to provide a guide to the basic principles of digital photography, to be a source of creative inspiration, an introduction to broader digital horizons and a directory of useful contacts. Existing or potential digital photographers originate from a wide range of backgrounds, such as photography, computing, the Internet, graphic design and hobbyists, each group equipped with its own jargon. The text of the book has been kept as jargon-free as possible and has been pitched to try and satisfy most of the people most of the time.

Where relevant, reference has been made to working with digital photography on the two most popular personal computers - Apple Macintosh and IBM-PC compatibles. Although the computer industry continues to promote proprietary solutions, which can create problems of compatibility, don't despair. There is usually a straightforward answer which is all too frequently glossed over by the hyperbole delivered by the sales personnel. Indeed, many companies have specialised in providing easy-to-use hardware or software to iron out difficulties created by proprietary standards in the marketplace. This book adopts a common sense approach to foster enjoyment of digital photography.

Research was undertaken between January and July 1998 and so the book is a particular snapshot of the technology driving digital photography. New products are continually emerging, and some suggestions are given as to the possible future directions for digital photography, but the underlying principles remain constant.

Once aquainted with the basic technological principles the reader should be aware that digital hardware and software is merely a servant to creativity. Given a paint brush very few can aspire to be a Van Gogh, Michelangelo, or Salvador Dali. Similary, a computer and the right digital tools don't automatically produce a digital masterpiece. However, it's generally easier to create a visually interesting image with these digital tools than it is using a paint brush, which requires manual dexterity. It is for this reason that the creative possibilities with digital photography are myriad.

Many new frontiers are ripe for exploration in digital photography. Enjoy the journey...

Alastair Fuad-Luke
August 1998
Porthleven, Cornwall, UK

e-mail: kaw84@dial.pipex.com

CHAPTER 1

# A brief history

Digital images are a visible fact of modern life with photo booths, security cameras, one-hour photo processing labs and Internet cafes all using the technology. Digital photography is an everyday tool for estate agents, insurance companies, service departments of electricity, gas and water utilities, the health service, the police and the media. Digital photography products can be brought from high street retailers, specialist dealers and computer warehouse companies (Appendix I). Competition between the manufacturers and retailers means keen prices for the consumer to try digital photography for the first time.

The new world is not altogether unfamiliar. It mimics the three step process of conventional photography - exposure, development and printing - with its own sequence of capture, manipulation and output. Yet it also has some unique characteristics: digital images can be cloned, so you can't distinguish the original from the copy; a digital image can be sent via telephone or satellite networks to any point around the world within seconds of the original image being captured; digital images can be stored in a wide variety of different file formats and sizes making them compatible with a more diverse range of output media and publishing systems than conventional photography.

Cheap personal computers, the Internet and desktop printers have primed the growth of digital photography. Images captured by digital camera, by scanning conventional photographs, or by grabbing video frames can be downloaded to a personal computer (PC) where they can be manipulated, stored and managed. The mid-1980s revolution in desktop publishing gave birth to desktop printers to produce text and image proofs and, more recently, photo-realistic prints. The Internet permits rapid distribution of images and instant global exhibitions.

As always specialist consumer magazines follow new trends (Appendix IV). Computer and photographic trade fairs buzz with the launch of digital photography products. Exhibitions of digital photography are becoming more widespread and the Arts Council has designated 1998 as The Year of Photography and the Electronic Image. The year long event, co-ordinated by a Yorkshire-based organisation, Photo '98, celebrates the diversity and creativity of image makers using digital and conventional photography (see Appendix II for contact details).

The current ascendency of digital photography is a result of some remarkable technological achievements over the last two decades.

## DIGITAL STILL VIDEO

Capturing an image electronically, without the use of film, was the first challenge to the early developers of digital photography technology. While television cameras had been capturing moving electronic images since the 1940s, it took another three decades to develop the technology to capture higher resolution still electronic

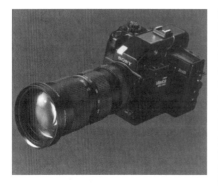

images. In 1981 Sony revealed a still video camera, the Sony Mavica, which recorded images on a light-sensitive sensor called a Charged Couple Device (CCD) chip. Embedded in this chip were 278,000 sensors arranged in a grid of 570 x 488 picture elements (pixels). Incident light was converted to electrical pulses forming a continuous analogue signal which was stored on a 2 inch magnetic floppy disk. Images were recorded in the same manner as TV pictures, comprising two separate fields in each frame, the two fields being interlaced or combined to produce one picture. Images could be captured and stored as full frames (up to 25), or as individual fields (up to 50), The camera was equipped with a single lens reflex

**The Sony Mavica still video camera** (SLR) system with four inter-changeable lenses. When shooting in field mode it was possible to capture up to 10 frames per second. Since the images were stored as analogue data, they could be viewed directly on a TV, but had to be converted into digital data before they could be viewed on a computer. This was achieved using a special microprocessor and printed circuit board known as a frame grabber or digitiser. Images could only be viewed on a TV that conformed to the NTSC video signal standard used in the US and Japan. Europe, based upon the PAL video signal standard, couldn't take advantage of the Mavica's technology.

Six years elapsed before Canon released a still video camera to the European market. The RC-701 was also based upon an SLR style body with four manual focus lenses, and could be used with certain conventional 35mm SLR lenses using an adapter. It captured images in field-mode only using 190,000 pixels, but in 1988 was upgraded in the RC-706 model to full-frame capture using a CCD chip of 640 x 480 pixels (307,000 pixels) with an equivalent light-sensitivity range of ISO100 or ISO480.

Since these early still video cameras cost thousands of pounds they were aimed at the professional market, especially publishing. Such businesses were attracted by instantaneous pictures which could be directly integrated into electronic desktop publishing, saving time and money. However, the image quality was poor

**Canon's ion RC-560 with x3 zoom which was for the pro market** relative to the price of the equipment so the manufacturers went back to the drawing board. In 1991 Canon launched the ion RC-260 still video camera, which used the PAL video standard. This camera rejected the SLR body style of previous designs in favour of a flattened box-like body which contained an integral fixed lens, a flash, and a 1/2 inch CCD (786 pixels horizontally). The ion RC-260 kit for IBM-PC compatible computers included a digitiser to convert the video signal to digital data. Canon pitched the Ion RC-260 at the consumer and business market with a price tag of £500. An upgraded model, the Canon ion RC-560 equipped with a 3x zoom lens and 795 x 596 pixel CCD, unveiled that same year, was successfully targeted at publishers. Several newspapers used these cameras and in 1992 Autotrader, the

weekly magazine about secondhand cars, converted its publishing operation to digital capture using Canon ions.

In 1991 Canon also produced a colour video printer, the RP-731, which could convert PAL video into 101 x 77mm digital prints. This dye-diffusion thermal transfer printer output at 180dpi, using 128 shades of cyan, magenta and yellow, onto special coated paper. This was the first example of connecting a printer directly to a digital still (video) camera without the need to link to a computer.

Still video technology limited the capture resolution and hence the quality of digital images which were produced. The professional photography market, which was the only market that could afford the technology, demanded cameras with higher resolution. Kodak had been collaborating with Nikon and in 1991 released the world's first portable digital camera capable of capturing images at resolutions in excess of one million pixels (one megapixel). The Kodak Digital Camera System (DCS) inserted a CCD chip of 1.3m pixels in place of the film back in a modified Nikon F3 camera body. Images were downloaded to a separate Digital Storage Unit or DSU, linked by cable to the camera, containing a hard disk of 200 megabytes (Mb). The DSU contained various controls and a black and white screen display on which to preview the images. The DCS has a sensitivity of ISO400-3200 in the monochrome version and ISO200 to ISO1600 in the colour version. The DCS

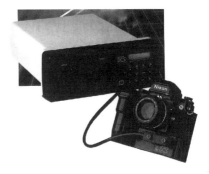

100, as it was later designated, was bulky and suffered from several technical drawbacks. Nikon SLR lenses could be used, but their effective focal length was doubled as only the central portion of the focused image was actually captured by the CCD which occupied a much smaller area of the focal plane than the original 35mm frame format. Although up to 2.5 images could be snapped each second, several seconds were required to write the image data to the hard disk. This prevented further shooting until the writing was completed. Battery power consumption was rapid.

Kodak and Nikon continued to refine DCS technology, releasing a more practical unit, the DCS 200, where the storage disk and the electronics were attached to the underside of a Nikon 801s (8008s in the USA) camera body. The chip was boosted to 1524 x 1012 pixels (1.54m pixels), but the M5 CCD chip still

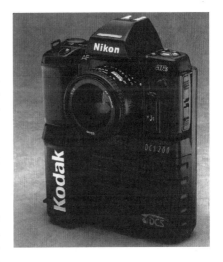

effectively doubled the focal length. Again a mono or colour option was available, reflecting the tendency of newspapers to still print photographs in black and white.

Subsequent DCS models, including the DCS410/420/460, were released between 1992 and 1995. The DCS460 had a 6 megapixel chip making it an effective camera for use in the field or the studio. During the same period Kodak and Canon also released equivalent models to the Kodak-Nikon models using Canon-EOS

Apple's
QuickTake
100 point-
and-shoot
for
destktop
publishing

bodies and interchangeable lens system. Each new model improved capture resolutions, speed of capture and writing images to the disk, and general ergonomics. The big breakthrough came in early 1998 when Kodak revealed the DCS520 digital camera equipped with a 2 million pixel CCD chip which is the exact area of a conventional 35mm format film frame, i.e. 36mm x 24mm. Images can now be captured at the exact focal length of the interchangeable SLR lens being used, making it possible to make greater use of wide-angle lenses.

## CONSUMER DIGICAMS

Developments in consumer digital photography lagged behind the professional products. Early manufacturers of consumer digital cameras came from the electronics and computer industries, as well as the traditional photography manufacturers. 1995 saw the release of the QuickTake 100 from Apple Computers, the FotoMan Pixtura from Logitech and the pocket-sized QV-10 from Casio. It was the latter that captured the imagination of the high street retailers with its rotating lense and LCD screen, acting as viewfinder and preview facility.

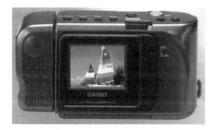

These early low resolution digital cameras adopted the point-and-shoot design features of 35mm compact cameras, with fixed lenses, simple button controls and, often, built-in flash. Images were generally stored in internal memory rather than on removable PC cards. Capture resolutions varied between 320 x 240 pixels up to 640 x 480 pixels, capable of generating image files of sufficiently high quality to be displayed on a computer monitor. Printing options were initially limited by the small size of the image files, but they could be reproduced in corporate literature or magazines at sizes up to 3 x 4 inches. In fact it was the enthusiastic response of the corporate rather than the consumer market which galvanised the manufacturers to upgrade or produce new models.

The Casio
QV-10 VGA
resolution
camera
with LCD
screen for
image
preview

By mid-1998 there were over 50 models available in the UK (see Chapter 4 and Appendix V). About half use CCD chips of 307,000 to 350,000 pixels, capturing at 640 x 480 pixels. Most of these produce image files which are fine for the production of images intended to be viewed on a computer monitor or output as small prints. Nearly all of these low-end cameras heavily compress images during capture and use software interpolation to bulk up the file size when outputting as prints. Mid-range digital cameras with 750,000 to 1.25 million pixels are better for producing photo-realistic prints, as well as images suitable for including in word processing documents and page layouts output on desktop printers.

## STUDIO DIGITAL CAMERAS

In the early 1990s advertising and corporate photographers were attracted to the post-production flexibility of digital photography. Manufacturers opted for two

development routes for image capture. Some designed digital camera backs that would replace the conventional film back on popular medium and large format cameras. Others designed complete new systems linked to a proprietary computer workstation and imaging software.

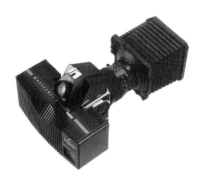

The first significant development of a digital camera back came in 1992 when Scitex's Leaf Systems DB4000 Back was launched for the Hasselblad medium format camera. The DB4000 contained a 30mm x 30mm CCD chip of 4 million pixels. An exposure required up to 30 seconds, as three separate exposures were made under red, blue and green filters.

Another digital camera back option was also explored - the digital scanning back. A linear arrangement of CCD sensors, a CCD array, was moved over the entire image area on the focal plane. Medium format camera manufacturers Rollei tested this technology with its Digital ScanPack fitted to a Rolleiflex 6008 camera. Maximum capture resolution was an effective 30 million pixels by using a CCD array of 5,000 pixels multiplied by a travel distance of 6,000 pixels. Exposures took up to 15 minutes.

*An early scanning back, the DB4000, for medium format Hasselblad cameras*

Other manufacturers developed complete new cameras. One example, the Arca Swiss M line camera required just one exposure of several seconds to capture an image on a 1.2 million pixel CCD measuring 20mm x 20mm. This limited use of this camera to shooting stationary objects.

Other companies saw the potential of the market for professional photographers who wished to consider digital capture. Leaf Systems produced a digital scanning back to fit large format monorail cameras.

Between 1992 to the present day studio digital cameras have tended to favour the use of CCD arrays in digital scanning backs to maximse the capture resolution, although there are some very competent fixed CCD chip cameras. Today's most popular cameras for studio work are made by Dicomed, Phase One, MegaVision, Scitex and Kodak.

*PhotoCD, a proprietary system for scanning and writing images to special CDs*

## KODAK AND PHOTOCD

One of the early developments in digital photography for the consumer market was made by Kodak. Kodak's PhotoCD system was launched in the USA in 1992 (see Chapter 6). It involved several futuristic concepts. Conventional film (negatives or transparencies) were scanned and the images written to a special compact disc (the PhotoCD) by professional photo labs using a Photo Imaging Workstation (PIW). The images on the PhotoCD could be viewed on TV using Kodak's CD-player. PhotoCD wasn't an immediate success but the strength of the underlying technology meant the system was successfully relaunched and over the years it has gained many followers.

The most revolutionary aspect of the PhotoCD system was, and still is, its use of a new image file format called a PCD file or Image Pac. The PCD file is a hierachy of five files containing data of low, medium or high resolution. Kodak realised that different people wanted to do different things with their images. Some only needed low resolution images for viewing on a monitor or TV. Others wanted to use the images in word processing documents or output them as quality photo-realistic prints, requiring higher resolution image files. With the Image Pac one simply selects the appropriate file size for the task. File size can be matched with the intended output method and the memory capability of your computer.

Matching image file size to achieve the desired quality of image according to the type of output device is a fundamental requirement of all digital photography. Although Kodak was running ahead of its time there is some criticism of the inherent quality of the higher resolution images within the PCD file. Scanned files are subject to significant compression of data in order to fit 100 images on the 540Mb storage capacitiy of a PhotoCD. A PCD file varies between 4.5Mb to 6.5 Mb. This size file permits reasonable data access speeds by most CD-ROM drives but does mean that when the higher resolution files are decompressed, lost data has to be re-inserted by a process called software interpolation. Most software interpolation can result in minor artefacts in the re-constructed image file. How noticable these are in the final image depends upon the quality of the interpolation and type of digital print.

In 1995 Kodak launched another hierachical file format called FlashPix. This format was co-developed with other key players from the digital imaging and computer industries, including Microsoft, Hewlett-Packard and Live Picture. FlashPix is an ideal file format for consumer imaging for the output of digital snaps and for the Internet. Whether it is widely adopted remains to be seen.

### SCANNERS AND PRINTERS

Since the emergence of electronic printing techniques and desktop publishing in the mid-1980s, the media and printing industries have been the testbed for technology to digitise photographs ready for printing. These industries used flatbed scanners, for digitising prints and artwork, and drum scanners when digitising prints or film. To increase capture resolutions a light sensitive CCD chip scans over the surface of the print or film, or the latter are moved over the CCD. Optical capture resolutions of the early desktop scanners, used for capturing and importing digital images into page layouts for corporate literature, were in the order of 300dpi. Nowadays even low-end flatbed scanners offer respectable capture resolutions of between 300dpi x 600dpi to 600dpi to 1,200dpi (see Chapter 5, Appendix VI).

Scanners for 35mm format film, scanning at resolutions of between between 1,950dpi and 2,700dpi or more, were the preserve of professional photographers until prices dipped below £1,000 in 1997. Kodak, Nikon and Polaroid dominated the market for professsionals who required a portable film scanner. The last 18 months has seen the release of several scanners capable of digitising 35mm or Advanced Photo System (APS) format film. Manufacutrers, such as Epson, Fujijilm, Minolta, Microtek, Nikon, Olympus and Polaroid, have recognised the need to produce affordable consumer film scanners (see Appendix VI). These operate at capture resolutions between 835dpi to 2,820dpi.

The final link in the digital photography chain, the output of quality digital prints at the desktop, was provided for the professional and consumer markets, during the

early 1990s. Kodak and Fuji dominated the professional arena producing printers capable of photo-realistic quality prints for proofing or display. Kodak's 1992 XL7700 series dye-sublimation printer was replaced by the XLS8600 series. Fuji's Pictrography 3000 offered a silver halide based print using a process called thermo-autochrome. But these machines cost thousands of pounds. This was too much for those who just wanted to print a quick rough proof of their page layout, or a short run of brochures or flyers which incorporated images. This end of the market was dominated by manufacturers of inkjet printers. The most well known of these early desktop printers was the Canon bubblejet printer, produced from 1991 onwards. Bubblejets, so called because each drop of ink produces a bubble as it is forced through each heating element, made low-cost quality desktop colour printing a reality. Since then a wide variety of printers, using solid ink, inkjet, thermal wax, dye-sublimation and thermo autochrome have been introduced to the consumer market (see Chapter 9, Appendix VII). Most offer output at 300dpi, regarded as the threshold output resolution to obtain photo-realistic results. Manufacturers include Alps, Canon, Epson, Fargo, Fuji, Hewlett Packard, and Lexmark.

CHAPTER 2

# What is a digital image?

Digital information is stored on the hard disk of a computer in blocks of data or files. When the data in a digital image, a special type of file, is viewed on a computer monitor it is displayed in a grid of picture elements, usually square or rectangular, known as pixels. The x and y co-ordinates of each pixel and the colour, brightness and saturation within each pixel is recorded as binary data, strings of binary digits, ones and zeros.

Pixels are the electronic equivalent of silver halide grains in conventional photographs. Fine grain film which reacts more slowly to light (typically film speeds of between ISO25 to ISO400) can generally retain more detail than coarser faster films (typically ISO800 to ISO3200). Similarly the greater the number of pixels in a digital image the greater amount of detail it contains. Increasing the number of pixels in an image increases the amount of detail (resolution) captured and the file size.

The term pixel also refers to a light-sensitive element known as a charged-couple-device (CCD). These CCDs are grouped together to form a CCD chip. These chips are installed in digital image capture devices such as cameras, film scanners and flatbed scanners (for capturing prints and artwork). Capture resolutions in these devices are often specified as the number of horizontal pixels multiplied by the number of vertical pixels in the CCD chip(s). This is a measure of the amount of detail each device can record or capture.

An infinite number of CCDs in a CCD chip could record all the light in a scene. In practice there is a physical limit to the number of CCDs that can be manufactured in a CCD chip, so each CCD actually samples the light from several points and averages the result. A high-end (high resolution) large-format camera digital scanning back can have up to 30 million CCDs (pixels) in one chip. Typical low-end sub £1,000 digital cameras for the consumer market have one CCD chip of between 400,000 to one million CCDs (pixels), resulting in reduced sampling of the true light condition from the scene being captured, and therefore less detail is recorded in the digital image. More pixels in a CCD usually equates to finer detail in the digital image.

The CCDs generate electrical impulses in proportion to the light falling on them. This charge is an analogue (continuous) signal which must be converted into binary data which can be read by the computer. Analogue to digital converters are usually incorporated into each capture device enabling the data to be downloaded to a temporary storage medium (such as a PCMCIA, CompactFlash, Smart Media or other removable cards) or directly to the hard disk of a computer via connecting leads.

## BIT-DEPTH AND BITMAPS
Bit-depth, also known as bits per pixel, defines the amount of colour information in a digital image. Binary digits, either 1 or 0, are known as bits. A 1-bit image is comprised of pixels which can represent one of two tones, such as a line-art image

a

b

c

d

a 1-bit line
art
b 8-bit grey
scale
c 3 bits per
pixel,
indexed
colour
d 24-bit
colour

which is just black and white. The relationship between bits and the tones they represent is exponential. A 2-bit image is represented by four tones (2x2), a 4-bit image by sixteen tones (2x2x2x2) an 8-bit image by 256 tones (2x2x2x2x2x2x2x2). Black and white images (usually referred to as greyscale images) are 8-bit depth, comprising a black tone, a white tone and 254 tones of grey. A 24-bit image represents 16.7 million tones and is the default bit-depth for most cameras capable of capturing colour digital images. Each colour, red, green, and blue, is represented by 256 tones ie 8-bit multiplied by three colours gives 16.7 million tone combinations.

A bitmap is an image presented as binary data, each bit allocated to a specific position (usually a pixel) on a grid whose colour value can vary from 1-bit depth (black and white) to 8-bit depth (grayscale or colour), 24-bit depth (red, green, blue colours) and 32-bit (cyan, magenta, yellow and black colours).

## FILE SIZE

The maximum image file size that a capture device can generate is directly controlled by the number of pixels in the CCD chip and the bit-depth. The size of a file is either quoted as Kilobytes (one thousand bytes = 1K = 1Kilobyte)) or Megabytes (one million bytes = 1Megabyte = 1Mb) where one byte equals 8 bits. File size in bytes is readily calculated from the following formula:

no. of horizontal pixels x no. of vertical pixels x (bit-depth x no. of colours) = total no. of bits/8

For example, a consumer digital camera with a CCD chip of 640 x 480 pixels capable of 8-bit depth capture per colour channel for RGB generates a maximum file size of:

640 x 480 x (8 x3)/8 = 7,372,800 bits/8 = 921,600 bytes = 0.92 megabytes= 0.92Mb

File size is directly related to the amount of detail (resolution) contained within the file. Size therefore determines how big the image can be produced according to different types of output methods, each with its own resolution output capabilties. Typically images on Web pages, viewed at 72 dots per inch (dpi) on a monitor, are 10Kb (0.01Mb) to 400Kb (0.4Mb). A digital 6 x 4 inch print output on a dye-sublimation printer at 300dpi requries image files between less than 1Mb to 6.5Mb, depending upon the source of the original image and whether the printer software is able to add extra information to the smaller files by a process known as interpolation. Writing a digital image to 35mm format photographic film, using a laser film writer at 2,700dpi, requires files between 18Mb to 30Mb. As the physical size of the printed image is increased file sizes must be increased to maintain sufficient quality of detail (Table 2.1).

Certain image file formats, such as PhotoCD (PCD) and FlashPix (see below) contain a hierachy of small and large image sub-files within one image. This is a

Screen resolution 72dpi (left), print resolution 300dpi (right) for the same output size

clever arrangement which allows selection of the correct file size according to the type of output required. This sub-file arrangement also creates more options for presenting the images in multimedia environments such as CD-ROMs and the Web, and has significant advantages in networking and image distribution.

**Table 2.1 Matching file size, capture method and print size at 300dpi***

| Capture method | Capture file size (Mb) RGB colour | 6 x 4 inch print 6.5 Mb | 10 x 8 inch print 21.6Mb | A4 print 26.0Mb | A3 print 52.0Mb |
|---|---|---|---|---|---|
| Low-end digicam 640 x 480 pixels | 0.9Mb | +** | - | - | - |
| Mid-range digicam | | | | | |
| 1,280 x 1,024 pixels | 3.9Mb | +** | - | - | - |
| High-end digicam | | | | | |
| 3,060 x 2,036 pixels | 18.7Mb | + | +** | +** | +** |
| 35mm negative or transparency | | | | | |
| film scanned at 2,700dpi | 29.2Mb | + | + | + | +** |
| 6 x 4 inch print scanned at 300dpi | 6.5Mb | + | - | - | - |
| 10 x 8 inch print scanned | | | | | |
| at 300dpi | 21.6Mb | + | + | +** | +** |
| 6 x 4 inch print scanned at 600dpi | 25.9Mb | + | + | + | +** |
| 10 x 8 inch print scanned | | | | | |
| at 600dpi | 86.4 | + | + | + | + |
| PhotoCD BASE/16 | 0.07Mb | - | - | - | - |
| PhotoCD BASE/4 | 0.29Mb | - | - | - | - |
| PhotoCD BASE | 1.1Mb | - | - | - | - |
| PhotoCD BASE x 4 | 4.5Mb | +** | - | - | - |
| PhotoCD BASE x16 | 18.0Mb | + | +** | +** | - |
| ProPhotoCD BASE x72 | 72.0Mb | + | + | + | + |

Notes:
+ denotes photo-realistic quality prints can be output from the given file size
- denotes photo-realistic quality is not likely to be attained, but see further notes below
* As a general rule 300dpi is regarded as the minimum output print resolution to obtain photo-realistic quality prints using simulated halftone printers (mainly inkjets). Lower output resolutions of 200dpi can be used for continuous tone printers, for example dye-sublimation and theremo-autochrome printers, and consequently smaller file sizes may be used than those quoted in this table.
** Interpolation, the process of adding extra pixels, is usually applied to ensure that files which are too small to reproduce good quality prints will still be of an acceptable quality on a par with photographic prints. Even the low-end digicams which capture at file sizes of 0.9Mb or less can still produce reasonable quality prints if interpolation is applied at the capture stage or at printing.

**Table 2.2 File size, photo-realistic quality and type of image output**

| Image output as... | Output medium | Resolution (dpi) | Minimum file size without interpolation* (Kb or Mb) |
|---|---|---|---|
| Imagemap on a Web page | monitor | 72 | 10Kb |
| GIF and JPEG Web images | monitor | 72 | 10Kb to 400Kb |
| Image for edutainment CD-ROM | monitor | 72 | 10Kb to 1Mb |
| Digital 6 x 4 in ch print | thermo-autochrome or dye-sub printer | 200 to 300+ | 6.5Mb* |
| Digital A4 print | inkjet printer | 300dpi | 6.5Mb* |
| Digital A4 print | Inkjet printer | 600dpi | 26Mb* |
| Newspaper photograph, 100mm x four column width | newsprint | 80 to 100lpi | 3Mb |
| Glossy magazine, A3 double page spread | glossy finish paper | 150lpi | 53Mb |
| Digital 35mm transparency i.e. written to film | photographic film | 2,700dpi | 29Mb* |
| Digital medium format transparency | photographic film | 2,700dpi | 122Mb |
| Advertising poster, A0 size | 150g/m2 paper | 150dpi | 100Mb |
| Advertising poster A0 size | 150g/m2 paper | 300dpi | 401Mb |

Notes:
* Smaller files can be output at photo-realistic quality by using interpolation.

## RESOLUTION

Resolution is a measure of recorded detail in a digital image file, a screen image, a photograph, or a printed page. Unfortunately resolution means different things to different people. A newspaper printer will talk about printing on line screens at 85 lines per inch (lpi), a Web designer refers to 72 dots per inch (dpi) monitor resolution and a photographer captures images on a digital camera at a resolution of 640 x 480 pixels. The language of resolution is varied yet specific to each aspect of the technology. Different people use different resolution terminology.

### Resolution: the human eye

Variations in the reproduction quality of a photograph can be detected, up to a defined limit. The eye is, after all, an optical instrument which is capable of detecting up to 3.8 million colours. In digital parlance the eye is a capture device capable of capturing images somewhere between 8-bit depth (256 colours) and 24-bit depth (16.7 million colours).

Human vision operates in the colour space of the visible spectrum, that part of the electromagnetic spectrum varying between violet at 400 nanometres through blue, green, yellow, orange, red and deep red at 700 nanometres. Humans vary in their ability to see the whole range of the visible spectrum. Not everyone is blessed with eyes of similar resolving power. People who are red-green colour blind can not see the full colour gamut. Totally colour blind people have 8-bit depth vision, seeing everything in black, white, or shades of grey. Different people will therefore view the same digital image with their own unique, subjective, colour gamut.

## Resolution: digital capture devices

Capture resolutions are usually defined by the total number of pixels. In a digital camera, or digital video camera, the number of pixels in a CCD chip is defined by the dimensions of the chip and number of CCDs per millimetre. Hence capture resolution is ususally specified as the number of horizontal pixels multiplied by the number of vertical pixels.

Scanners normally have an array of CCDs which either moves over the photograph to be scanned or remains stationary while the photograph is moved. The capture resolution is stated as horizontal pixels multiplied by vertical pixels. Often two resolutions are specified namely, optical and interpolated. Optical resolution is the actual capture resolution (and hence is the most important). Interpolated resolution is the optical resolution plus additional resolution computed and applied by the scanner's software. The quality of the resolution is entirely dependent upon the mathmatical processes used to derive the tonal values of the additional pixels.

## Resolution: monitor

Most personal computers are equipped with monitors where the image is displayed on a cathode ray tube. Electrons are bombarded through a thin metal grill or mask creating a number of electron beams which excite the phosphor coating on the inside of the screen. Monitors with small holes in the grill or mask, with a dot pitch of less than or equal to 0.26mm, generate fine grain images. Conversely, higher dot pitches produce coarser, more grainy, images.

Ideally one electron beam should create one dot of light equivalent to one pixel of the image. In practice even the best monitors used by graphics and imaging professionals which are up to 21-inch across the diagonal, with a resolution of 1,600 x 1,280 pixels, can't display RGB colour images at their actual physical dimensions for files in excess of 6.14Mb. For the purposes of editing, images are frequently displayed at sizes smaller than their actual dimensions. Editing can only be achieved at the individual pixel level by using zoom facilities within the image editing software.

Today's multimedia personal computers tend to be supplied with monitors capable of a maximum resolution of 800 x 600 pixels. This is known as Super Video Graphics Array (SVGA) resolution. Consumer PCs from the late 1980s and early 1990s tended only to support VGA resolution, 640 x 480 pixels. Typically this is the capture resolution of many low-end digital cameras.

Monitor resolutions are also quoted as dots per inch. A 14 inch screen with an image viewing area of 9 1/2 x 7 inch and resolution of 640 x 480 pixels has a resolution of 67dpi. A similar size screen supporting SVGA resolution equates to 84dpi. A 19 inch screen supporting 1,024 x 808 pixels equates to 75dpi. Typically 72dpi is used as a benchmark when preparing images for screen display.

## Resolution: output to the printed page

Full colour reproduction uses four coloured inks, cyan, magenta, yellow and black (represented as CMYK). Newspapers and magazines are printed using four plates, one for each colour, in a process called halftone printing. Light is passed through the negative of an image via a fine mesh or screen held in close contact with negative lith film which is then converted into a positive metal plate for applying the inks to paper. A screen with 85 lines per inch (lpi) creates 84 dots of light per inch. The size of the dot of light varies according to the amount of light that passes through the negative

and through each grid of the screen. This controls the colour saturation in the final print as ink is applied through the four colour plates on to the paper.

Newspapers are printed at between 65 lpi to 85 lpi, low-cost commercial printing between 85 lpi to 100 lpi and glossy magazines at 133 lpi. Fine art work is usually printed at line screens between 150 lpi to 200 lpi or more. Commercial imagesetters convert digital images into plates for printing. Film needs to be scanned at about 2,500 dpi to be able to output satisfactorily at 150 lpi, a quality suitable for glossy magazines and fine art work. See Chapter 9 for more on the relationship between the resolution of digital image files in dpi and halftone output in lpi.

### Resolution: output to digital desktop printers

Desktop colour printers simulate the halftone printing process by using drops of ink (inkjet printers), dots of electrostatic toner (colour laser printers or photocopiers), or drops of coloured wax (thermal wax transfer printers). Resolutions are usually quoted as dpi, referring to the density of the drops or dots. Typically these types of printers quote output at 300dpi to 1,200dpi. This figure can be an overstatement of absolute resolution since it usually refers to the resolution of the printing head device. This gives an indication of the actual number of discrete spots of each tonal colour which are formed by the superimposed application of CMYK colour inks.

There are two other types of desktop digital printers which produce a simulated continuous tone image similar to a conventional photograph. The first uses dye-sublimation where transparent coloured dye in ribbons is transferred to paper by the action of vapourising it using heating elements. The vaporised inks merge rather than forming discrete spots or dots. Resolution defines the density of the heating elements and is typically 200dpi to 600dpi. The second process, known as thermo-autochrome, exposes light-sensitive donor paper to an RGB laser beam, the donor is then heat sealed to a base paper. The silver halide based chemicals merge during this process. Output resolution is dependent on the density of the laser beam dots and is typically 300dpi.

### Resolution: output to photographic film

Outputting digital images to photographic film is generally the preserve of digital imaging bureaux since film recorders are expensive. Digital film recorders use RGB laser beams to expose the film and are capable of outputting at resolutions up to and in excess of 6,000dpi. Analogue film recorders use a cathode ray tube (CRT) to generate an image which is projected onto film, the output resolution being determined in the same way as the pixels are generated in a computer monitor. This type of system is usually used for outputting to 35mm film stock at resolutions between 2,200 to 2,700dpi and is often used to prepare transparencies for the corporate market.

### Resolution: conventional photographic film

The resolving power of conventional photographic film is still huge when compared to many of the digital imaging resolutions mentioned above. Consider each silver halide grain (and its associated colour dyes) as being the equivalent of a pixel in a digital image. Photographic film ranges from a resolution of 2,500lpi to over 4,000lpi. Typically ISO 50 to ISO 200 colour negative and transparency has a resolution of 2,500lpi to 3,200lpi. A few fine grained specialist films, such as those

used in portraiture work, have even higher resolutions. For example, Kodak's Ektar 100 (4,060lpi) and Agfa's Portrait 160 (3,800lpi). Taking a baseline average of 2,700dpi for 35mm format colour photographic film (36mm x 24mm frame) it's necessary to capture an image file of about 30Mb to record the same amount of detail.

## FILE FORMATS

The information in a digital image can be stored in a wide range file arrangements or formats. Tens of different file formats have evolved to meet the needs of the imaging and computer industries. Some file formats are proprietary (native) to individual software packages, computer platforms and operating systems. Other formats have been designed to provide worldwide, royalty-free formats which encourage inter-operability irrespective of companies' individual commercial interests.

Most digital photography software can read and convert all the popular image file formats. But it pays to check before buying. Specialised software, such as DeBabelizer 1.6.5, offers a conversion facility for most image file formats and has useful tools such as batch conversion. A number of file format conversion utilities are available as freeware on the Web (see Chapters 7 and 19).

The most popular file formats are:

**BMP:** Also known as Windows' Paint BMP, this is a standard bitmap graphics format specific to the Windows (3.1+, 95 and NT) operating system. So it is possible to view a BMP image on a Windows PC withou needing any special digital imaging software. BMP is occasionally found on the Web but is not a popular format since resizing and compressing files doesn't produce brilliant results. Used for: Drawing, Windows operating system.

**EPS:** The printing industry finds the Encapsulated PostScript (EPS) format indispensable since it can be used for bitmapped and object-orientated images (images defined . For this reason it is often imported into files created by word processing or page layout software for desktop publishing. This is achieved by incorporating information in the file header of the EPS which specifies the resolution, size, and (type) fonts. EPS uses the PostScript language code to define images with vectors which essentially link the resolution of the image to the resolution of the printer or film recorder. EPS files tend to be large and require lots of processing power. Used for: Desk top publishing (Dtp), Printing industry.

**FIF:** The Fractal Image Format, developed by Iterated Systems, is not widely used, but may become popular in the future because of its ability to compress large image files or video sequences using fractal technology. Used for: High-end digital photography, Image distribution.

**FITS:** A format devised by NASA to capture images in space, FITS (Functional Interpolating Transformation System) is a file which contains information about an image editing sequence which is stored separately within a larger image file format called IVUE. Used for: High-end digital photography.

**FlashPix:** This is a relatively new file format developed by a consortium including Kodak, Hewlett-Packard, Microsoft and LivePicture. A FlashPix file contains a hierarchy of files of progressively smaller resolutions. The largest file is suitable for outputting to a digital print or the printed page. Smaller, lower resolution sub-files are ideal for images intended to be viewed solely on-screen or online. A special FlashPix Viewer software is necessary to take full advantage of the display options

for this format, which include smooth, continuous, zooming and choice of file sizes for different output requirements. Used for: Internet, Consumer prints, Dtp.

**GIF:** Compuserve, one of the original Internet service providers, created the Graphic Interchange Format (GIF) for use on its commercial online bulletin board. GIFs are 8-bit greyscale or colour images with 256 tones and consequently tend to be small files, typically 10K to 50K, used for online graphic content. There are various incarnations of GIFs, GIF89a being one of the most popular formats for the Web since it supports animation. Used for: Internet, Online databases.

**IVUE:** This format is used within a high-end image editing application, Live Picture 2.6, which employs the technology of the FITs file format to significantly speed up the process of viewing, zooming into and editing images. Most editing tasks can be performed in real-time because each FIT file stores the editing instructions and edited results, but editing steps are executed on a low, screen, resolution file. Once all editing is complete the IVUE file format is reconstituted using the information in the FIT files. Used for: High-end digital photography.

**JPEG:** The Joint Photographics Experts Group (JPEG) format, created by a group of software developers, is versatile and capable of being compressed to one-hundredth of the original file size. This has ensured that it is one of the most popular formats for image distribution by transfer media or by telephony networks via a modem or ISDN, since the quality and resolution of the file can be selected for the output and/or transmission requirements. The compression routines confer rapid download speeds for online display. JPEG compression is lossy, so significant information necessary for quality printing can easily be jettisoned if the wrong compression ratio is selected. Interlaced or progressive JPEGs are special derivative files which permit the whole image to be instantaneously displayed at coarse resolution then gradually sharpening and revealing fine resolution as more data downloads. Used for: Internet, Dtp, Online databases, General digital photography.

**PCD:** Is a proprietary format developed by Kodak for writing a hierachy of image files to a special CD-ROM called a PhotoCD. Conventional 35mm silver halide films are digitised by a special PIW scanner at high street photo outlets. Each PCD file, referred to as an Image Pac, contains five or six files from high to low resolution,enabling the appropriate resolution file to be matched with the required output. Small, low resolution files are fine for screen display whereas the larger files are required for print output. Launched in 1990, PhotoCD was promoted as the ideal way of viewing snapshots on TV. Since then PhotoCD has been repositioned as an economical method of digitising snapshots, cataloguing digital images and outputting as digital prints. PhotoCD has also attracted some interest from the low-end printing market. Used for: Internet, Dtp, Digital prints.

**Photoshop:** Photoshop is the native file format of Adobe Photoshop, arguably the most popular image manipulation/editing software in the world. It's a sophisticated format which enables lots of information about image editing to be retained within the file. Compression routines are lossless. Consequently it is very popular with digital imaging bureaus, professional photograhpers and graphic designers, who all demand quality results. Used for: Digital prints, Graphic design, Printing, High-end digital photography.

**PICT:** This is the versatile, native, file format for use on Apple Macintosh computers using the Mac operating system. The original PICT only supports 3-bit colour (8 colours - black, white, red, green, blue, cyan, magenta, and yellow) but the later

version, PICT2 supports 8-bit colour depth (256 colours). Both formats are capable of supporting a range of resolutions and are equally adept at processing bitmapped and object-orientated art originals. The colour palette of PICTs can be customised to suit individual monitors, but display may be affected when opened in different software applications. PICTs can be converted to JPEGs using Apple's Quicktime and can be inserted in common word processing software such as Microsoft Word. Used for: Drawing, Mac Operating System.

**PNG:** The Portable Network Graphics (PNG) file format was designed by software developers to offer a royalty-free alternative to the GIF. PNG uses a very powerful lossless compression routine, supports 24-bit depth and permits rapid online downloads of interlaced images. Currently, PNG is not supported as universally as GIF, though both popular Web browsers, Microsoft Internet Explorer and Netscape Navigator do support PNG and its popularity is likely to grow. Used for: Internet, Multimedia Products, Online databases.

**TIFF:** Aldus and Microsoft created the Tagged Image Format File (TIFF) in 1986 to provide a cross platform (Mac/PC) bitmapped file format which could be used for high resolution production for desktop publishing and colour separations during printing. Individual blocks of data, known as tiles, are identified by tags which specify how they should be stored, read and interpreted by scanners and printers. TIFFs are saved in a format for Mac or PC platforms according to preference. TIFFs use the lossless compression routine known as LZW. A TIFF file acutally comprises the main file and a preview 72dpi image which can be dropped into page layouts. Professional photographers, digital imaging bureaux and printers frequently favour handling TIFFs over other formats. Used for: Archiving, Digital Prints, Dtp, Printing, High-end digital photography.

## FILE COMPRESSION

Digital images create files which are frequently several orders of magnitude larger than a text file, such as a word processing document. Large digital files create lots of problems. Large volumes of digital storage space are required. It doesn't take long, even with small digital images of between 1 to 18Mb, to fill up the average hard drive of a computer (250Mb to 2.0Gb), removable hard disks (100Mb to several Gb) or 650Mb recordable CD-ROMs (CD-R). Distributing large digital image files down the telephone networks via a modem or ISDN can be a time-consuming process. Handling large image files in image editing, word processing or desktop publishing software applications can be very slow. So, many software developers build in special algorithms (mathematical routines) for compressing the size of the file.

The process of compressing the digital information in an image file can result in a reduction in quality of the output image to screen, paper or the printed page. Compression works by two basic methods, lossless compression (also known as run-length encoding) and lossy compression.

Lossless compression is based upon the principle of only storing the minimal amount of information needed to reproduce the correct range and amounts of colour in the entire pixel grid. If the same colour tone is present in adjacent pixels then the algorithum allocates the colour information to a string of pixels rather than storing the (repeated) information of the exact tone in each pixel. Colour fidelity and resolution between the original file and the compressed file is very good. Generally, files subject to lossless compression can be compressed to up to one-fifth of the

Image compress-ion: whole image (top row) and the image viewed at 1,200% magnific-ation (bottom row). All images shot using an Epson PhotoPC 600

Original uncompressed JPEG file, 1,025Kb     Most compression, 36Kb     Least compression, 334Kb

original file size, or a compression ratio of 5:1, without loss of detail. However, this does depend upon the image subject, the contrast range and original file format.

When the file is opened up/decompressed for viewing on screen the software application re-inserts the original pixels. This process actually requires at least as much computer memory (RAM) as the original file. Lossless compression is therefore often used for storing original digital images in a database and for maintaining detail in high resolution images used for high-end (high resolution) output. TIFF files, which use a lossless compression routine known as LZW, are universally used for archiving, image manipulation and high quality output.

The only way of reducing the time required to open up an image file, or to send it down a telephone line, is to dispose of less necessary information without significantly impairing the final quality for the intended output method. Lossy compression routines actually discard information. This information can not be retrieved, so its always best to make a copy of an original file and compress the copy.

Different compression routines are used for different file formats. Two compressed files of the same size, which have been subject to different compression routines do not necessarily offer the same amount of detail (resolution). This depends upon the exact nature of the compression routine.

One of the most popular lossy compression file formats was devised by the Joint Photographic Experts Group whose acronym, JPEG, provides the file format name. Adobe Photoshop includes ten settings for JPEG compression, but lower-end software may not include such a large range of settings. At any one setting there is a mathematical examination of blocks of pixels from which an average colour (tone) is calculated. Larger blocks of pixels are defined as higher compression ratios are used, resulting in reduced colour detail in the whole image. High compression ratios tend to produce a phemomenon called pixelation, when these blocks of pixels, now

represented by one large averaged tone pixel, become visible. Pixelation is also caused by re-sizing an image to a lower resolution and displaying or printing at resolution which reveals the pixels in the image.

Proprietary file formats containing a hierarchy of files, such as FlashPix and PCD, use their own compression routines.

Images presented on Web pages tend to use GIF or JPEG file formats, but image databases held on special Web or FTP servers use other file formats which are designed to automatically decompress on downloading. This process is achieved using software utilities. Common file types, identified with a suffix, can be opened by the following utilities:

.sea = self extracting files which don't need a special program but decompress themselves automatically.

.hqx= BinHex files compressed according to Binary Hexadecimilisation (often used on FTP sites). BinHex files open with the software application BinHex 4.0 or Aladdin's Stuffit Expander (mainly for Mac users).

.sit= Stuffit files also open with Stuffit Expander.

.zip= PKZip files open with PKUnzip (mainly for PC users).

## COLOUR SPACE

Colour space is any system that describes all the colours (tones) irrespective of the ability of a recording device to recognise the full colour range (gamut). Colour space is also referred to as colour mode or colour model.

Colour photographic images are created by a combination of cyan, magenta and yellow (CMY) translucent dyes associated with black grains of light-sensitive silver halide. Digital images are more complex as they can exist in a number of different colour spaces, where colour is created by different additive or subtractive mixing processes.

## RGB

All images displayed on monitors, Liquid Crystal Display (LCD) screens, and those captured by digital cameras, combine a mixture of translucent red(R), green(G) and blue (B) light. This is an additive process (Figure 2.5). Every colour can exist in 256 different shades or values. The gamut is 16.7 million colours or 24-bit depth. If the R, G and B levels are set at the same value, this creates a shade of grey. If all colours are set to zero the resultant colour is black and, conversely if all colours are set to a value of 255 white is created. Most digital image file formats are designed to be viewed in RGB colourspace, but they can be converted to other colourspaces.

## HSL or HSB

Another important additive colour space is defined by levels of Hue, Saturation and Lightness or Brightness (HSL or HSB), a model closest to human vision (Figure 2.6). Objects reflect or transmit wavelengths of light which we perceive as colour or hue.

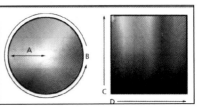

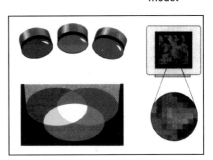

RGB colour space: an additive model

HSL colour space uses a colour wheel: A-Saturation, B-Hue, C-Brightness D- All hues

**CMYK colour space: a subtractive model**

Hue is defined as a position, in degrees, on a 360 degree colour wheel. Saturation, or chroma, defines the purity of the colour. This is controlled by the levels of grey of the hue. A fully saturated hue (10 per cent) has no grey and is a strong, vibrant, rich colour. An undersaturated colour, say 10 per cent to 20 per cent, is dark, lacklustre and dull. Grey is represented by 0 per cent saturation. And lightness or brightness (L or B) expresses the lightness or darkness of a colour as a percentage, black being 0 per cent and white being 100 per cent.

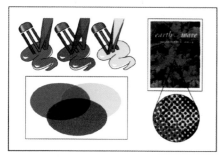

### YCC

This is a variant on the HSL model. Electronic images on television are described by a colour space called YCC which defines the hue, saturation and lightness of each colour in the system. Kodak's PhotoCD (PCD) file format operates in YCC colour space. Conventional film (shot in RGB colourspace) is scanned and converted to YCC colour space to enable the photographer to view images on a television. PCDs can be viewed on a monitor, but are converted into back into RGB files for this task.

### CMYK

There's another important colourspace called CMYK (Cyan, Magenta, Yellow and Black) used in the printing industry. Inks of the four colours are applied to paper where they mix together to create new colours. White is usually represented by the original colour of the paper. This is a subtractive process, since light falling on the paper is absorbed by each coloured ink and the unabsorbed light is reflected and generates the colour. Equal mixtures of CMY should absorb all incident light to produce black but it is often not a pure black, so black ink (K) is applied separately.

**CIELab colour space: A- Luminance = 100, B- Green to red, C- Blue to yellow, D- Luminance = 0**

Artists often refer to CMY as the three primary (paint) colours, but call them blue, red and yellow rather than cyan, magenta and yellow. Mixing paints creates secondary colours. In a similar fashion, RGB colours can be mixed with themselves, as can CMY colours. The additive colours of the RGB colour space and subtractive colours of the CMY space are complementary colours. Mixing two additive colours creates a subtractive colour, mixing two subtractive colours creates an additive colour. Mixing the additive colours R and G produces yellow, mixing the subtractive colours C and Y produces blue, and so on.

### CIELab

RGB colourspace has a larger gamut than CMYK colourspace but both these colourspaces can be described by the CIE Lab colourspace. CIE Lab is an internationally recognised standard created in 1931 by the Commission International d'Eclairage (CIE) based upon a combination of Luminance (L), 'a' colours (green to red) and 'b' colours (blue to yellow).

## Greyscale

This colour space is represented by 256 levels of brightness, with black (0), white (255) and 254 levels of grey. Greyscale images are the digital equivalent of black and white conventional prints. Colour images can be converted to greyscale.

## Indexed colour

This colour space can be customised, but usually comprises a palette of 256 colours. When an colour image is converted into an indexed colour image the colour of each pixel in the image is changed to the closest colour in the indexed palette. Indexed colour images are used to reduce file sizes and control the uniformity of display of a colour on widely different devices. Indexed colour space is used in the preparation of images for multimedia products and the Web.

## COLOUR MANAGEMENT SYSTEMS

Maintaining true colour fidelity throughout the digital photography cycle from capture to manipulation to output is fraught with problems. Anyone who's had a colour transparency made into a conventional print will know colours often don't match. Digital cameras, scanners, and monitors generally operate in RGB colour space, though some funcion in greyscale mode, but just like humans each device will represent an image with a slightly different version of RGB. Similary converting exactly the same RGB image file to CMYK and outputting it at a fixed resolution via different models of inkjet printer will not produce identical colour images. In short, any device attached to a computer will posess its own unique colour gamut or profile. Minimising variability between different devices linked to a computer improves colour fidelity through the digital loop of capture, manipulation and output.

Colour gamut: A-CIELab, B-RGB, C-CMYK colour spaces

Various proprietary systems have been developed to try and overcome these problems and to produce high colour fidelity irrespective of the input or output device. The principle underlying most colour management systems is to use the CIELab colour space as a standard, reference, gamut. It has a larger gamut than RGB and CMYK and so can be used to translate from one colour space to another. It is also possible to map the gamut of a device using the CIELab colour space. The gamut of each device can then be compared against another and best fit corrections made to equate the profiles. So colour management systems compare images in different colour spaces and the gamut of different devices using a translation engine which uses CIELab as a reference point.

Apple Computers achieved an industry coup when it built a colour management system called ColorSync into their Mac OS version 7.1 operating system. This meant that every image file handled by a peripheral device (camera, scanner, monitor, printer) was controlled by one colour management system. ColorSync further popularised the Apple Mac in the graphic design and photography markets and ColorSync 2.0, the current version, also won over parts of the printing industry.

Microsoft followed suit when it incorporated Image Colour Management (ICM) software into Windows 95, updating to ICM 2.0 in 1997. Apple's ColorSync and Microsoft's ICM are compatible since they both are based on the same translation engine from LinoType-Hell, specialists in the printing industry.

Kodak and Agfa have produced their own colour management systems, called Precision CMS and Fototune respectively. Both systems are bundled with their own scanners. Fototune can be used as a plug-in for Adobe Photoshop. Other popular professional level colour management systems include ColorPro (BinuScan), LinoColor (LinoType), and ColorDrive (Pantone).

High-end workstations, such as Barco's Creator, use a colour loop where every device is calibrated to a defined colour standard or reference. So whatever goes in will come out very closely matched to the original.

**Monitor Setup dialog box for Windows95**

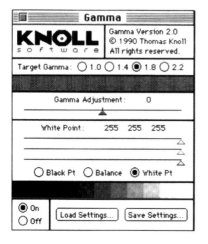

**Gamma Control Panel, for Mac OS**

## MONITOR CALIBRATION

Any calibration of a monitor should be made in the normal lighting conditions in which the monitor is usually located and the monitor should have been running for at least 30 minutes before calibration is attempted. Most computer monitors tend to show a bluish tint. This can be corrected by using the Gamma Control panel on a Mac or the Gamma colour preference on a Windows PC. If outputting CMYK images to print or downloading to a transfer medium a target gamma of 1.8 is best, if outputting images to screen then set a target gamma of 2.2.

Red, green and blue sliders in the control panel can be dragged to adjust the colour of white a monitor displays. This is useful for calibrating the monitor to the paper used for printing. Hold a sheet of paper up to the screen and adjust the sliders until the white colour matches as close as possible to the paper. This tends to darken the appearance of the image on screen, but will give better matching of the colour output.

Many scanners and digital cameras are supplied with software which enables calibration of a monitor's gamma, contrast and brightness, to assist with producing more consistent results when outputting to screen, and/or to print.

A number of Web sites offer methods for calibrating a monitor (see Chapter 19), and some photo libraries encourage viewers to download their calibration routine so that images viewed via the Web browser are as close as possible to the original scans.

# Images and computers

Image files are large compared to other types of file, such as text or sound. File sizes of between 1Mb to 6Mb (uncompressed file size) are needed to produce photo-realistic 6 x 4 inch enprints, depending on the type of printer. Larger prints, such as A4 or 10 x 8 inch require files between 6Mb to 30Mb. Such files require a lot of processing power to perform image editing operations, and quickly occupy storage space on a computer's hard disk.

## COMPUTER POWER

The Central Processing Unit (CPU, otherwise known as the chip or microprocessor) controls the speed at which the computer can execute tasks. Apple Macintosh personal computers are generally fitted with chips manufactured by Motorola, whereas manufacturers such as Cyrix, AMD, and Intel tend to supply chips for IBM-PC compatibles. Wintel computers are IBM-PCs fitted with Intel chips and installed with the Windows operating system.

Many chips these days are equipped with MultiMedia eXtensions (MMX) technology which facilitates handling graphics, text, sound and video from multimedia environments such as CD-Roms or the WorldWideWeb.

Today's PCs operate at CPU speeds of between 133 megahertz (Mhz) to 400Mhz, whereas Apple PowerMacs can operate at speeds up to 350Mhz using the latest PowerPC G3 chip. Contrast this to the PCs and Macs of the late 1980s which crawled along at 16Mhz to 40Mhz.

The computer's CPU has to memorise data as it performs operations. This is done within Random Access Memory (RAM) which reads and writes data between the CPU and a computer's hard disk, where the data is stored. Operating system software (such as Mac OS, MS-DOS, Windows) requires RAM, as does any software application stored locally on the hard disk and used for specific tasks. For any serious image capturing, cataloguing, editing and outputting, 16Mb RAM should be regarded as the minimum, 32Mb RAM is advisable and 64Mb RAM or above is nice.

Faster manipulation of graphics files, including images, is also achieved by installing a separate memory chip to speed up re-displaying of edited images on your computer's monitor or screen. Video RAM (VRAM) chips also control the number of colours that can be displayed in relation to the resolution of the monitor. Typically you need a minimum of 1Mb VRAM for a 14-inch colour monitor to ensure you can display 24-bit colour (16.7million colours). Today's multimedia Macs and PCs usually offer between 2Mb to 4Mb VRAM.

### High volume storage

The hard disk (located inside the hard drive) is the computer's storage cabinet where files, applications, system software and software drivers for peripheral devices are all located. Computers in the late 1980s were equipped with 100Mb hard disks, but in today's computers the storage volume has been beefed up to between 1.2Gb (1,200Mb) to 6.4Gb (6,400Mb) or higher. It doesn't take long to fill up a hard disk with images so choose as big a hard disk as is affordable. Alternatively, store images on a peripheral storage device (see below).

### High speed read/write to the hard disk

It's no good having lots of storage space if it takes ages to read and/or write image files to the hard disk. Two methods of data transfer are popular. Apple Macs (and their clones) use a system called Small Computer Systems Interface (SCSI) which enables transfer rates of up to 32Mbit per second (Mbs) equivalent to 4Mb of data per second. PCs tend to use an Integrated Drive Electronics (IDE) or enhanced IDE (EIDE) system, transferring at slightly slower speeds, though some PCs are nowadays fitted with SCSI adaptors.

### High resolution monitor

The ability of a monitor to display detail is critical with all digital photography work. The absolute resolution a monitor can display depends upon the screen size, the number of colours available and the degree of sharpness. Most PCs are bundled with 14-inch or 15-inch screens (measured across the diagonal) with an effective viewing area of 7 x 9.5 inch to 8 x 10.5 inch. With this visible area the screen is divided into small dots known as picture elements or pixels. A minimum of 800 pixels x 600 pixels, known as SVGA, or Super Video Graphics Array, is desirable. To give images of a photo-realistic quality each pixel should be able to display 16.7 million colours referred to as 24-bit colour. Each pixel can display any combination of 256 tones of red, 256 tones of blue and 256 tones of green.

Sharpness is controlled by the system used to project the electron beams which excite the red, blue, and green (RGB) phosphors on the inside of the cathode ray tube, the exterior of which forms the screen. Monitors with a dot pitch of 0.26mm or less give sharp bright images because the holes in a thin metal plate (the shadow mask) through which the electron beam pass are close together. Sony developed its own system called Trinitron for sharp high resolution monitors which uses a grill of wires rather than a metal plate. A dot pitch of 0.28mm is fine for general imaging work, but serious retouching work requires a big 20-inch or 21-inch monitor with a small dot pitch installed with 4Mb of VRAM.

### Ability to connect peripheral devices

A peripheral device is anything that can be physically connected to the computer, be installed with its own special software (often called a device driver) and can be operated from within the computer's operating system. Peripheral devices are used for image capture (cameras, scanners, video grabbers), image storage (external hard drives, CD-R writers), image editing (mouse pointers, graphics tablets for detailed retouching operations), and image output (printers, storage devices, communications devices). All peripherals are connected via sockets or ports on the back of the box holding the computer's CPU unit.

The number of serial and parallel ports is generally fixed, so it is quite important to make sure a computer has sufficient ports. Serial ports, also known as RS-232 ports, transmit data one bit at a time, as a series of bits, using one line to transmit, one line to receive and several other lines which help maintain a smooth flow of data. Typically peripheral devices such as modems, pointers (mouses, graphic tablets, joysticks) are connected via serial ports. A parallel port has a series of multiple pin holes, each pin connector connects to a parallel wire enabling several data streams to be carried at once. Most printers are connected via a parallel port. SCSI (Small Computer Systems Interface) is a special system for rapid data transfer, up to 32 megabits per second, which utilises a parallel interface and is capable of connecting up to seven peripheral devices (internal and/or external) via one SCSI port. SCSI-2 has a much higher data transfer rate of 10Mb per second.

Typically, today's budget and mid-range IBM-PC compatibles are equipped with one parallel port and two serial ports, a PS/2 port, and between two or three PCI slots. Budget and mid-range Apple Macs are usually equipped with two parallel and two/three serial ports. Apple Macintosh PowerMac series typically have between two to three PCI slots. The top of the range PowerMac 9600/350 has six PCI slots and 12 DIMM slots (for upgrading with extra RAM).

### Speed of data transfer

Data transfer rates between the CPU, the motherboard, peripheral devices and serial or parallel ports depends upon the size and type of the electronic pathway along which signals travel. A 32-bit bus transmits 32 bits of data at one time at a speed measured in megahertz (Mhz). Different types of buses have evolved for use on different computer platforms, the most popular 32-bit systems being NuBus (Mac), PCI - Peripheral Component Interconnect local bus - (Mac/PC), and VESA local bus (PC). PCI has emerged as a universal bus architecture for Apple Macintosh PowerMac and PowerPCs, and IBM-PC compatibles.

### Ability to expand and upgrade

The computer industry continually releases PCs with faster processors, more storage and improved inter-operability between different platforms. Software development companies take advantage of these improvements by releasing new versions of operating system software and software applications which often require much more memory (RAM) and hard disk storage space. It is therefore important to consider how easily a PC can be expanded or upgraded to take advantage of new software.

Just how much a computer can be upgraded is largely dependent on the motherboard, the main printed circuit board, which contains the CPU, RAM, controllers for disk drives and peripheral devices, and various expansion slots to which extra PC cards can be installed. The motherboard also connects to serial and parallel ports at the back of the computer which link to peripheral devices.

A computer's RAM can be expanded for most motherboards by replacing existing memory modules or adding extra memory modules called SIMMs (single in-line memory modules) or DIMMs (dual in-line memory modules) into existing slots or sockets. SIMMs have 72 pin connectors and transfer data at up to 32-bit, whereas DIMMs have 168 pins and support 64-bit data transfer. DIMMs are available in two RAM versions, Dynamic RAM (DRAM) or the quicker Synchronous RAM (SRAM) which requires an SDRAM structured motherboard.

Similarly VRAM can also be upgraded by adding new memory modules to existing slots on the motherboard or on a Video Card attatched to an expansion slot on the motherboard.

Another feature to examine is whether the base unit, containing the CPU, floppy disk drive and hard drive and CD-ROM drive, has an expansion bays to allow you to fit additional peripheral devices.

Screen shots of the MacOS8 operating system designed by Apple

## WHICH COMPUTER?

As far as digital photography is concerned there are two types of personal computer platform that are popular: Apple Macintosh computers (and their clones), using the Mac OS 7 or OS 8 operating system; and IBM-PC compatibles, using the Windows 3.0+, Windows 95 or recently released Windows 98 operating system. Both are well adapted for digital photography. IBM-PC compatibles account for about 85 per cent of the desktop computer market worldwide, Apple Macintosh 10 per cent and other marques 5 per cent.

### The Apple Macintosh/Mac OS

Many professional photographers, graphic designers and artists cut their teeth using an Apple Mac. There's a good choice of Apple Mac models ranging from home multimedia systems, to SOHO (Small Office Home Office) machines and high-end graphics workstations. Today's fastest Mac, at 350Mhz, is the Apple PowerMac 9600/350 equipped with 64Mb RAM as standard. It uses the Motorola PowerPC G3 processor which is also capable of running applications designed for Mac OS, MS-DOS and Windows operating systems.

Mac clones are also made by other manufacturers, such as Computer Warehouse and UMAX, under licence, though the long term future of these arrangements is uncertain. During 1996 to 1997 Power Computing, Umax and Motorola made Mac clones, but only Umax has retained its licence for the Mac OS 8. Nonetheless the Mac clones have similar types of processors to Apple's own computers and will support the latest version of the Apple Macintosh operating system, Mac OS 8.

Apple Mac's strongest market sector is content creation (desktop publishing, advertising, Web site design and graphics). This has attracted software developers to design some of the best image editing and graphics applications currently available. Adobe Photoshop, the world's most popular image editing application was written for the Mac platform long before an IBM-PC compatible version was introduced.

The quality of the Apple Macintosh hardware has stood the test of time. Hardware is all matched, configured and tested using the Mac OS under Apple's supervision giving, generally, trouble free computers which are plug n' play i.e. they can be set

up straight out of the box. This is not always the case with IBM-PC compatibles where a computer's components (the CPU box, various drives, monitor and keyboard) can originate from different manufacturers, and where operating systems often have to be installed by the user.

It's the user-friendliness of the graphical user interface (GUI) and the Mac OS that put Apple Macs at the cutting edge of digital photography. The Mac has many features for aspiring digital photographers. One glance at the online Macintosh Guide in Mac System 7.5+ shows a wealth of helpful tips relating to imaging. Setting a Mac monitor for the best colour display is delightfully simple using the Gamma Control Panel. The monitor's gamma curve controlling the intensity and luminance of the colour in the display can easily be changed from the factory preset curves. Apple's colour management software, ColorSync 2.0, operates from within the Mac OS. ColorSync compares the colour profiles or gamut of each peripheral device and matches the colour as closely as possible to the CIELab colour standard. ColorSync enables you to set your monitor at defined levels of white to ensure good colour matching on printing. Another feature, called CloseView, enables any portion of the screen to be magnified between x2 to x16. Fonts (typographic characters) can be viewed as fixed-size bitmap fonts or as scaleable fonts (eg TrueType, PostScript). Mac OS supports the PICT image file format which can be used in many image editing, drawing and page layout applications. Screen shots (grabs, dumps) are saved as PICT files. The QuickDrawGX system extension permits rapid display of print previews and images. Digitised video and audio files can be opened with QuickTime.

Many different types of imaging software applications are available for the Mac OS for both professional and amateur use. The Mac is also well catered for in terms of word processing, desktop publishing, graphic design and Internet software, but doesn't have quite such good choice for business/office administration and computer games as IBM-PC compatibles.

Software emulators, enabling Macs to run PC applications, have been available for ten years. The Leading software is SoftWindows by Insignia Solutions. Other options include Connectix's Virtual PC and Insignia's RealPC, the latter orientated towards the games market. Virtual PC can not only run Windows 95, but also Windows NT, IBM's OS/2 and NeXT's OpenStep (the foundation for Apple's forthcoming operating system, Rhapsody).

Apple's PowerMac series, introduced in 1995, use the Motorola PowerPC microprocessors 601, 603 and 604. The Mac OS used in combination with these microprocessors enables the computers to operate applications designed for Mac OS, MS-DOS and Windows operating systems. Consequently PowerMacs have access to a vast range of software applications.

### IBM-PC compatibles with Windows operating systems
IBM-PC compatibles use the MS-DOS (Microsoft Disk Operating System). This operating system is designed around the use of typed instructions, with specific syntax, to execute particular operations. File names are limited to eight characters plus three characters at the end which define the type of file. Third party software developers helped improve the lack of user-friendliness in MS-DOS by placing the detailed instructions behind more graphical, intuitive, interfaces. Microsoft launched Windows 1.0 in 1986 gradually upgrading it to Windows 3.1+ in an attempt to add more functionality to the MS-DOS operating system at the same time as making it

Windows95 screen shot (top), Paint(BMP) image file, normal size (middle), same BMP image x 200% (bottom)

more accessible. But it wasn't until the launch of Windows 95, in 1995, that their GUI seemed on a par with that of the Apple Mac OS 7.5+. Many new features were added (see below) including the use of long file names. Windows 98, launched in mid-1998, includes even more functionality.

Most imaging software for IBM compatible PCs is written for the Windows 95 operating system, though some applications were designed to work in Windows 3.1. However, Windows 3.1 only supports 16-bit processing which gives reduced functionality for some imaging and multimedia applications. Windows 95 operating supports 16-bit and 32-bit processing.

With the correct VRAM adapter (software driver) fitted to a computer's monitor, it is possible to control the properties of the display such as resolution settings, number of colours and simple calibration. Setting the display gamma in Windows isn't quite as easy as using the Mac OS. Setting up new software drivers for the monitor or additional monitors is relatively easy using software wizards (sub-routines) activated by following instructions in dialogue boxes on screen, though complications can ensue if the computer won't recognise the monitor's graphics/video card.

There are a number of other features built into Windows 95. QuickView enables files to be viewed on screen without opening the application, saving time and memory resources. Several image file formats are recognised by software integrated into the Windows 95 operating system. These include the Bitmap Image (formerly BMP) and PCX (Image Document) opening in Microsoft Paint, TIFF (TIF Image Document) opening in the application Wang Imaging. Over the last eighteen months Microsoft has bundled its Web browser, Internet Explorer, with Windows 95 so it's also possible to view ART, GIF, JPEG and XBM image files on Web pages. However this bundling practice may be curtailed by the US courts. Windows is also enabled to view video files such as AVI, Quicktime and MPEG and includes other software applications, such as Adobe Reader for viewing Portable Document Format (PDF) files which can include images and/or text.

The look and feel of the Windows 95 GUI can be readily customised to suit individual preferences to include shortcuts to programs (applications), the contents of the hard disk, the startup folder and a host of screen savers, desktop patterns and colours. Customisation options tend to be more varied than the Mac OS 7.5+. And those used to initiating sequences of operations using MS-DOS can still perform run commands from Windows 95.

Windows 95 is the world's most popular operating system for desktop IBM-PC compatibles so software publishers have been keen to create new applications for this operating system. Consequently there is a wide choice of imaging software for Windows 95 for professionals and amateurs. Almost every other type of software is well provided for including games, database management, business administration, desktop publishing and more.

Choosing a PC can be a difficult task. The most popular IBM desktop models include the Aptiva and 300 range. Compaq, Hewlett Packard and Dell are the most well known manufacturers of IBM-PC compatibles but there are hundreds of other companies assembling their own branded machines. IBM machines use IBM 686 microprocessors (the latest chip of the famouts 286, 386, and 486 series microprocessors). A common feature of most IBM-PC compatibles is the use of Intel's Pentium microprocessors, though other chips such as AMD-K6 and Cyrix are now becoming more popular.

An IBM-PC compatible capable of running Windows NT and 32-bit multitasking is necessary for serious imaging power, similar to Apple's PowerMacs.

**Exchanging image files between Macs and PCs**

Macs and PCs have to format blank storage media (such as floppy disks, CD-ROM, and Syquest, Jaz or Zip cartridges) before data can be written to them. This can cause problems when exchanging files between Macs and PCs. PC formatted floppy disks can be read on a Mac using the software PC Exchange which is integrated within all Mac OS packages from version 7.1.1 onwards. Mac formatted floppy disks require a third party utility software if they are to be read on an IBM-PC compatible using the Windows 95 or Windows 3.1+ operating systems. Its generally easier to transfer images using recordable CDs (CD-Rs written to ISO 9660 standard), or have your images written to PhotoCD, since both Mac and PC platforms will be able to read these transfer media. And another tip is to save images in TIFF file format which is a cross-platform format. When saving images as TIFFs in the image editing application Adobe Photoshop, choose whether to format the file in Mac or PC bytes.

**HOW AND WHERE TO BUY**

Hardware and software for digital photography can be purchased from high street retailers, mail order warehouses and specialist dealers of the computer and photographic industries. A directory of suppliers in the UK is given in Appendix I. Contacts for international companies and manufacturers via the World Wide Web may also be useful to check technical specifications (see Chapter 19).

It pays to research where the best deals can be found. Many monthly consumer magazines catering for computer enthusiasts, photographers and Internet surfers (see Appendix IV) keep up to date with the fast changing technology. These magazines frequently list suppliers in the UK and their latest offers, reviewing hardware and software and the performance of different suppliers.

Whether buying new or secondhand, it's worth preparing a quick check list.

1 Which software programs or applications do you want to use? Check with the software publishers as to the minimum RAM, VRAM and hard disk space requirements - add these figures to those needed for the operating system software. Allow a 50 per cent additional margin on RAM and VRAM. Not all software applications work on all operating systems. Often software applications are bundled with computers at the point of sale. Check carefully whether these freebies are really worth having.

2 Which platform and operating system software suits you best? The basic choice is an Apple Macintosh personal computer running Mac OS 7.5+/8.0 or an IBM compatible PC running Microsoft Windows 95/98.

3 What essential hardware do you require? Usually retailers and dealers refer to a computer package they include the base unit containing the CPU/motherboard/memory modules/hard drive/floppy drive/CD-ROM drive/expansion slots/external ports; the monitor; the keyboard; the mouse or other pointing device; and the operating system software. Other peripheral devices may be offered at additional cost.

4 Is the quality of the monitor sufficient for digital photography work? Generally a resolution of 800 x 600 pixels, SVGA, and a 14-inch or 15-inch screen is the minimum specification required.

5 Do you have sufficient expansion slots to upgrade memory (RAM) and sufficient external ports for the connection of all the peripheral devices you need?

6 What type of peripheral devices do you require? Digital cameras, scanners, external storage drives, printers? Check each device to make sure it connects to the computer hardware and operating system.

7 What type of after sales service is offered? Does it include technical support by site visits, telephone or online? Does the company offer personal training or supply training CD-ROMs? What type of warranty is offered? Does the warranty include the supply of an alternative computer while yours is being repaired? Do you have to pay carriage costs returning the computer for repair?

8 How can the purchase be financed? Are there options for a discount on outright cash purchase? What kind of credit options are offered? Can you rent? Will the finance company cover the warranty if the supplier goes into liquidation?

9 Are extra free items of hardware and/or software really good value? Suppliers may offer free printers, modems, CD-ROM encyclopedias and the like. Often these models/products have been superceded. That said, the additional functionality of these freebies may be valuable.

10 Do your initial research, wait one month then repeat. If it still looks good, make your purchase.

There are two routes for buying secondhand. Make your purchase from a reputable dealer, whose livelihood depends on satisfied customers, or take an experienced computer friend with you to buy from a private vendor advertising in the classified sections of newspapers or magazines. Usually secondhand dealers will give a limited warranty of between three to six months, but may extend this for a small fee. This should be sufficient to discover any niggles or problems.

Generally you're a little more at risk buying privately, though Sale of Goods legislation still applies. It's important to check that the vendor has the licence to all the software that comes with the computer. Verification should be made by opening the applications and checking whose name appears in the opening window. The presence of original manuals, CD-ROMs and software boxes is another indicator that the software hasn't been illegally copied. You can always ask to see the original purchase receipt or invoice. And obtain a written receipt for your purchase.

## Specifications for your personal computer (PC)

The systems described below can all be operated using the following basic hardware and software specification:

### Computer power

CPU operating at between 40Mhz to 300Mhz, 100Mhz being an acceptable speed. Random Access Memory (RAM) of 16Mb (32Mb is better and necessary if you're running Windows 95 operating system; 64Mb or more is wonderful).
VideoRAM of 1Mb (2Mb to 4Mb is better; greater than 4Mb is better). You'll need 4Mb PCI graphics card to enjoy full 3-D support.
A CPU with MMX technology is useful for viewing multimedia files (containing images, sound and text).

### Storage

Hard disk of 0.5Gb to 1.0Gb (2.0-4.0Gb is better).
Removable storage, for example a 1Gb Jaz or Syquest drive, or a 100Mb Zip drive. Alternatively a CD-writer to archive on CD-R.

### Drives

A 3.5 inch floppy disc drive
A CD-ROM drive, x8 speed (x16 or x24 speed is better)

### Modem

A 28.8Kbs modem or faster.

### Expansion slots

2 or 3 PCI slots to take additional PC cards.

### Ports

2 serial, 2 parallel

### Monitor

14-inch or 15-inch screen, SVGA resolution (800 x 600 pixels), 24-bit RGB colour (16.7 million colours)

### Operating system software

Mac OS 7.5+ or Windows 95 (earlier versions, Windows 3.1+, can also be used)

### Extras

To take full advantage of today's multimedia games, edutainment CD-ROMs and the WorldWideWeb you'll need a pair of speakers with a Wavetable sound card or similar model.

### Software programs/applications

Choosing software is a personal decision based upon what you want to achieve with your digital photography. Chapter 7 describes popular image manipulation software, Chapter 8 deals with image cataloguing and managment software and Chapter 19 lists the basic software requirements for access to the Web. Examples of software capable of specific tasks, such as downloading images from digital cameras or scanners, are given in the relevant Chapter of the book.

## HOME DIGITAL PHOTOGRAPHY SYSTEMS

There are many ways to experiment with the creativity of digital photography. Defining exactly the kind of creative methods you wish to use and quality of the output will help you choose the hardware and software you require. Nine digital photography systems are suggested below. Some systems, such as System 2, don't even require the use of a computer. Each system is characterised according to:

1 The type of original material e.g. digital still image, digital video, conventional photographic prints or film

2 The type of capture method

3 The quality of photo-realistic prints you can generate. These are classified as low-end or mid-range. If you require higher quality prints it is best to download your image files to a suitable transfer media (removable storage media), such as a Zip, Jaz, or Syquest cartridge, or a CD-R, and submit this to your local digital imaging bureau (Appendix III). Here you will have the option of making photo-realistic prints using, colour laser copiers or dye-sublimation, micro dry, or thermo-autochrome printers, or can have the image written to conventional photographic film.

### Different types of system

**System 1: Digital still images**
Capture by digital still camera
Low-end output to high-end output

Currently there are over 60 digital still cameras available in the UK market (Appendix V) which can capture at resolutions between 320 x 240 pixels up to 3036 x 2036pixels. Cameras with less than half a million pixels (0.5 megapixels) can be connected to a computer and thence to a dye-sublimation printer to produce reasonable quality 6 x 4 inch prints. Cameras with greater than 0.5 megapixels, but less than 1.5 megapixels can produce dye-subprints of a quality approaching those produced by high street photo labs. Cameras capturing at between 1.5 to 6.0 megapixels generate image files which are capable of producing high quality prints up to A4 size or 10 x 8 inch, and are suitable for creating images for reproduction in corporate literature, magazines and newspapers.

The Snappy 2.0 video grabber

### System 2: Digital still images
Capture by digital still camera or scanner
Low-end output

It is possible to create digital prints without using a computer. Fuji is one of several companies to promote this system. The Fuji DS-7 digital camera or the AS-1 scanner can be directly connected to a thermo-autochrome printer, the Fuji NC-3D, which produces glossy digital prints, 148mm x 100mm size. Other printers that link to the manufacturers' own cameras include the Epson PhotoStylus, Olympus P300E, Ricoh RXP10, Vivitar ViviPrint 5000, and Sony Up-D2500.

### System 3: Digital video
Capture by digital video camera (camcorder)
Low-end output

Digital camcorders capture images at 500 lines horizontal resolution using CCD chips of less than 0.5 megapixels. There are a number of video grabbers to enable the downloading of individual frames to a computer. Popular systems include Falcon's Digitiser Quora A4, Iomega's Buz (www.iomega.com), Play Incorporated's Snappy 2.0 and Videonics' Python (www.videonics.com). Popular digital camcorder's include the Canon DM-MV1, JVC GR-DVL 9000, Panasonic NV-DX100B and Sony DVCAM.

### System 4: Video tape
Capture by video grabber from video recorder/TV
Low-end output

Play Incorporated's Snappy 2.0 captures video images in 24-bit colour at resolutions up to 1,500 x 1,125 pixels. The Snappy box connects a video cable from a TV or VCR player or camcorder via the parallel port of a computer. A graphical software interface reproduces the video on a PC's monitor. The required frame is snapped using commands via a mouse or other pointer. Other video grabber systems, listed in System 3 above, can also be used.

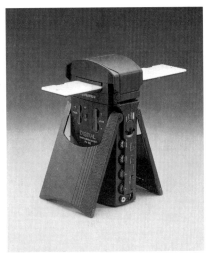

Fuji's FV-10D Video Imager is capable of scanning prints, film and 3-D objects

### System 5: Prints/film/3d objects
Capture by 3D image grabber
Computer: Low-end output

Fuji manufactures an innovative device called the FV-10D Video Imager which can capture a digital image by scanning negatives or transparencies (35mm or Advanced Photo System - APS - film), the printed page and even 3-D objects. The captured images can be viewed on any IBM-PC compatible running Windows or on a TV monitor and can be output to an inkjet or micro dry printer.

### System 6: Prints
Capture by flatbed scanner
Computer: 8 x 10 print output

There are hundreds of different types of flatbed scanner that can digitise everything from 6 x 4 prints to A4, A3 and A2 size original photographs, artwork or printed matter. Colour bit-depth varies from 24-bit to 30-bit or 36-bit. A 24-bit scanner, capturing at an optical resolution of 600 x 1,200 dpi is sufficient to produce image files suitable for producing up to 8 x 10 inch photo-realistic prints on most desktop printers.

**System 7: Film**
Capture by film scanner
Mid-range to high-end output
Conventional 35mm or APS format negatives or transparencies are scanned at high capture resolutions, typically between 1,000 x 1,000dpi to 2,700 x 2,700dpi or higher. Software bundled with the scanner usually permits basic image correction, retouching and resizing. Captured file sizes typically vary between 6Mb to 30Mb enabling output of large photo-realistic prints on a desktop printer or to 35mm film using a digital film recorder at a local imaging bureaux.

**System 8: Film**
Capture via PhotoCD bureaux
Low-end to mid-range output
Kodak pre-empted the recent interest in digital photography when they launched the PhotoCD system in 1990. High street photo labs, approved by Kodak, scan 35mm or APS film using specially developed scanners. An image pack, consisting of five (PhotoCD) or six images (ProPhotoCD), is then written to a special CD called a PhotoCD. The PhotoCD can be read by most computer CD-ROM drives and the image files can be viewed in many image editing applications. File sizes are 72Mb (ProPhotoCD only) to 18Mb, 4.5Mb, 1.1Mb, 288Kb and 72Kb. The three largest files can be used to produce 8 x 10 photo-realistic digital prints on a desktop printer.

**System 9: Digital images**
Capture via Internet/Web downloads
Low-end output
There are hundreds of thousands of photographs which can be downloaded from the World Wide Web using Web browser software. These images can be edited and printed. Most of these images are copyright and may not be reworked and published without the permission of the copyright holder. Having said that there are quite a wide variety of Web sources offering images which are available for private use. Some offer royalty free pictures for a modest fee, others are copyright free.

Web images are usually quite small files, between 50Kb to 500Kb and occasionally up to 1Mb. Despite this limitation it is possible to produce reasonable quality dye-sublimation prints.

**BUSINESS DIGITAL PHOTOGRAPHY SYSTEMS**
The corporate world has welcomed the new era of user-friendly digital photography into its existing desktop publishing environments. Many companies have a need to frequently update and/or produce sales literature, catalogues, in-house reports and stock databases. Low cost image capture using desktop scanners or digital still cameras, coupled with word processing and page layout software applications has enabled companies to cut out several middlemen (such as photographers, graphic designers and printers).

Today estate agents, insurance brokers, utility service companies and corporates capture images with digital cameras or desktop scanners to incorporate them straight into databases, word processing and desk top publishing applications.

## PROFESSIONAL DIGITAL PHOTOGRAPHY SYSTEMS

Photojournalist: Digital photography has been a boon to photojournalists who have to meet tight press deadlines. Systems tend towards capturing images of between 2Mb to 6Mb which are sufficient for printing on newsprint at 80lpi and magazines at 150lpi. These image files can be rapidly transmitted by modem/telephone to picture desks of newspapers and magazines. On receipt A5 or A4 prints are made using dye-sublimation or thermo-autochrome printers for proofing, archiving and/or syndication. Scanning of 35mm film is the favoured capture method, though an increasing number of images are being captured by photojournalists using the Kodak DCS/Nikon/Canon 1.5 or 6.0 megapixel digital still cameras. These are popular because conventional Nikon and Canon 35mm SLR lenses can be used.

Advertising photographer: Advertising and design agencies demand high quality photography so originals can be used for a variety of output resolutions for sales literature, printed matter, advertisements and billboards. Advertising photographers therefore tend to capture very high resolution images, up to 270Mb or more, which can be re-sized for lower output requirements. Since most of their work is studio based, digital cameras or digital scanning backs, fitted to medium/large format cameras, are directly linked to powerful computer workstations. Variations in studio lighting and capture options can be viewed directly on a monitor. Once the desired result is achieved, the image is usually downloaded to a suitable transfer media, such as a CD-R, Jaz or Syquest cartridge. This transfer medium is delivered to a digital imaging bureaux for professional retouching, comping (montaging), colour proofing and finally printing to paper or writing to photographic film.

High street social photographer: Studio-based work, such as portraiture, is captured on a medium to and high-end digital camera, capable of generating image files of between 18Mb to 144Mb. The camera is linked to computer workstation and digital printer capable of producing photo-realistic prints, using a dye-sublimation, inkjet or thermo-autochrome printer. All the hardware is calibrated by colour management software to maintain high colour fidelity throughout the system.

Photo agencies and libraries: The photo licencing industry has been revolutionised by technological advances in digital photography. Many photo agencies and libraries maintain an online archive of digital images for internal use and/or for customers to browse. Original prints or negatives are scanned by mid-to high resolution film and flatbed scanners. The scanners are often linked to a local area network (LAN) which permits access to the online image database stored on tiers of hard disks, called RAIDs (Redundant Array of Inexpensive Disks). The RAID usually stores captions and screen resolution images (from thumbnails to full screen), whereas the high resolution images (between 6Mb to 18Mb or more) are archived on CD-ROM, Digital Audio Tape (DAT) or other archival storage systems. Stock photo libraries may also have powerful workstations dedicated to retouching and creating new images by comping (montaging) using elements from existing photographs.

# Image capture: digital cameras

How is an image captured? A digital camera converts light into data which can be viewed a computer monitor or television, or output via a printer. Some digital cameras can directly download data to a television or a printer.

## DIGITAL STILL CAMERAS

The ability of a digital camera to capture images depends upon a wide variety of factors, the most important being: the type and number of pixels in the light sensor or CCD chip; the lens system; the microprocessors; the image handling and compression software and the internal or removable storage capacity.

### The CCD chip

The capture quality of a digital camera is largely dependent on the light sensitive receptor, known as a CCD (Charged-Couple-Device) chip, that converts light into electrical energy which is subsequently converted into digital data. The CCD chip comprises a grid of hundreds of thousands or millions of individual CCDs (pixels) fixed onto a microscopic printed circuit board. The constituent materials of pixels are excited on exposure to light. A continuous, analogue, stream of electrical charges or pulses is generated. The value of each charge is in proportion to the amount of light received by each pixel. Being sensitive to wavelengths of light in the visible spectrum and beyond, CCD chips are often used for camera work involving infrared and ultra violet photography associated with satellite imaging and scientific study.

### Capture resolution

Resolution is a measurement of the amount of detail the digital camera can record. The total number of pixels in a CCD chip determines the number of points at which the light in a given scene or picture can be sampled. The higher the number of pixels the more accurately will the variation in light be recorded. An infinite number of pixels would record a perfect facsimile of the actual scene or picture. In reality digital cameras are fitted with CCD chips of between 250,000 pixels in low-end, low resolution, cameras to 30 million pixels or more in high-end, high resolution, cameras or digital camera backs.

Capture resolutions are usually specified as horizontal pixels multiplied by vertical pixels, giving reference to the physical fact that the pixels are arranged in a grid on the CCD chip. Low-end cameras capture at resolutions of between 320 x 240 pixels and 640 x 480 pixels. Capture resolutions of high-end cameras vary between 1,524 x 1,012 pixels and 6,400 x 4,800 pixels and higher. Mid-range resolution cameras fall between low- and high-end systems and include megapixel cameras which have CCD chips of one million pixels. A range of low-end to high-end models, with different capture resolutions, is given in Appendix V.

Typical low resolution, digital cameras

Fuji DX-7

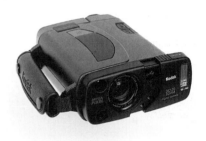

Kodak DC120

Typical medium resolution, and megapixel digital cameras

Fuji MX-700

Kodak DC220 and DC 260

Typical high resolution, portable digital still cameras

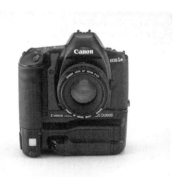

Canon EOS D2000

Kodak/Nikon DCS 315 Pronea 6i

Olympus C-420

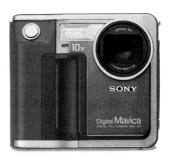

Sony Mavica FD7

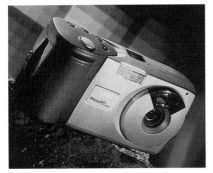

Epson PhotoPC 600

Olympus 1400

Kodak DCS 520 (front)

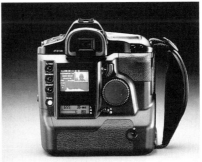

Kodak DCS 520 (back)

Images
captured
using an,
Epson
Photo
PC600
camera at
different
resolution
settings

Low resolution 55Kb

Medium res 133Kb

High res 400Kb

Images
magnified
to 1200%

Low res

Medium res

High res

## Lenses and focusing

CCD chips vary in size and shape from 8 x 6mm in low-end cameras to 36mm x 24mm (the size of a conventional 35mm film frame) for high-end SLR based digital cameras. The lens system has to focus the incoming light onto the area of the chip covered with pixels. Several systems are employed according to the type of digital camera. Low-end to mid-range resolution cameras tend to employ fixed lens systems using a lens of a fixed focal length or a zoom lens in which the focal length can be varied. Interchangeable lens systems tend to be employed with high-end cameras, enabling lenses of different focal lengths to be selected for different tasks.

Three-quarters of low-end cameras have fixed lenses of fixed focal length, usually between 4mm to 6mm, with minimum apertures of between f/2 to f/4. These focal lengths equate to between 38mm to 55mm for 35mm format SLR cameras, offering wide angle to standard angle of views. Low-end digital cameras with a zoom capability tend to use x2 to x10 zooms.

There are two lens systems for digital cameras with interchangeble lenses. The first uses dedicated lenses while the second utilises conventional 35mm or medium format lenses used on conventional SLR cameras. Dedicated lenses usually focus the entire image on the area of the CCD chip. Conventional lenses tend to only focus part of the image on the chip. This is due to the relative size of the CCD chips compared to the size of the image area created on the focal plane of the camera. Conventional lenses have been designed to create images on the focal plane of specific sizes according to the film format of the original SLR camera. For example, 36mm x 24mm (35mm format) or 60mm x 45mm, 60mm x 60mm (medium format) frames. Chip sizes tend to be between one-fifth and one-tenth of these frame sizes. The overall effect is to increase the apparent focal length of the lens. For the Kodak DCS models, manufactured prior to late 1997, conventional lenses double the effective focal length. A conventional 50mm lense is therefore capable of capturing images equivalent to a lense of 100mm or more, a 90mm lense equivalent

to 180mm or more and so on. Expensive, ultra-wide angle lenses (typically, 18mm, 24mm) are needed to take wide-angle shots. However in early 1998 this problem was resolved with the launch of the Kodak DCS 520 digital camera, based upon a Canon EOS 35mm SLR body. The DCS520 has a 2 megapixel CCD chip which covers the entire frame of 35mm format film, i.e. 36mm x 24mm, resulting in a 1:1 ratio between the image size created by the lense and the capture area of the chip. Canon's full range of 35mm SLR lenses can now be used to generate digital images at their correct focal length.

### Single and triple shot cameras

Most portable digital cameras, i.e. those which do not have to be attached to a computer to capture images, are single shot cameras. Single shot refers to the process of capturing an image with one exposure of the shutter. Colour digital images are captured in red, blue, green (RGB) colourspace, whereby all colours are described as an additive mixture of transparent red, green or blue light. Two technolgical solutions have emerged. The most common solution is to fix a mosaic of red, green or blue filters in front of each light-sensitive pixel. Different filter patterns are used by different camera manufacturers but all rely on the principal that special software calculates an average colour value of each pixel by referring to individual RGB filter clusters around each pixel. Another solution uses a prism to split the incoming beam of white light into its red, green and blue components, directing each split beam onto its own CCD chip. The data from the three chips is recombined by a special microprocessor and software.

Triple shot cameras expose one CCD chip three times, each exposure using a red, green or blue filter in sequence. The object/subject being captured must be stationary to maintain exact registration between the red, blue and green images. Consequently, triple shot digital cameras (also known as three pass or sequential filtration cameras) are generally not used to capture moving objects/subjects. These cameras are intended for studio based work and are usually connected directly to a powerful computer workstation that can handle large, high-resolution, image files.

Digital camera scanning backs attached to conventional medium and large format film cameras tend to use triple-shot exposure methods rather than single shot.

### Microprocessors within digital cameras

Just as computers have microprocessors to execute instructions and handle data, digital cameras have a special microprocessor(s) built-in to handle certain tasks. Digital still cameras i.e. those that capture one frame at each exposure, use a microprocessor to convert the continuous (analogue) stream of electronic pulses from each pixel into digital data. The same microprocessor or additional microprocessors perform other operations such as running special software to format and compress the digital data into files, and to send the data to an internal storage device, removable storage media or to an external storage device on a computer. Some cameras are fitted with microprocessors which can store special software to enable direct downloading of image files to a television or printer.

### Image capture software

A well manufactured chip with millions of pixels is useless if the data captured as electrical pulses can not be translated, converted and repackaged into a useable image

file format of digital data. Manufacturers tend to use proprietary software to calculate the exact colour tone of each pixel using RGB filter data, but most manufacturers store the data in commonly used file formats, such as JPEG (Joint Photographic Industries Group). JPEG is especially popular since this file format can be compressed to one-tenth to one-hundredth of its original capture size, thereby vastly increasing the storage capacity of any internal storage device in the camera. The benefits of different image file formats are discussed in detail elsewhere (see p?).

Low-end digital cameras capturing at 640 x 480 pixels can in theory generate an RGB image file size of 0.9Mb. In reality image compression software is used to reduce the capture size to between 50Kb to 250Kb, equivalent to compression ratios of 1:20 and 1:4 respectively. Many of these image files can not produce photo-realistic 6 x 4 inch prints without software interpolation being used to add additional pixel data before printing, and even then the best results may only be achieved using continuous tone dye-sublimation or similar printers. Mid-range digital cameras tend to use larger compressed file sizes, varying from 250Kb to 1.5Mb. Portable high-end digital cameras tend to use low compression ratios (1:5 or less) capturing compressed files of between 1Mb to 3Mb up to 18Mb or higher. The image capture software and amount of data lost when the file is compressed determines the maximum output quality which can be achieved (see Table 2.1).

**A selection of removable storage media and adapters from Impact**

### Internal storage devices

Conventional cameras accommodate film cartridges of 12, 24 or 36 exposures. By comparison portable digital still cameras can capture anything between 4 to 170 images according to the type of internal storage device and the image compression software utilised. Images in low-end digital cameras tend to be stored in ROM (Read-Only-Memory) microprocessors, the storage capacity being typically 1Mb to 4Mb, though there is a trend towards using removable storage media.

### Removable storage media

In the 1990s the digital camera industry searched for a means of improving the limited storage capacity of digital cameras using ROM storage. Many low-end digital cameras are now fitted with a drive into which removable PC cards are inserted. There are three popular types of PC card. CompactFlash, Smart Media and PCMCIA (Personal Computer Memory Card International Association) cards. Cards are manufactured at a range of storage capacities. CompactFlash cards use SRAM (Static Random Access Memory) vary between 4Mb and 24Mb capacity, and are about half the size of a credit card. Smart Media cards are of smaller capacity, between 2Mb to 8Mb. PCMCIA cards are about the size of a credit-card. Type I is the primary one used for image storge, capacity 4Mb to 24Mb. Type III are generally used for high-end cameras and have a capacity of between 85Mb to 340Mb.

Other removable storage media are used. In mid 1997 Sony made it possible to store digital images on the 1.4Mb capacity 3.5 inch floppy disk, when it launched the Sony Digital Mavica MVC-FD5 and MVC-FD7 cameras.

## Downloading images to a computer

Digital cameras download images by directly connecting to the computer via a cable, or by using a removable storage media which is transfered between the camera and the computer. Cable connection is from a socket on the camera to a serial or parallel port (socket) at the back of the computer. Software, called a device driver, is supplied with most digital cameras which allows the computer to communicate with the storage device in the camera enabling the images to be downloaded. Images written to a removable PC card or floppy disk can be read by inserting the media into a suitable drive connected to a computer. Nearly all personal computers are equipped with a 3.5 inch floppy disk drive, but special drives need to be attached to a serial or parallel port to read the data from a PC card. Some cameras have even been designed to insert directly into a PC card drive, such as Nikon's handy CoolPix range.

An Epson PhotoPC 600 Twain interface for download-ing images

There is also a non-contact method of downloading images from camera to computer. Infrared transmission permits cableless downloading of images in some cameras, for example, the Kodak DC120.

## Other camera features

Image quality selection: Many low-end and mid-range digital cameras allow you to select the amount of compression to which images are subjected prior to storage. This controls the number of images you can store in the camera or on a removable storage medium. Two or three modes are usually available from economy, normal, high quality, equating to very high, high and moderate compression ratios. On some models image quality selection is controlled by reducing the number of pixels which capture the original image.

Equivalent ISO exposure range: The sensitivity of a digital camera's CCD chip is rated as the equivalent of the ISO exposure range for films. Low-end and mid-range cameras typcially have an ISO equivalent fixed between ISO100 to ISO400, but high-end cameras can obtain satisfactory exposure between ISO100 to ISO 1600. Some high-end cameras can sometimes operate over this entire ISO range giving considerable flexibility for shooting in variable lighting conditions.

Exposure: Most low-end to mid-range digital cameras with fixed lenses have automatic exposure control, similar to that in most compact 35mm film cameras. A few models do offer exposure compensation of between +/-1 to 2 stops for difficult lighting conditions, such as strong backlighting. High-end digital cameras with interchangeable lenses offer sophisticated exposure control using automatic and manual override systems providing effective compensation up to +/- 5 stops. Multi sector, centre-weighted and spot metering functionality may vary according to the exact lenses used and any effects generated as a result of differences between the size

A Nikon CoolPix 100 inserted into a PC card slot in a laptop computer

of the chip and the optical frame size of the lens system.

Flash: Most low-end to mid-range digital cameras have a built-in flash which is capable of providing adequate exposure between 2.0m to 4.5 metres according to the ambient lighting conditions.

Viewfinders/viewing systems: A traditional point-and-shoot viewfinder or a small coloured Liquid Crystal Display (LCD) is used to view or display the subject area seen by the lens in low-end and mid-range cameras. Accurate framing using the viewfinder depends upon how well the manufacturer has minimised parallax errors and fixed the markings on the viewfinder window to correspond with the actual framed image. LCDs are used on a number of low-end cameras. They can be difficult to see in bright sunny conditions, but are useful to review and edit images captured. High-end digital cameras tend to use through the lens (TTL) viewing and metering, similar to conventional SLRs.

## DIGITAL CAMERA SCANNING BACKS

Certain conventional medium and large format cameras can be converted into digital cameras by inserting an interchangeable film back that uses a linear CCD or array to capture a digital image. Digital scan back cameras tend to be three-shot cameras using sequential exposures under red, green and blue filters. On each exposure the CCD array travels accross the area where the image is focused. Capture times are minutes rather than seconds, creating large files up to 270Mb or more. Typically digital scan back cameras are coupled with very powerful computer workstations and used for high quality advertising or corporate studio-based photography.

High-end digital studio cameras either use digital scan backs fitted to existing manufacturers' SLR cameras or proprietary all-in-one systems where the camera is designed to be coupled to a computer configured to match the camera's requirements. See Chapter 1 for details of current models.

## VIDEO CAMERAS AND CAMCORDERS

The digital still video camera was the forerunner of the low-end digital still cameras of today. CCD chips were originally developed in the late 1970s/early 1980s to provide a means of recording video images onto special 50mm sized floppy disks. The CCD converted light into an analogue electronic pulse which was recorded on the disk as 25 full frame images, equivalent to 50 separate fields. New data could be added to the floppy disk by simply recording over the old data. The still video frames could be displayed directly on a television but could only be displayed on a computer when the data on the floppy disc was downloaded and changed into digital information using a special analogue to digital converter.

Advances in video technology in the late 1980s led to the development of camcorders followed more recently by Digital Video (DV) cameras (digital camcorders). Camcorders use a CCD chip to record up to 25 frames per second onto re-useable video tapes of up to one-hour length. Chip sizes vary from 300,000 pixels to 600,000 pixels and higher, depending upon the age of the camcorder. The easiest way of downloading the images to a computer is to utilise a analogue to digital converter which connects to a parallel port on a PC. The camcorder is connected via the converter to a TV set and the computer. Run the tape and images appear simultaneously on the TV and in a preview window of the graphic user interface of the converter's software on the computer. Click the active icon when the correct

frame is in view to save the image to your hard drive. See Chapter 6 for details of commercially available image grabbers.

One thing to watch out for is which Video standard camcorders use. PAL has an aspect ratio of 4:3 and is used widely in Europe, whereas NTSC is the dominant standard in the USA and Japan and has aspect ratios 4:3 and 16:9.

Digital camcorders don't need to use a digitiser and don't have the compatibility problems of analogue camcorders since all the manufacturers follow a worldwide DV standard. DV captures at 500 lines of horizontal resolution using 0.25 to 0.5 megapixel CCD chips. Video quality is superb, but when individual frames are captured the file size is small. New FireWire interface connections allow data to be downloaded to computers at 25Mb per second. Currently digital camcorders are priced for the professional market, ranging between £1,500 and £2,000.

CHAPTER 5

# Image capture: scanners

While digital cameras offer a convenient portable device for image capture, the need to record in a single exposure, and the relatively high cost of CCD chips, conspires to keep capture resolutions modest in all but the most expensive digital cameras. The small digital image files generated can restrict output options, especially the production of large photo-realistic quality prints or film. A solution to these restrictions was sought in the use of scanning devices.

The printing industry has long confronted the problem of how to convert photographs into pictures on the printed page. The solution is simple, yet ingenious. Instead of arranging the individual pixels within the chip in a square or rectangular grid, the pixels are aligned in a single row or array. This CCD array is moved over the entire print, negative or transparency, which is illuminated with a light source. The motor drive is stopped at predetermined points or steps where the CCD array samples the light and colour in each pixel. Some systems reverse the relative motion of the components, moving the photograph over a stationary CCD array. Other systems use several CCDs arranged in a block. All these methods facilitate capture at higher resolutions than most digital cameras.

Thousands of movement steps of the CCD array, or the photograph, are required to sample an image. Resolution is increased with an increase in the number of steps and is therefore dependent on the degree of accuracy and design specification of the motor unit.

Resolution of scanners is usually defined as dots per inch (dpi) referring to the number of sampling points, i.e. CCDs or pixels per inch. This is known as the optical or true resolution. Some manufacturers define the capture resolution of their scanners by combining the optical resolution with additional data, known as interpolated resolution, calculated by special software applications. The software inserts new pixels using averaged values calculated from the surrounding (existing) pixels from the original CCD array samples. Capture by optical resolution based systems generally produces better quality scans than systems that rely heavily on optical combined with interpolated resolution. Manufacturers sometimes overstate the resolution capabilities of their scanners by only referring to the combined optical and interpolated resolution. Always check the manufacturer's technical specification.

Scanners record RGB colour using single-shot or triple-shot technology, just as digital cameras. Single-shot (single pass) systems utilise red, green, and blue filters on the surface of the CCD array. In triple-shot (triple pass) systems the CCD array scans the photograph three times, the first scan recording red light, the second green light and the final scan records blue light.

Scanners for the consumer market offer colour capture between 8-bit depth (256 colours) to 24-bit depth (16.8 million colours), but many scanners for professional photographers, graphic designers and printers have a minimum 24-bit depth.

Higher-end scanners record up to 30-bit depth or 36-bit depth. This is equivalent to 1,024 or 4,096 levels of grey per colour respectively. Capturing images at these bit depths creates large files, hundreds of megabytes in size.

One of the most important characteristics of scanners is their dynamic range. This is a measure of their ability to capture a wide range of contrast. Scanners with a higher bit-depth capture have a higher dynamic range. Measured in D units (acutally a Logarithm scale D), one D unit is roughly equivalent to three stops of contrast in conventional photography. Scanners with a D value of between 1.8 to 2.0 are fine for scanning reflective prints, and most flatbed scanners for the consumer market meet this D value. Film scanners should really have a minimum D value of 3.0 to accurately record the contrast range found in negatives and transparencies.

There are hundreds of different types of scanners tailored to meet diverse needs. Inexpsensive digital snaphots can be captured using scanners that cost a few hundred pounds or less. Specialised printers and digital output bureaux use very high resolution A3 drum scanners or large format flatbed scanners costing £50,000 and higher. These are capable of capturing very high resolution files.

Selection of a suitable scanner depends upon the maximum capture resolution required for the type of output selected, the photographic format (print, negative, transparency) being scanned, and the cost. Photographic prints or artwork tend to be scanned on flatbed or drum scanners. Negatives or transparencies are scanned on film or drum scanners, though large negatives/transparencies (medium format, 5 x 4 inch, 10 x 8 inch) can be scanned on some flatbed scanners using an adaptor to hold the film. Small files for screen usage or for output as small prints (generally less than 2 x 3 inches) can be captured on flatbed scanners using a 35mm film format adaptor, but dedicated film scanners offer much higher capture resolutions.

Maximum capture resolution for output to a monitor or desktop printer can be calculated using the following formula:

$$S = (Oh/Sh + Ow/Sw) \times O \times 0.5$$

where, S is the scanning or input resolution
O is the output resolution (of the printer, monitor, TV or other device)
Oh is the height of the output image
Ow is the width of the output image
Sh is the height of the input image
Sw is the width of the input image

Alternatively refer to Tables 2.1 and 2.2 (see pages 11 and 12, Chapter 2) which match the required input resolution and output resolutions according to the size of the input original and type of output. As a rough guide the following resolutions apply for obtaining photo-realistic quality output at the same size as the original:

1 Screen (monitor, TV) 72-75 dpi.
2 Desktop colour printers (inkjet, dye-sublimation, micro-dry) 150-1,200 dpi, according to the type of printer.
3 Professional photographic prints made at an imaging bureaux for commercial or exhibition purposes 200 - 1,200 dpi, according to the type of printer. Digital images written to film are output at 2,400 dpi to 6,000 dpi and higher.

4 True halftone printing in newspapers and magazines 65 -150 lpi (approximately equivalent to 130-300dpi output on desktop printers); fine art prints 200 - 400 lpi. As a rule of thumb the resolution of the digital image file should be no more than 1.5 to 2.0 times the halftone screen frequency for same size printing. For example, if the halftone screen frequency is 100 lpi then scanning a print at 50 dpi will produce a poor quality print at the same size, scanning at 100 dpi gives an improved print, 150 dpi is better still, and 200 dpi produces the best or photo-realistic quality halftone print. A 300 dpi scan will not necesarily produce an improvement in quality at this line screen frequency.

A typical low-end flatbed scanner, the UMAX Astra 610S

## TYPES OF SCANNERS
### Low-end flatbed scanners
Many low cost low-end desktop flatbed scanners have a maximum optical capture resolution of between 300 to 600 dpi, which is fine for scanning photographic prints for producing images for screen display and output via desktop printers (see Appendix VI). For example, the minimum scanning or input resolution (S) for a 6 x 4 inch print to produce a 9 x 6 inch inkjet print, output at 200dpi is:

$$S = (9/6 + 6/4) \times 200 \times 0.5 =$$
$$(1.5 + 1.5) \times 200 \times 0.5 = 300dpi$$

Most low-end scanners have a maximum capture area of approximately A4 size paper (297mm x 216mm), but a few models can only accomodate standard 6 x 4 inch prints.

Almost half of current low-end flatbeds are either fitted with or can be equipped with a film adapter. However, the smallest negative or transparency required to produce a similar 9 x 6 inch inkjet print, output at 200dpi , as in the above example, would have to be fractionally larger than a 5 x 4 inch i.e one generated by a large format camera. Other film formats, such as APS, 35mm and medium format, can be scanned but low capture resolutions create small files which are generally only suitable for screen viewing. For negative and positive films less than 5 x 4 inch dimension it is generally better to use dedicated film scanners or get it scanned by a professional digital imaging bureau on a drum scanner in order to produce sizeable photo-realistic prints.

The Epson FilmScan 200 a 1,200 x 2,400 dpi scanner

### Low-end film scanners
Photographic film has the ability to record detail at a resolution of between 2,500dpi to over 4,000 dpi which enables large prints of up to 20 x 16 inch to be successfully reproduced from a 35mm negative measuring 36mm x 24mm. Film scanners have

Fuji's AS-1
APS and
35mm film
scanner

to also be able to capture detail from the same 35mm negative at high resolutions if prints can be output at photo-realistic quality and at reasonable sizes. Low-end film scanners operate at resolutions between 800-1,200dpi up to 2,400dpi and usually offer 24-bit or 30-bit colour depth. Interpolation is used to boost resolution on some models. All models accomodate 35mm film and some will also permit APS film to be scanned (see Appendix VI).

### Mid-range flatbed scanners
Typically, optical capture resolutions are between 600 x 1,200dpi, but many use sophisticated software interpolation to give a combined resolution of up to 9,600 x 9,600dpi. The quality of the scan depends upon the ability of the software to fill-in the missing pixels. Image capture areas are generally A4 size, though a few more expensive models can accomodate A3 size originals.

### Mid-range film scanners
These are aimed at the professional photography market. Minimum capture resolution tends to be between 2,000dpi to 4,000dpi, with many capturing at 2,700dpi which equates roughly with the amount of detail recorded on general purpose photographic film. Portable film scanners, such as the Kodak RFS 2035 and Nikon CoolScan LS-1000, used by photojournalists operating in remote locations, tend to scan 35mm format film only. Desktop film scanners can often accommodate 35mm, 120mm rollfilm and/or 5 x 4 inch film. Most mid-range scanners capture between 24-bit to 36-bit depth colour.

### Mid-range to high-end drum scanner
These specialist scanners operate on a different

Nikon's
popular
Coolscan II
and
LS1000 for
pro users

principle to the flatbed and film scanners. A Photo Multiplier Tube (PMT) replaces the CCD array as the light sensitive detector. The PMT and a light source operate either side of a hollow perspex cylinder onto which the original film is fixed. As the drum spins at high speeds the PMT is mechanically moved over the image area. The scanning path of each sensor in the PMT is usually a spiral. Drum scanners can capture at resolutions up to 10,000 dpi or higher and are linked to powerful workstations and printers. All these devices are all calibrated to each other forming a loop where colour fidelity, between the scan, monitor and printer, is very high.

Systems based around a drum scanner are often linked to film recorders, which write digital images back to conventional film, or are an integral part of imagesetters, used for preparing plates for full colour printing by commercial printers. Drum scanners are used by the professional photography and printing industries for most film formats and conventional prints up to 20 x 16 inch or larger. To produce exhibition quality digital prints, take original film or prints to a digital imaging bureau (Appendix III) to have them scanned and output on a high-end printer.

### High-end flatbed scanners

Capture resolutions of high-end flatbed scanners are similar to mid-range flatbed scanners. The difference lies in the image area which is scanned, which ranges from A3 to A1 size, the latter are referred to as large format scanners. Image files are massive requiring very powerful computer workstations to handle them. These scanners are strictly for commercial.

### SCANNER SOFTWARE

Almost all scanners are sold with some bundled software. Driver software assists with the process of communication, selection of scanning settings, display of preview images, and movement of data between the computer and the printer. Many manufacturers also bundle an image manipulation/editing software package. Low-end scanners tend to be supplied with basic software which allows you to do simple editing tasks such as colour correction, removal of scratches and resizing. Cut-down versions of full software packages are also bundled, two popular examples being Adobe Photoshop LE and Live Picture XT. A lot of the software bundled with mid-range to high-end scanners is designed as a plug-in to Adobe Photoshop or is a stand-alone application, such as FotoLook (Agfa) or ColorPro (Binuscan). Omnipage OCR (Optical Character Recognition) software is bundled with a wide range of scanners and is useful for those that want to scan in text as well as images.

Some basic features are required of all scanning software. After cropping the image to define the area to be scanned other data should be specified such as the scanning resolution, the type of original (reflective print, negative, transparency with an option to specify greyscale or colour) and brightness/contrast levels. Note the file size these settings will create and preview the image. An option to optically focus the scanner on the print or film is very useful and assists in getting sharp scans. At this colour corrections can be applied together with the colour space and file format for saving the image. Alternatively colour correction can be applied after the scan using image manipulation software. Most low-end scanners only offer the option to use RGB colour space, but higher-end scanners offer the option to scan files directly to CMY or CMYK colour space. When using 30-bit or 36-bit scanners some colour correction will be necessary prior to scanning, but with 24-bit scanners auto settings generally produce acceptable scans which can be corrected later.

Many scanners - and most digital cameras - are TWAIN-compliant devices, i.e. they use the TWAIN protocol or signalling language when communicating between the scanner, the scanner or image maniuplation software, and the operating system software on the computer. TWAIN software drivers are bundled with the scanners

Scitex Eversmart Pro with a Dmax=4.5 for images with high contrast

A drum scanner at Metro Imaging, London

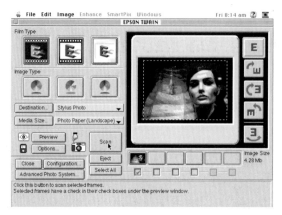

**The Epson FilmScan 200 TWAIN interface to control scanning features**

and are configured when you install your scanner. Some software allows TWAIN devices to be accessed directly from within drop-down menus of image editing software.

Consistent digital prints from desktop printer can be achieved by regularly calibrating scanners, monitors and printers and may require the use of colour management software. This ensures high fidelity of colour between all devices. Mac OS and Windows 95 operating system software both have their own colour management systems, ColorSync 2.0 and ICM respectively. Both these colour systems tend to work in the background, matching the colour profiles of each device (scanner, camera or other peripheral device). Most scanners are compatible with ColorSync, which was launched before ICM.

CHAPTER 6

# Image capture: miscellaneous systems

**A PIW Kodak scanner for writing images to PhotoCD**
Photographs can be digitised by high street photo services or professional imaging bureaux which will write the images to removable transfer media. If a computer has the appropriate drive, the removable media can be read and the images viewed by importing them into a suitable image manipulation software. There are also a number of devices which capture video images, converting them to still digital images to be viewed on a computer or TV.

## PHOTOCD

High street photo labs, approved by Kodak, scan Advanced Photo System (APS) or 35mm film using a Photo Imaging Workstation (PIW) to write the images to a special compact disc called a PhotoCD. The PhotoCD can be read by most CD-ROM drives in a personal computer, or can be linked to a TV with a special CD player. Each image on the PhotoCD consists of a hierarchy of files, an Image Pac, comprising low and high resolution images, as follows:

BASE/16 = 128 x 192 pixels
BASE/4 = 256 x 384 pixels
BASE = 512 x 768 pixels
4 x BASE = 1,024 x 1,536 pixels
16 x BASE = 2,048 x 3,072 pixels

Proprietary image compression techniques are used to save data storage space. Without compression the 16 x BASE file would be 18Mb. In fact an entire Image Pac varies between 4.5 to 6.5 Mb, enabling up to 100 photographs to be stored on a 540Mb PhotoCD. High compression, without significant loss of quality, is possible because the Photo CD System records the BASE file then only adds information from the extra pixels for higher resolution files, and subtracts the information from the lower reslution files. This avoids repeating the same information in each file.

BASE resolution was selected in 1990, when Kodak launched PhotoCD, because images were intended to be viewed on TV and BASE was an accepted TV resolution standard. As usage of personal computers expanded, Kodak retained the role of the BASE file in construction of the Image Pac. Images equal to BASE resolution or lower are fine for displaying on screen. BASE and higher resolution images can be output

The Kodak
PhotoCD
cover
showing
the index
prints to
help
identify
image files

as low or high quality prints, depending upon the output device.

There is another higher resolution file called 64 x BASE = 4,096 x 6,144 pixels, which is included in the Image Pac for the ProPhotoCD. This file is created when scanning 120mm rollfilm or 5 x 4 inch film. Two other PhotoCD formats are available, the Photo CD Master suitable for archiving purposes and the Portfolio II which is designed for presentation purposes.

**FLOPPY DISK**

Specialist mail order photo labs will process film, scan it and write a digital image of each frame onto 1.0Mb or 1.44Mb high density floppy disks. Images tend to be about 72Kb in size, are compressed in JPEG file format, and are suitable for screen presentation and low-end printing.

**DIGITAL IMAGING BUREAUX**

These bureaux are often integrated with a professional photo lab, so the film can be developed first then the selected images can be digitised. A typical bureau is equipped with a wide range of scanners suitable for digitising prints, film and original artwork from APS/35mm film to 20 x 16 inch prints and larger. Bureaux can scan originals at a resolution which will produce large enough image files to match the customer's requirements to output to paper, film or the screen. Image files can be downloaded to suitable transfer media, such as floppy disks, CD-R, PhotoCD, Zip/Jaz/Syquest cartridges, magneto-optical tape or removable hard drives. The service is geared to produce professional quality image files balanced for colour, retouched (if required) and in the right file format for the desired output. Prices vary significantly according to the type of job. Bureaux can be an economical option if the full costs of upgrading a computer and/or printer is considered. There is also a good choice of output media and papers on which to produce archival quality prints. Refer to Appendix III for a list of main UK bureaux.

## FUJIFILM FV-10D PHOTO-VIDEO IMAGER

This device scans a wide range of prints, negatives and transparencies, and 3-D objects at a maximum resolution of 640 x 480 pixels. The FV-10D comprises a scanning head, which holds the 470,000 pixel CCD chip, linked with a zoom lens and autofocus system. APS or 35mm negatives and transparencies are scanned using a special holder, while prints, larger negatives and 3-D objects are scanned by moving the scanning head over the surface of the original. A Digital Signal Processor (DSP) within the body of the imager converts the captured video signal to digital data for viewing the image on a computer, or the video signal can be sent directly to a TV for immediate display. The FV-10D is ideal for capturing images for screen display or for low-end digital snapshots, but it can also be used for capturing cutout images to use in larger digital montages or composites.

## VIDEO FRAME GRABBERS

There are a number of devices which can grab a frame from a camcorder's video tape and convert it to digital data. But one of the neatest ways of capturing video is to connect a digitiser to any parallel port on a PC, such as that used by a printer. Connect the video camera, TV and computer in series via the digitiser. PCI video digitiser cards are slotted into the motherboard of a PC and have an external socket for connecting a TV and a camcorder. Devices are either fitted internally or externally, and support PAL and/or NTSC video standards. Each is accompanied by driver software which has a graphic user inteface to preview the video. At the appropriate frame it is grabbed by clicking with a mouse or other pointer and converted to a digital still image.

There are many video grabbers on the market. Some of the popular ones include Falcon's Digitiser Quora A4, Iomega's Buz (www.iomega.com), Play Incorporated's Snappy 2.0 and Videonics' Python (www.videonics.com).

New Digital Video (DV) camcorders can be connected with a very fast digital data transfer interface called FireWire which is fitted into PCI equipped Apple Macs or IBM-PC compatibles.

# Image editing

All software designed to permit editing, manipulation and retouching of two-dimensional digital images operates on the principle of changing the pixels. Existing colour levels within individual pixels, the spatial arrangement of the pixels to each other, and/or the absolute number of pixels in the image can be changed. The process of editing the raw image file to create a new file can involve a single step or many steps. Steps can be applied to the entire image, to selected parts of the image, or to individual pixels. Discrete parts of the image can be saved as separate sub-files (often called layers or separation areas), which can be edited independently from the main image file.

Software can be purchased directly from photographic and computer high street retailers, mail order companies and, more recently, by online shopping via the Web. In the latter case software can be paid for and downloaded online. A version of the software known as shareware can also be downloaded free of charge to test for a trial period. If the software does the required job payment the full version can be be downloaded and payment is expected within 30 days or so. Freeware is available for downloading free of charge and is not subject to any further charges. All software is covered by copyright law and in most cases the user has to register personal details with the software publisher.

Software is also frequently bundled with digital cameras, scanners, and other graphics hardware. In this instance the full software package or a cut-down version may be supplied.sometimes it may be an earlier version of the software which, if required, can be upgraded at a later date to the current version.

## SOFTWARE VERSIONS AND THEIR SYSTEM REQUIREMENTS

Software which has not yet been commercially launched is called beta software. Most software developers name the launch version of their product as version 1.0. Sometimes software that was originally written for the Apple Mac/MacOS platform is ported to the IBM PC compatible/Windows platform, or visa versa, and a new version is released. Each new version or upgrade of a software often requires more computer memory and space on the hard disk. It is therefore important to check the minimum system requirements specified by the software publisher.

When publishers issue a new version of software maintain a certain amount of backwards compatibility with previous versions of the software running on older PCs. Naturally publishers wish to maximise their financial return by making the software available to the largest possible number of PCs, so they ensure the software will work on their specified minimum system requirements. However, to get the best work rates out of new software it is a often a good rule of thumb to use double the minimum RAM specified. A lot of low-end imaging software will work at between 5Mb to 8Mb RAM, but 12Mb to 16Mb is a more realistic minimum. Mid-range

imaging software usually requires between 24Mb to 64Mb to realise acceptable rates of work during image editing.

Imaging software has originated from the photographic, graphic design and printing industries, each industry striving to meet certain output objectives. Photographic orientated applications tend to assist in the production of images capable of outputting photo-realistic results. Graphic design applications, often referred to as paint programs, aim for seamless integration of photographs, applied artistic effects and typography. Printing applications are geared to converting digital images to the CMYK colour space of the printed page.

Some imaging software contains wide ranging functionality (photographic, graphic design and printing orientated) while other software is only capable of undertaking specific image editing tasks. Low-end applications include a smaller range of editing/manipulation/retouching functions than high-end applications which are used by professional photographers, graphic artists and printers. A good range of plug-in software is available for many mid-range and high-end applications (see Chapter 13). Plug-in software is a separate application which has been designed to add specific functionality to existing applications.

Most image editing software includes filters to apply special effects to all or part of the image (see Chapter 13). Filters can also be added to software by using plug-ins.

Software is available as commercial, shrink-wrapped, products from high street retailers, computer warehouses and directly from the manufacturers. But it is also distributed via the Web (see Chapter 19) and via consumer magazines as free cover mounted CD-ROMs (see Appendix IV). Both distribution sources can include freeware shareware. Paint Shop Pro 4.12 is a popular image editing shareware package (see below).

Although there are tens of different software packages for image editing/manipulation only some of the more popular commercial examples suitable for two-dimensional digital still images are described below. This section is intended to give a brief description of each software. Developers regularly upgrade their software with new versions. Check out the consumer magazines listed in Appendix VI or the developers web sites listed in Chapter 19.

### Software for less than £150

About 30 per cent of low-end image editing software can operate on Mac and IBM-PC compatible platforms, 10 per cent is specific to the Mac platform and 60 per cent is specific to the PC platform. The majority of low-end image editing software enables control of colour balance, red-eye removal, brightness/contrast and sharpen/blur, and permits crop, rotate and flip commands. Software pursuing the fun end of the digital photography market tends to favour automatic options for retouching. They also include easy to use templates and special effects filters for photo-based projects, such as calendars and greetings cards. Adobe PhotoDeluxe 2.0, PhotoImpact and PictureIt! 2.0 are good examples. Software packages which incorporate a palette of tools for cropping, cloning (rubber stamping) and painting, as well as a set of retouching tools, offer more creativity and control over output. Typical examples include iPhotoExpress, PaintShop Pro 4.12, PhotoFix 3.0, Photostudio 2.0 and Picture Publisher 7. Kai's Power Soap falls somewhere between the two categories, offering a fun user interface which includes quite sophisticated auto and manual retouching tools. Adobe PhotoDeluxe 2.0, PhotoImpact 3.0, PhotoStudio 2.0 and

Picture Publisher 7.0 offer some of the better options for comping or digital montage. Most low-end image editing software will read and write a range of popular image file formats (see Chapter 2). It is essential that they can handle JPEG, TIFF, GIF, and PCD file formats to facilitate using images in non-imaging applications, for distributing and/or importing images. For those with a weather eye on the future, its useful if the software supports the new image file format FPX (FlashPix), developed by a consortium headed by Kodak, since the usage of this format is likely to increase in multi-media environments such as the Web and CD-ROMs.

Adobe Photo-Deluxe 2.0 interface showing selection tabs

**Adobe PhotoDeluxe (Adobe)** - This is Adobe's image editing package aimed at consumers who wish to undertake basic retouching tasks and to utilise their photos in standard templates for greeting cards, calendars and the like. Access to automated correction and special effects controls is via a series of tabs and buttons on the interface. A more comprehensive series of retouching controls is available under the Advanced button. This facility uses many Photoshop tools, and so is a good place to start before progressing to PhotoDeluxe's big brother, Photoshop 5.0. A selection of filters is also included.

**Kai's Photo Soap (Metacreations)** - Software designer Kai Krause's mission in life is to make digital photography fun. This package goes a long way to achieving that by using an intuitive interface to enable full image editing and retouching using automated and manual correction techniques.

**Kai's Power Goo (Metacreations)** - Another offering from the Kai stable. This is an easy to use package for distorting, stretching and exaggerating elements in an image. Powerful routines back up a user friendly interface.

Kai's Power Soap with its radical, but practical, interface

**iPhotoExpress (Ulead)** - Quite a useful tools palette equips this package with reasonably competant retouching options. A wide range of photo product templates is also included, but comping facilities are absent.

**LivePix (Broderbund)** - A package enabling basic brightness and contrast control, photo collage using cutouts and standard templates, text importing and a simple image management facility.

**Paint Shop Pro 4.12 (JASC)** - This long established software is a popular inexpensive package which enables basic image retouching, using a floating toolbox and paint operations, giving reasonable digital darkroom capability. Colour, contrast/brightness controls can be adjusted by preset values or by Levels type histograms, but there's only one level of undo. Up to 40 different file formats can be imported and there's a good batch conversion option. An image browser facilitates cataloguing images in separate directories. A TWAIN option allows images to be imported directly from scanners.

**Photo Finish (SoftKey)** - Aims to take the hard work out of image retouching by offering automatic correction for brightness, colour and sharpness combined with an interesting range of filters.

**Photo Suite (MGI)** - A package for the production of greetings cards, calendars and framed photos using preset special effects filters and background designs.

**PhotoFix 3.0 (MicroSpot)** - Multiple undos and lots of mid-range image editing features provides a standard digital darkroom with a full tool palette. Control over colour, contrast/brightness and selection tools offers good flexibility. A temporary items folder, which stores raw data for each editing step, is created during editing. This improves performance and enables data to be recovered in the event of a crash. There's also an option to use the software's own dithering capability to improve print quality on low-end printers. PhotoFix accepts a wide range of Photoshop plug-ins.

**PhotoFlash (Apple Computers)** - An entry level software which offers a basic set of tools for standard retouching operations, such as scratch removal, exposure correction and sharpening. Common file formats are accepted, and files can be exported to word processing and page layout applications. Its versatility is extended by its ability to handle plug-ins compatible with Adobe Photoshop. This opens up a range of weird filters and permits connection of scanners via acquire modules.

**PhotoImpact 3.0 (Ulead)** - A versatile image retouching and creative package which uses an extensive toolbox and permits quick previews of any changes to the original file. It also offers neat tools for preparing and exporting images to the Web and an image cataloguing facility.

**Photomate 1.0 (Connectix)** - This is a basic package aimed at those who wish to improve images captured by Connectix's QuickCam or other low-end digital capture devices. Contast/brightness and colour are controlled by a fixed range of settings. Tools are available for selecting areas, applying paint effects and using built-in filters.

**PhotoStudio 3.0 (Hama ArcSoft)** - Takes a leaf out of the Adobe Photoshop book by offering a tool palette window which allows precise control over retouching. The effects of filters can be previewed in a separate window and customised filters can be created and saved for later use. RGB files can be converted to CMYK for printing.

**Picture Publisher 7.0 (Micrographx)** - A comprehensive and popular image editing and paint package with versatile comping facilities. Other features include the ability to customise editing sub-routines and a good choice of filters for special effects. This application has a long pedigree, has been regularly upgraded, and now offers straightforward editing tools to prepare images for publication on the Web.

Micrographx Picture Publisher - a cheap pro option

**PictureIt 2.0 (Microsoft)** - A package which includes automatic correction of brightness, red-eye and sharpness, and basic comping facilities. There is also a good range of filters for artistic effects and templates for the output of personalised photos, cards and stationery.

**Software between £150 and £1,000**
Comprehensive retouching facilities are the hallmark of mid-range image editing software. These packages can handle a range of colour spaces (RGB, Greyscale, CMYK, HSL, CieLab and Indexed colour) and use their own native file formats to carry out complex image editing tasks based upon layers, objects and masks. They also include a wide range of options to apply special effects, import graphic objects and text and re-position individual layers/objects. Images ouput to the Web, multimedia products, proofing prints, high-end exhibition prints and more. For those who find that low-end software is limiting their creativity, and aren't afraid of a steep learning curve, then mid-range software will pay handsome dividends.

**Adobe Photoshop 5.0 (Adobe)** - This is the benchmark by which other image editing/manipulation software is judged. Launched in 1990 for the Apple Mac/MacOS platform, and several years later for IBM-PC/Windows platform,

Photoshop has been adopted by photographers, graphic designers and creative artists all over the world. The latest version, Photoshop 5.0, was launched in the UK in mid-1998. It is an essential application for those who wish to exercise control over their imaging and output options at the same time as realising their full creative capability. There's a wide range of tools which can be selected from the floating toolbox, enabling rapid selection of areas, cloning, cropping, brush and pen work, text importation and much more. Its main drawback is that it is quite memory hungry, requiring lots of RAM. Version 5.0 has introduced multiple undo command with a linked History palette which is a vast improvment on the single level of undo found

Microsoft PictureIt! - a fun versatile package

in previous versions. Photoshop reads and writes a wide range of image file formats and its own native Photoshop file format, making it easy to import and export files to other computer platforms and a wide variety of non-imaging applications. There is a huge range of tools, and it accepts a vast list of third-party plug-ins. It takes time to get to know Photoshop, but it's excellent for basic manipulation, or extensive retouching and comping where creativity can run riot.

**The world's most popular imaging software, Adobe Photoshop**

**Adobe Photoshop LE (Adobe)** - This is a cut-down version of Adobe Photoshop which is bundled with some scanners. It is more powerful than Adobe PhotoDeluxe 2.0 but not as good as the real thing, Photoshop 5.0.

**Corel PhotoPaint 8.0 (Corel)** - Another graphics orientated package with full retouching, drawing and 3-D design facilities accompanied by hundreds of royalty free photographs, clip art and design templates. The latest version includes new object management and a lens option to preview special effects applied to an image. Symmetrical patterns can be painted with the Orbits brushes.

**Painter 5.0 (Fractal)** - Aimed predominantly at serious artists and graphic designers, this software package arrives packaged in a paint can. A comprehensive range of image retouching tools is complemented by a good choice of special effects, named Natural-Media, which mimic a host of painting techniques, textures and more. Painter has quite a few floating palettes from which to select different tools, patterns, and colours. In combination with a pressure-sensitive pad and stylus this gives a high level of control.

**LivePicture 2.5 (Live Picture)** - Launched in 1993, this application is regarded by many as a complementary tool to Photoshop for those having to process large files, since this software can deal with multiple large image files in real time. This is achieved by working on sections of the file at (low) screen resolution. The software creates an IVUE file format from TIFF or Photoshop files. IVUE offers unlimited zoom on any part of the image. Any manipulation made to the IVUE file is stored in separate layer along with its mathematical data specifying the changes, all the manipulation steps being stored in another file called FITS. Each manipulation or layer can be edited independently, giving an unlimited undo functionality. Since the manipulations are based upon mathematical equations rather than moving individual pixels, the software quickly applies the manipulation. Once all the manipulations are complete the FITS files are recombined with the original IVUE file and a bit-mapped image is recreated.

**Sartori 2.0 (Spaceward Graphics)** - Is this the new challenger for the Photoshop crown? It is a resolution independent software using vector-based files rather than bitmaps. It builds a proxy model of an image file and creates a new layer for each alteration made to the image. These objects create an infinite layering facility. On completion of the editing the proxy model and objects are rendered to convert the image back into a bitmap. Coupled with infinite undo, the modus operandi of Satori's system gives very fast processing times for all editing operations. Those with a high-end monitor you can take advantage of the 64-bit version of the software i.e. 48-bit RGB colour (65,536 levels per colour) combined with 16-bit alpha channels. Naturally this requires a lot of processing power to compute files with this amount of colour information, but the results can be stunning.

**Wright Design (Wright Technologies)** - This software offers full retouching capability combined with linework drawing and page layout functionality. It uses an object-orientated approach so individual editing marks or selected elements can be easily moved around. There's lots of tools and filters including warping. Functionality can be extended using 32-bit Windows (Win32) compatible plug-ins.

**xRes 3.0 (Macromedia)** - A package with a neat combination of image editing and design creativity, with an extensive artists tools palette including popular twentieth century painting styles. Works in a similar vein to LivePicture 2.5 in that editing operations can be carried out on low resolution files of the original file in real time, thereby requiring less memory than Photoshop. The interface permits multiple windows and many Photoshop compatible plug-ins are accepted.

**Software for more than £1,000**
This software is designed to operate on proprietary digital imaging workstations and is used for high-end retouching and comping. Once the preserve of the graphic design and printing industries, high-end software is now used by many digital imaging bureaux and retouching houses. Leading brands include Creator (Barco), Paintbox (Quantel), and Imaginator 6 (Dicomed).

**SOFTWARE FOR SPECIAL TASKS**
Hundreds of filters and plug-ins extend the capability of existing software packages by adding new creative options. These are described in detail in Chapter 13.
   Some software has carved a niche for itself in a particular area of functionality. Examples include:

**PhotoPerfect Master and ColorPro (Binuscan)** - For those interested in producing excellent colour separations with a flatbed scanner this software makes it all look simple. Images can be acquired through a scanner using a batch processing facility, automatically colour correcting, sharpening and converting them to CMYK ready for printing.

**DeBabelizer Toolbox 1.6.5 (Equilibrium)** - A great utility for the Mac which increases productivity enabling batch processing from one image file format to another. It recognises all the popular file formats and many less familiar ones too.

**Graphics Converter 97 (IMSI)** - Another productive utility for IBM-PCs for converting images from one file format to another.

**Stitching panoramas**

PhotoVista 1.01 (Live Picture), Spin Panorama (PictureWorks) and Nodester (Roundabout Logic) are software capable of stitching together a sequence of shots to create panoramas (generally defined as photographs with an angle of view in excess of 100 degrees). Apple's QuickTime VR Authoring Studio takes the process to its ultimate limit enabling production of 360 degree panoramas.

# Image storage and management

Digital image files contain large amounts of data. An image captured by a low-end point-and-shoot digital camera, typically sized between 100Kb to 1Mb, requires ten to one hundred times more storage space than a page of text. A PhotoCD Image Pac has a storage requirement of between 4.5Mb to 6.5 Mb. A 35mm negative or transparency scanned at 2,700dpi, containing the equivalent amount of detail as conventional silver halide film, creates a 30Mb file. Images quickly consume storage space so it is important to plan for future storage needs. Image management software can assist in filing, storing, and retrieving images, though it is not essential if a methodical system is used to name files and attach other text data. Backing-up or copying an image database is advisable.

## STORAGE TIPS

### Tip 1 Archiving original images

Store all your original image files captured by camera, scanner or other device on your hard disk and, where possible, on back-up storage media. Keep the back-up media in a separate location to the computer. Avoid storing back-up media near sources of heat and/or magnetism, since this can corrupt the data.

### Tip 2 Protecting the file

Lock the image file to prevent accidental editing of the data in the file. Usually this can be done by opening the file in an appropriate software applicaiton and selecting File info from the File menu. Open the dialogue box and click the option to lock the file. This way you can always return to the original file to copy it. Never edit the original file unless absolutely necessary because once it has been altered it is not always possible to cancel the changes made to the file.

### Tip 3 Maintaining file quality

Store all original image files without compressing them. If you do need to compress them to save storage space, use a file format that uses lossless compression, such as TIFF, PNG, or a lossless file format native to a specific image manipulation software. This type of compression maintains the maximum image quality of the file. TIFF is one of the most popular file formats for archiving.

### Tip 4 Naming files

Name your image files using a systematic method. A simple method of file naming is to use a three or four digit numeric code plus a short natural language title and the date of capture (or original date the photograph was taken). For example, you may wish to use the code 001 for landscape shots, 002 for close-ups, 003 for sports pictures and so on. A file containing a view of a large country house set in parkland

taken on 06 August 1997 could be named, 001CountryHouse060897. It is not necessary to specify the file format, since this is usually stated automatically as a suffix at the end of the file name or is clearly recognisable from the file's icon.

Apple Macintosh computers running Mac OS 7.5 onwards will support file names up to 31 characters long, while IBM PC-compatibles using Windows 95 will support file names up to 255 characters long. Image cataloguing and management software specify their own syntax for naming files which facilitates retrieval when using a (software) search engine.

**Tip 5 Calculating file size**
If you know the maximum size and resolution of the output image you can calculate the minimum file size at which you can store the original image. File size is calculated using the formula given in Chapter 2.

Alternatively you can refer to Table 2.1 (see Chapter 2) which shows the minimum file sizes required for some common print sizes at different output resolutions. If the images are to be displayed on a monitor at 72dpi, such as images on a Web page, you don't really need to store images much larger than 200Kb. The original capture image file can be re-sized to this smaller file, but only discard the original if you don't want to reproduce it in the future at a larger output size or resolution.

**Tip 6 Store large image files on removable storage media**
Keep your hard disk on your computer free for working on current images by regularly downloading original image files to a removable storage media (see below for different options). Copy the originals to two separate storage media and store these in two different locations, keeping one for daily use and the other for long-term arhiving.

**Tip 7 Use a text-based archive application**
If you already have a database application this can be used for image cataloguing. Set up a data file to contain information about the image, such as file name, location of the file in a directory/sub-directory or folder, whether stored on hard disk or a removable storage media, the subject of the image and other attributes such as type of image (colour, black & white, portrait or landscape orientation). Access (Microsoft) and Filemaker Pro (Claris) are powerful database applications which enable lots of different ways of cross-referencing and searching the data files. Searches will retrieve a list of files showing their locations. The main disadvantage of this method is that the images themselves have to be opened individually to check whether they are the ones you actually wanted.

**COMPUTER STORAGE MEDIA**
**PC hard disks**: PCs manufactured for the consumer market from the mid-1990s onwards are equipped with hard disk of 1.0 gigabyte (Gb) to 6.4Gb, but earlier PCs have less capacity, typically ranging between 200Mb to 500Mb. Hard disks store the operating system software and software applications as well as file data. Consequently, the speed of operation of a computer is partially governed by the time taken to locate and transfer data between the hard disk and the central processing unit (CPU) and/or the active software. Access times vary between 10 to 20 milliseconds. Some disk drives use special interface circuits in the CPU to improve

data transfer, for example, Integrated Drive Electronics or IDE disk drives.

**Peripheral hard disks**: These provide an external hard disk, enclosed in its own plastic/metal casing and attached to the computer by a cable. They are not intended to be used as a removable device, but can be detached and connected to another computer. Typically storage capacities are 500Mb to 4Gb with access times of 10 to 20 milliseconds. Leading brand names include LaCie (formerly Electronique d2), Quantum and Seagate. An icon representing the peripheral hard disk can be set up on your computer's desktop. This disk can be made the default start up disk. Peripheral hard disks can be used to back up data from the internal hard disk.

A 100Mb removable Zip disk by Iomega

**Removable hard disks**: These are external hard disks encased in their own special cartridge. The cartridge can be removed from the drive which usually remains permanently connected to the computer. There are many proprietary standards for removable hard disks, the leading brand names being Iomega and Syquest. Capacities, data transfer rates and access times vary. Iomega's Zip cartridges are 100Mb, transfer data at 1Mb per second (Mbs) and have an access time of 29 milliseconds. The 1Gb or 2Gb Jaz cartridge by Iomega, and 230Mb EZFlyer and 1.5Gb SyJet by Syquest, can transfer data between 4Mbs to 10Mbs.

**Floppy disks**: Launched in 1986, the 3.5 inch floppy disk, encased within a plastic sleeve, has become the most popular removable storage medium in the world. Its capacity varies from 720Kb to 1.44Mb, so it is capable of storing tens of small images suitable for screen display or one or two image files suitable for low-end printing. It is a useful emergency back up medium for low resolution images.

A new floppy disk drive was introduced by Compaq in early 1997, which reads/writes to a 3.5 inch floppy disks of 120Mb capacity. Penetration of this floppy disk system in the marketplace is currently limited, but it may yet emerge as a new, widely used, standard. The Compaq drive also reads the 3.5 inch 0.72Mb to 1.44 Mb capacity floppy disks.

A 1Gb removable Jaz disk by Iomega

**Compact discs (CDs)**: This is a versatile storage medium offering a capacity between 540Mb and 650Mb of storage. There are many different types of CD, the most important for digital photography being the Compact Disc Recordable (CD-R), the Compact Disc Recordable Writtable (CD-RW) and the PhotoCD, Kodak's proprietary CD format. Data can be written to CD-Rs in single or multiple sessions, but can not be erased or overwritten. CD-RW is a new format, introduced in 1997, which enables data to be written in single or multiple sessions, to be erased and to be overwritten. PhotoCD is a read-only format CD i.e. the data is locked and protected and new data can only be written by professional imaging bureaux appointed by Kodak.

CDs are read and/or written by different types of CD drives. All the above CD formats can be read by a CD-ROM drive fitted internally in a PC or connected

externally as a peripheral device. Typical access times for data location are between 300-500 milliseconds. Standard rates of data transfer vary between x12 speed (1.8Mb/s) to x24 speed (3.6Mb/s), though older drives tend to read at lower speeds, between x2 to x8. Special drives are required to write CD-R and CD-RW formats at speeds varying between x2 to x4. Most CD-ROM drives will read both PhotoCD and CD-R formats, but only the newer MultiRead specification CD-ROM drives will read CD-RW.

CDs offer a flexible, high capacity storage sytem. The commonly used CD formats described above provide a platform independent, and universally useful, removable storage medium. They have become a popular method of storing and distributing data. Witness the proliferation of free cover mounted CDs on consumer magazines. The versatility of the CD has also attracted many photo libraries who use CD-Rs to archive their digital image database and to send images to customers and use CD-ROMs to distribute digital catalogues.

**Magneto optical discs**: Data is stored on a metal alloy disc whose crystals can be realigned by a magnetic field. The data is read/written by a laser beam. The disk is held within a plastic cartridge which is inserted in the disk drive. Magneto optical discs are large capacity, 230Mb to 640Mb storage media suitable for long term archiving rather than short-term data exchange, because data transfer rates are generally slower than aforementioned sytems.

**Digital Audio Tape (DAT)**: Large capacity storage media, varying from 1.2Gb to 24Gb, which utilises inexpensive 4mm or 8mm tape held in plastic cassettes. Access times are measured in seconds rather than milliseconds and data transfer rates are slow, so DATs tend to be used for long-term archiving.

## DIGITAL CAMERA STORAGE MEDIA
Digital cameras use a variety of storage media. Internal storage is provided by EPROM microprocessors or hard disks. Removable, peripheral storage media include

Compact Flash, PCMCIA and SmartMedia cards. Compact Flash vary between 4Mb to 24Mb capacity and Smart Media cards between 2Mb to 8Mb. PCMCIA is a large family of cards offering 4Mb capacity up to 20Mb for Type I and II, and between 85Mb to 340Mb for Type III. Additional storage can be provided by buying an inexpensive, older model, laptop computer with an internal hard drive of between 100Mb to 750Mb to which you can regularly download images directly from the digital camera or from the removable storage media.

## IMAGE CATALOGUING SOFTWARE
Software applications that catalogue images to facilitate storage and retrieval vary considerably in their capabilties. However, most applications contain three interconnected, functions. The first enables data to be assigned to an individual image file, such as name, descriptive category/sub-category, type of image (colour, black & white) and a caption. The second enables images to be retrieved from their storage location by searching through categories or sub-categories and/or by using a search engine using keywords or natural language. The third function enables images to be viewed initially as thumbnails, which can be opened to a full screen image when selected.

Low-end image cataloguing software is available as stand-alone applications or as part of an image manipulation software package. In the latter the cataloguing capability is often referred to as an image browser. Mid-range to high-end image management software offers functionality well beyond basic cataloguing. Typically this includes a full database capability, a greater number of image and data display options, the ability to save images to a lightbox and a keyword or natural language driven search engine.

Image browsers are included with most low-end image manipulation software. Some image cataloguing applications are bundled with scanners and colour printers, such as Corel Multimedia Manager. The more capable image cataloguing and management applications are generally sold as shrink-wrapped commercial products.

**Image browsers within image manipulation software**
**PaintShop Pro 4.12 (Digital Workshop)**: This popular image editing application includes a useful browser which displays thumbnails like a conventional plastic wallet slide holder.

**PhotoImpact (Ulead)**: Allows comprehensive data records to be attached to each image enabling a full database type search. Images can be located by entering queries using caption and description  keywords or data field, such as date taken, date modified and so on.

**Multimedia Manager (Corel)**: This management software is included within Corel's PhotoPaint graphic design/image editing software, but is also bundled with some scanners. It allows basic cataloguing of images into directories whose contents can be viewed as thumbnails and has an option to create a slide show. A split window shows the directory hierarchy on the hard disk. This is a no-frills entry level image browser suitable for those with a small database of images.

**Low-end to mid-range image cataloguing software**
**Image AXS Classic (Digital Arts & Sciences)**: A capable database driven software using drag and drop for creating a lightbox or contact sheets. Every word in an image caption is a searchable keyword. A sensible option for those who wish to upgrade later to the Pro version.

**K5 Photo (Keybase)**: K5 Photo is a serious contender for those who wish to build an expansion capability into their original database. The full blown professional database supports up to 300,000 images. Special management wizards allow reconfiguration of the database, so although images are categorised into collections these can be redefined at a later date. This flexibility is invaluable, since it is always difficult deciding on the best categories when a database is small. Other useful features include the ability to find images on a hard disk and bring them into the database. Over 40 image file formats are recognised.

**Photo Album (Image Resource)**: An entry level database image management software capable of handling up to 20,000 images which can be scaled up to the Photo Album Pro (100,000 images) and Digital Catalogue (13 million images). Data

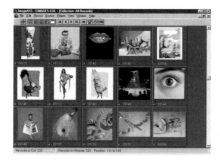

Image AXS Classic - thumbnail view

Image AXS Classic - screen view

K5Photo - general record view

K5 - data entry view

Image Resource Photo Album –
thumbnail view

Image Resource Photo Album - record
view

NBA Photowallet - general view     NBA Viewfinder - category details view

Query by Image Content (QBIC) - a visual search engine at the Fine Arts Museums of San Francisco Web site

records attached to each image have a wide range of fields many of which can be further sub-divided to provide a hierachical structure. This makes for a flexible system when scaling up the size of the database. Searching is by keywords and data fields and retrieved images can be displayed in four different configurations.

**PhotoRecall (G & A Imaging):** A database designed image management application with capable searching abilities which displays images in a photo album or catalogue. New subject categories are set up as the database is expanded. Images are located using a keyword driven search engine.

**PhotoWallet (NBA):** A button bar controls the functionality of this image cataloging software which has been specially tailored to facilitate importing images from a wide range of digital cameras and scanners. Images appear as thumbnails in a simulated photo wallet display. New photo wallets are created for different categories of image. Each image can be annotated with extensive text or audio captions.

**PolyView (Polybytes):** A basic image browser combined with automated routines for image retouching and enhancement. Uses a split window for thumbnail and directory display.

### PROFESSIONAL IMAGE MANAGEMENT SOFTWARE
**Cumulus Desktop Plus 3.0 (Canto Software):** Another scaleable system which allows construction of a small database of images and other multimedia files using Cumulus Desktop. Data records include numerous fields and hierachical categories. There is a comprehensive search facility. Desktop can be expanded to a professional browsable on-line library with Cumulus Desktop Plus. A royalty free browser can be distributed to third parties with images downloaded to a transfer media and images can be exported to Web pages.

**Image AXS Pro (Digital Arts & Sciences):** A comprehensive package which can manage a large database system and includes templates to display images on Web pages. Every word in the image caption and text description is searchable, so images can be retrieved for specific subjects or broader conceptual themes. The system can be scaled up to be a multi-user networked online image database.

**Photo Album Pro and Digital Catalogue (Image Resource):** Photo Album Pro is similar to Photo Album above but can manage up to 100,000 images and has a wide range of optional software extensions to enable publication of sub-databases on CD-ROM, importation of PhotoCD, and a network capability. Digital Catalogue is the full-blown commercial image database software with enables a multi-user networked and/or online capability for managing up to 13 million images.

**PhotoWallet Pro and Viewfinder (NBA):** PhotoWallet Pro is the professional version of PhotoWallet above and is capable of handling 10,000 images. NBA's Viewfinder enables full image database construction and management.

## IMAGE DATABASE SEARCH ENGINES

There are many different types of search engine used to locate images from a database. Most of them examine the words in the caption or text description attatched to an image. Search queries are based upon defined keywords or natural language. The ability to retrieve a good match of images to the original query depends upon the quality of the captioning the definition of keywords and the power of the search engine. Natural language driven search engines offer a more conceptual approach and tend to rank the retrieved images defining, in percentage terms, how close the images match the query.

Many international photo libraries have excellent examples of keyword and/or natural language based search engines on their Web sites. Sites well worth a visit include Corbis (www.corbis.com), PhotoDisc (www.Photodisc.com), PNI Publishers Depot (www.publishersdepot.com) and Tony Stone Worldwide (www.tonystone.com).

Another approach to image search engines is to match the visual elements. One of the leading exponents of this technology is IBM which has developed its Query By Image Content (QBIC) search engine (wwwqbic.almaden.ibm.com). Images are defined by colour percentages, colour layout, textures and other visual characteristics, as well as keyword indices. Several digitised fine-art collections from international museums use QBIC. With time this technology may spill over into consumer software products.

## CREATING DIGITAL CATALOGUES

Those wanting to create colourful image catalogues will find MiniCat 2.1 (Different Angle) is very user-friendly. Up to 100 images and associated captions and text can be written to a 1.44Mb floppy disk or up to 30,000 small screen resolution images to CD-ROM, CD-R or CD-RW. And catalogues can be converted into Web pages. This is an excellent piece of software to explore the potential of earning cash from digital images.

There are other options for creating catalogues. Some of the professional image management software, such as Canto Cumulus, Digital Catalogue and ImageAXS, support facilities to publish images, combined with a search engine, on CD-ROM.

# Image output: printers

Photographers assess quality of a print or film by looking at the tonal range, contrast, sharpness and accuracy of colour reproduction. Some photographers deliberately under- or over-expose to achieve a desired creative effect. So photographic quality of conventional prints, negatives or transparencies is often measured by rather subjective criteria.

Printers assess photographs in a different way, since they have to convert the photograph to a digital image, and then to a halftone screen, before using inks to apply the image to the printed page. Excessive contrast and large blocks of colour in the original photograph can present conversion problems for printers.

The quality of a photograph also depends upon the ratio of the final print to the size of the original negative or transparency. Quality starts to degrade when enlarging prints beyond 20 x 16 inches from a 35mm format film. Print quality also varies according to the quality of the original negative/transparency, the type of enlarger, the chemical development process, and the type of paper used for printing. In many ways the quality of prints from digital images is affected by a similar range of parameters.

## PRINTS FROM DIGITAL IMAGES
The quality of prints made from digital images is affected by the size of the image file, the file format and whether it is compressed data, the software associated with the printer, the type of printer, the output resolution of the printer and the type of paper on which the image is printed.

### Print quality and printer output resolution
To obtain photo-realistic prints that are of a similar quality to silver halide prints, a minimum printer output resolution of 300dpi is generally required. Printers using transparent inks or dyes which merge together (dye-sublimation, thermo-autochrome) may give photo-realistic quality at lower resolutions, between 150dpi to 300dpi. Lower resolution printers may be acceptable for draft purposes and reproducing physically small prints, but will not generally provide sufficient detail to render a photo-realistic effect.

### Print quality and file size
Every image capture device creates a maximum image file size which can be compared with the image file size required to produce a print at a specified output resolution. Table 2.1 shows the maximum files sizes of images captured by a range of digital cameras and scanners, and by PhotoCD (Kodak's Photo Imaging Workstation) and indicates whether these files sufficiently large to enable output at 300dpi, 200 dpi or 100dpi. Images captured by low-end and mid-range digital

cameras have rather more limited output options than those captured by high-end digital cameras and flatbed and film scanners.

Most low-end digital cameras with a capture resolution of 640 x 480 pixels or less can not produce a good 6 x 4 inch photo-realistic print at 300dpi without significant assistance from software interpolation, since the original capture file size (0.92 Mb) doesn't contain sufficient information (Table 2.1). The maximum print size without interpolation at 300dpi is approximately 3 x 2 inches. For many low-end models the capture file sizes are considerably smaller, having been subject to high compression to maximise in-camera storage (see Appendix V).

Some manufacturers have circumnavigated the inherently low image capture file size of low-end digital cameras by using software to add extra pixel information to the file. Software interpolation bulks up the original file size permitting output as 6 x 4 prints at resolutions between 150dpi to 300dpi. Simulated continuous tone printers, such as dye-sublimation and thermo-autochrome (see below) can use files much smaller than 0.92 Mb to produce photo-realistic 6 x 4 prints at 300dpi, because of the printing technology encourages individual dots of dye or ink to merge together, rather than remain as discrete dots.

As the capture resolution of a camera increases so does the capture file size and more printing options emerge. Mid-range digital cameras, capturing colour images with a 1280 x 1024 pixel CCD, can successfully generate photo-realistic 6 x 4 inch prints at output resolutions of 200dpi. High-end digital cameras can capture large image files enabling 10 x 8 inch or A4 size prints to be output at 200dpi to 300dpi.

Scanners offer a more flexible approach since the capture resolution and hence maximum output size can easily be changed. Doubling the scanning resolution for a particular size film or print quadruples the file size. To output prints at twice the physical size of an original print the horizontal and vertical scanning resolutions must be doubled. For example, if you want to reproduce a 300dpi 12 x 8 inch digital print, from a 6 x 4 inch print you will have to scan at a resolution of 600dpi.

### Print quality and file format

Many professional photographers, retouchers, graphic designers and imaging bureaux prefer to handle an original digital image as a TIFF. This is a favoured archiving format because it can be compressed without loss of information (it uses a lossless LZW compression routine). TIFF is used in Mac and IBM-PC environments.

It is better to avoid using JPEGs which have been compressed using a high compression ratios, in excess of 1:5 or 1:10, if high quality output is required. Such files can show reduced sharpness, a reduction in colour gamut and/or certain artifacts resulting from the compression process.

### Print quality and colour space

Most image file formats are configured for RGB colour space so they can be viewed on a monitor. When these files are output to printers they are converted into CMY or CMYK colour space. The main exception is the PCD file of PhotoCD which is converted from YCC colour space to CMYK. RGB files written to film by a digital film recorder output the files in photographic CMY colour space. The ability of each printer or film recorder to faithfully reproduce the range of colours, saturation and contrast in your original RGB file depends upon its reproduction gamut (colour

profile), the output resolution, colour media and output substrate. Colour management software helps improve colour fidelity between monitor and printer.

**Print quality and colour gamut**
The range of colours a printer can reproduce is controlled by the mechanics of the printing process. Most printers offer 24-bit colour (16.7 million colours), but the methods used to produce this colour gamut vary considerably. Continuous tone printers (see below) tend to produce the full gamut by allowing the inks or dyes to diffuse with each other, creating new colour tones. In contrast, there is little or no mixing of individual dots of inks or dyes in simulated halftone printers (see below), so new colour tones are created by processes called dithering or error diffusion.

There are lots of dithering techniques, which all follow the same general principle. The printer software groups individual pixels in the digital image into small square blocks of pixels, analyses the data, finds the average colour tone value and then rearranges the pixels in fixed or random patterns within each block. Some pixels will have been assigned a brightess level of 255 (white), 0 (black) or one of 254 levels of grey. A dot of ink or dye will not be applied where a white pixel exists. The proportion of white to non-white pixels in each block is a crude approximation of dot size in true halftone printing.

High resolution inkjet printers (eg 720dpi x 1440dpi) use error diffusion to extend the colour gamut. Error diffusion requires accurate placement of discrete dots of quick-drying ink, so dispersion of the ink is minimised.

**Print quality and type of printer**
Printers use widely varying technologies to transfer inks, dyes, coloured waxes or toners on to paper or film substrates. There are two basic groups: printers that produce simulated continuous tone colour prints (similar to conventional photographs), and those that produce simulated halftone prints (similar to photographs in newspapers and magazines).

Fargo's FotoFun budget dye-sub printer

**SIMULATED CONTINUOUS TONE PRINTERS**
The human eye can not usually detect the discrete physical elements (the black grains of silver halide with microscopic blobs of coloured dye) which make a up photograph. A conventional photograph reproduces continuous tone, each tone appearing to merge from one into another. Similarly it is impossible for the viewer to distinguish the discrete physical elements in continuous tone prints made from digital images. Continuous tone printers most closely mimic the conventional photograph using semi-transparent dyes which merge with each other on the output substrate, which is usually paper. There are two main types of continuous tone printer, the dye-sublimation and the thermo-autochrome. Colour laser printers, also known as colour laser copiers, create prints which fall somewhere between the quality of continuous tone and simulated halftone.

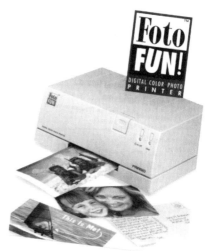

**Dye-sublimation printers (CMY or CMYK colourspace)**
Cyan, magenta and yellow dyes are held on a plastic ribbon which is exposed to a print head of thousands of elements. The temperature of each element is precisely controlled causing the dye on the ribbon to vaporise and transfer to paper or film covered in special coatings which encourages the vaporised dye to diffuse and mix. Colour saturation is controlled by the amount of vaporisation and diffusion which is regulated by the heat applied to each element and the interaction of the ink with the substrate. The output resolution is a measure of the density of the heating elements. Each colour is applied in one pass of the paper, so good registration is critical to maintaining sharpness in the print.

Fujifilm's NC-300D dye-sub printer for A5 and A6 size prints

Dye-sublimation printers vary from consumer desktop printers, capable of output at 300dpi, for example, the Fargo Fotofun, to high-end proofing printers used in the printing industry, which can output at up to 1400dpi. The process is also known as thermal dye-sublimation or diffusion transfer. Though strictly speaking the latter refers to the diffusion of heated dyes directly from the ribbon to the paper in the absence of an air gap. Typical resolution range: 300dpi to 600dpi Paper: Special. Paper size limit: A3. Output type: Photographic, Graphic Design, Printing Proofs

**Thermo-autochrome printers (CMY colour space)**
Data in the digital image is converted into a red, blue and green laser beam or laser diode which is used to expose a special donor paper impregnated with cyan, magenta and yellow silver halide-based photosensitive materials. Dot size is a function of the width of the laser beam. Diffusion of colours occurs in the second part of the process. After the image is formed on the donor paper it is then aligned with the special printing paper. Distilled water and heat are the catalysts which enable the transfer of the image from the donor paper to the print paper. Unused silver halide is recovered from the donor paper by the manufacturer. Since the image on the special print paper is formed of silver halide

Fujifilm's Picto-graphy 3000 for A4 thermo-auto-chrome prints

materials and dyes, the output is extremely photo-realistic and has a known archival longeivity. Fuji is the lead manufacturer with this technology and offers a range for printers for the consumer (the NC-3D) to the professional (the NC-500, Pictography 4000). Typical resolution range: 300dpi to 720dpi Paper: Special. Paper size limit: A3. Output type: Photographic, Graphic Design, Printing Proofs

**Laser printers (CMYK colour space)**
The technology used in laser printers is similar to that used by many photocopiers. An electrostatic charge is applied to a rotating drum coated with a photo-sensitive material. Exposure of this material by a laser beam removes the charge, creating a negative image of the original digital image file. Coloured toner (a dry powder fixed with dyes or inks) is attracted to wherever an electrostatic charge remains on the

drum. Paper has an opposite electrostatic charge and therefore attracts the toner to it when pressed against the drum by a system of rollers. Finally the toner is bonded to the paper by heat and/or pressure, causing the toner to melt into the paper and encouraging some diffusion of different coloured toners. Each colour (CMYK) is applied separately to produce the final print, so registration of the different colours is critical to maintain image sharpness. A wide range of papers can be used because the toner is applied to the surface with limited absorption into the paper. Canon are leaders in colour laser technology and many output bureaux use Canon's CLC range. Typical resolution range: 300-600dpi Paper: Ordinary. Paper size limit: A3. Output type: Graphic design, Desk top publishing.

## SIMULATED HALFTONE PRINTERS

In true halftone printing, used by the publishng industry to reproduce photographs on the printed page, continuous tone photographic film is converted into dots of coloured ink onto paper. The ink dot size is varied according to the colour saturation of the original film. Large dots give high saturation, small dots give low saturation and absence of dots gives zero saturation (effectively the background colour of the paper). The acutal dot size is controlled according to the amount of light that passes through the film and then via a fine wire mesh (screen). Light is projected through each grid in the mesh forming a vignetted circle (dot) of light onto a negative lith film which is then converted into a (positive) printing plate. Desktop digital printers mimic or simulate the halftone printing process. The printing heads of desktop printers produce dots of ink, dye or wax of a fixed size, so they simulate the effect of colour saturation and increase the tonal range they can reproduce by using other means.

### Inkjet printers (CMYK colour space)

Inkjets are one of the least expensive types of printer for printing digital files. There are two main types; those where the ink is heated to the point of vaporisation (also known as bubble jets); and those that physically place the ink using vibrating piezoelectric crystals. In the former the ink is heated, vaporises and is forced through a microscopic nozzle onto the paper.

Drop on demand systems produce drops of ink at the nozzle when required whereas continuous flow systems use a steady stream of ink which is constantly deflected between the paper and a waste ink reservoir.

In the piezoelectric system a voltage is applied to crystals sandwiched between two electrodes, causing the crystals to vibrate. The strength and timing of the voltage controls the vibrations within nozzles connected to the ink cartridges. Ink is ejected from the nozzle as the crystal moves.

The interaction between the behaviour of the inks and the type of paper controls

Epson's Photo Stylus set new standards of photo-realism for inkjet printers

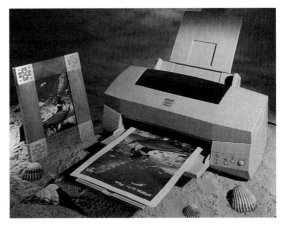

the colour saturation and sharpness of the print. The inks are specially formulated to provide different results according to the absorbency of the paper. Inks can be encouraged to diffuse beyond the initial point of application improving the merging of different colours but reducing sharpness. Inks with limited diffusion capabilities, or papers with limited absorbency, can reproduce greater detail and retain sharpness. The three additive colours (CMY) are usually held in one cartridge and black (K) is held in a separate cartridge. Greyscale images can be printed using the full colour space CMYK or just using black ink. Colours are generally applied in three or four passes so accurate registration is necessary to maintain sharpness.

Inkjet techology is undergoing rapid evolution and printing quality continually improving, especially the output gamut. One of the latest innovations is variable dot size, such as seen in some of the higher-end inkjets such as the Iris Realist FX 5020, which gets closer to mimicking true halftone printing. Error diffusion is also replacing dithering as the preferred method of improving colour gamut in high resolution inkjet printers. Many modern inkjets can output at high resolutions, up to 1,440dpi and some even incorporate extra ink feeds for light and dark shades of C, M and/or K.

Leading manufacturers include Epson, Canon, Hewlett Packard and Lexmark (see Appendix VII). Typical resolution range: 300dpi to 1200dpi. Paper: Special and ordinary copy paper. Paper size limit: A2. Output type: Photographic, Graphic Design, Printing Proofs, Large Format Printing

### Micro-dry or solid ink printers (CMYK colour space)
These printers function in a similar way to inkjets, but use solid sticks of ink which are liquified on heating before the ink is ejected through microscopic nozzles. The ink re-solidifies on contact with the paper surface, with little ink being absorbed, so a wide range of papers can be used. After the ink has been applied the paper is pressed between rollers to ensure permanent adherence. Four colours (CMYK) are held in separate solid ink cartridges. Alps are one of the leading manufacturers using micro-dry technology. Typical resolution range: 600dpi to 1200dpi. Paper: Wide range. Paper size limit: A4. Output type: Graphic design, Desk top publishing.

### Thermal wax (CMYK colour space)
These printers use a continuous ribbon impregnated with panels of cyan, magenta, yellow and black coloured waxes. Coloured dots of wax are transferred to the printing paper or transparent media when microscopic elements are heated to melt the wax. The dyes in the wax do not diffuse.

Typical resolution range 300dpi to 600dpi : Paper: Wide range. Paper size limit: A4+. Output type: Graphic Design, Printing Proofs

### PRINTING SPEED
Low-end inkjet printers typically take between 5 to 10 minutes to output an A4 print at 300dpi. It's not a hard and fast rule, but inkjets that take longer generally produce better quality prints. Dye-sublimation printers outputting 6 x 4 prints take two to three minutes from initialisation to completion. It takes a few minutes to produce A5 and A4 prints on a thermo-autochrome printer.

## PRINT PAPERS AND COST

Printers using colour media which diffuse into the paper (inks, dyes) are often designed to produce the best quality and largest gamut using the manufacturer's own special papers. In contrast it is possible to use a much wider range of special and non-proprietary papers with printers using colour media which dries on application (wax, toners). Thermo-autochrome printers use special photo-sensitive papers which ensure very accurate colour and consistent results.

Costs per print (the colour media and the paper) vary between £1 or less to over £3 depending upon the printer. Inkjets tend to produce cheaper prints than other types of printer.

The choice of papers for inkjets is considerable. Printer manufacturers (eg Canon, Epson, Hewlett Parckard, Lexmark, Kodak) and independent manufacturers (eg Kentmere, Tetanal) cater to this burgeoning market. Special papers are usually coated to control the size and shape of the ink dots, and hence the amount of diffusion. Ideally an ink-paper combination produces good reflection from the applied colour which translates into good colour saturation. Different grades of paper (graded by weight, 100g/m2 to 266g/m2 and type of surface coating - matt, semi-gloss or glossy) are also available to control colour reproduction and finish.

It's best to experiment with a few brands of paper to check the results. Some manufacturers offer a swatch of different papers for this purpose. Make a series of prints or set up a test strip to relate colour reproduction with colour corrections applied during image manipulation. Print individual test image files or better still use a neat Photoshop plug-in called Test Strip (Vivid Details) which produces a photo-lab like test strip on one sheet of paper.

### Prints and longeivity

Prints using silver-halide based media, such as thermo-autochrome, or laser photographic prints (see below), will produce better archival quality than other media. Current research shows that inks, dyes and other colour media in other types of prints will degrade over time if exposed to strong sunlight over several years. Degradation by ultra violet is significantly reduced if prints are laminated or coated with a UV protection layer. If longeivity is important, it may be best to get images printed by a professional imaging bureau who can advise on the protecting prints with UV resistant laminates.

Print on plain copy paper (top) and Epson Photo Paper (bottom)

## CURRENT MODELS

Low-end desktop printers capable of outputting A4 to A6 prints in the sub £400 to £500 category and which have been well received include: the Alps MD 1000, MD2300 (micro-dry); Canon BJC-620, BJC-7200 (bubblejet); Epson Photo Stylus and Stylus 600 (inkjet); Fargo Fotofun (A6 dye-sublimation); Fuji NC-3D (A6 thermo-autochrome); Hewlett Packard DeskJet 690C, 720C, 820cxi (inkjet); Lexmark 7000, 7200 (inkjet). See Appendix VII for a full listing of the current model range and types of printer.

## OTHER PRINTING OPTIONS

### Printing at a digital imaging bureau

Digital imaging bureaux (Appendix III) use mid-range and high-end printers and are capable of producing photo-realistic quality from 6 x 4 inch prints to A0 posters, with a variety of papers and finishes. Prints up to A4 or A3 size are often output using Kodak's popular XLS8600 or updated KDS8650 A4+ dye-sublimation printers or Fuji's Pictography 3000 which produces A4 prints or the Pictography 4000 for A3 prints, using thermo-autochrome technology. Popular large format printers include electrostatic (eg Xerox 8954 series), inkjets (eg Novajet Pro50) and photographic lasers (eg Durst Lambda 130). The Durst Lambda produces stunning quality prints.

Contact a local bureau to discuss the options. They will specify their preferred file format, file size and transfer media, and can show examples of different types of output to paper and film. Of course all this comes at a cost, but if quality and longeivity are important, it is well worth using an imaging bureaux.

### Printing at a commercial printers

From the mid-1980s onwards the printing industry has been driven by digital technology. It is possible to output digital image files using hundreds of different printing techniques onto paper, plastics, textiles and transparent transfer media. Printers generally work in the CMYK colour space but are also able to apply spot colour to CMYK or black & white output, to use special fluorescent colours, to apply Hexachrome printing using six colours (modified CMYK, a special orange and green) and a wide range of duotones, tritones and quadtones using two, three and four coloured inks.

Medium quality printing of posters, brochures and so on is usually output at between 85 lip to 100 lpi, but high quality fine artwork may use line screens of 200 lpi or more. Those scanning original prints should scan at twice the dpi to the quoted line screen frequency (lpi) and film should be scanned at 2,400 dpi to output at A4 size and higher resolutions if larger output is intended.

Higher-end image editing software, such as Adobe Photoshop 5.0, allows users to make their own separations for CMYK or Hexachrome (using a plug-in). Liase with a local printer at an early stage to save time and money. They will advise which file formats they prefer and so on.

It's just not economical to use printers for one-off posters of a favourite digital image, but is inexpensive compared to outputting via an imaging bureaux if reasonable volumes of printing are commissioned.

CHAPTER 10

# Image output: other devices

While outputting images to prints is probably one of the most immediately gratifying methods of viewing digital images there are many other options to consider which do not preclude printing at a later date.

## P..NTING FROM PHOTOCD

Professional digital imaging bureaux can produce photo-realistic prints at 300dpi directly from PhotoCD. The BASE x 4 (4.5Mb), BASE x 16 (18.0Mb) and BASE x 64 (72Mb) image files in the Image Pac is selected according to the output size desired (see Table 2.1). It is possible to output prints from 6 x 4 inch up to A3 size. The selected file is converted from YCC colour space to CMYK colour space ready for printing. Print quality varies according to the output device, but dye-sublimation or thermo-autochrome prints are of excellent quality.

Desktop printing from PhotoCD files requires software to convert from YCC to CMYK. This can be achieved in Adobe Photoshop using a plug-in called CMS PhotoCD which includes a number of standard printer output profiles ensuring the best possible colour matching of the image between the monitor and the

The Pegasus LED20 Digital Printer is ideal for printing images from PhotoCD

printer. Most low-end or mid-range desktop printers can be used to produce a print using this plug-in.

## WRITING TO CD-ROM

Images can be written to CD-ROM to create an archive or to distribute them to imaging bureaux or other remote users. There is a choice between the proprietary services, such as Kodak's PhotoCD, or writing images to CD-R (CD-Recordable) or CD-RW (CD-Rewritable) using a CD-writer.

Kodak's Portfolio PhotoCD is a special form of PhotoCD which enables images to be presented in a multimedia format, including sound and text. A remote user can only access the Portfolio PhotoCD if provided with a password.

A CD writing service is provided by Image Resource which also produces a

scaleable image cataloguing and database management software. The entry level system is Photo Album which can be upgraded to a professional solution with Photo Album Pro or Digital Catalogue.

Those wishing to write their own images have a wide range of CD-R writers and CD-RW writers to choose from. Popular CD-R and CD-RW models are available from Dynatek, La Cie, Philips, Plasmon, Ricoh, Verbatim and Yamaha. Three CD-RW models, Ricoh's MP6200S and Philips' CDD 3600/3610 conform to the MultiRead specification which means they can read audio-CD, CD-ROM, CD-R and CD-RW - which currently offers the most flexible solution.

Images should be written to CD-R or CD-RW using the ISO 9660 format since this is a cross-platform format for Macs and PCs. Software for writing the CDs is usually bundled with the CD-writer. Popular applications include Toast Pro (Astarte), Easy CD Creator and Direct CD (Adaptec).

Handle the CD-R and CD-RW media carefully, store CD-R away from strong lighting and use a software such as Press IT CD Label Kit (Performance Direct) to create your own customised labels.

### Creating a catalogue on disk or CD

MiniCat 2.1 (Prostar Interactive Mediaworks) software, available for the PC platform, offers an exciting promotional tool for any photographer. MiniCat is for creating full colour catalogues with subject categories and a keyword search engine on a variety of digital media. These include 1.44Mb floppy disks, CD-R/CD-RW discs and/or a Web page on the Internet. The viewing software is installed with each media, enabling clients to display and search for images. MiniCat can incorporate images, text, audio and video data so a catalogue can be a truly multi-media experience.

Minicat 2.0 is an ideal way to create catalogues of images on floppy disk or CD-ROM

### WRITING TO STORAGE MEDIA

The ability to transfer images from a computer's hard disk to other storage media confers great flexibility for archiving, printing and/or writing to film (see Chapter 8). Cartridge based transfer storage media, such as Iomega's Jaz and Zip cartridge, Syquest's SyJet and EZFlyer, offer storage capacities of between 100Mb to 1.5Gb. Each storage media is read and/or written by a disk drive which is located in the computer's main casing or as a peripheral. Software drivers enable read and/or write instructions to be carried out using a computer's operating system software.

Once images are written to transfer storage media they can be taken to a professional digital imaging bureau (Appendix III) for output to print or film using high-end devices for photo-realistic quality.

## WRITING TO FILM

Film writing or recording is the process of writing digital images to silver halide based film products. Using very high output resolutions the digital imges written by film recorders are often indistinguishable from those taken using conventional silver halide film. Unfortunately film recorders are currently well beyond the budget for amateur digital photographers. Film recorders vary from £5,000 to over £75,000, so their operation is generally the preserve of professional imaging bureaux.

There are two basic systems of film recording, one uses digital technology and the other analogue technology. Mid-range to high-end film output tends to be exclusively written using the digital system of reproduction. Digital film recorders convert the information in each pixel of the digital image into three laser beams of red, green and blue. The beam is projected on to medium or large format sheets of photographic film. Varying the width of the beam controls the dot size and hence the resolution of the film written image. Film recorders can write to 35mm format, 120mm format, 4 x 5 inch, 8 x 10 inch and 11 x 14 inch film at resolutions between 6,000 dpi to 8,000 dpi and higher. Interpolation by high-end software and hardware can quadruple the output size from a given image file size without visible loss of quality (to the human eye).

In the analogue system the digital image is projected onto a high quality cathode ray tube (CRT) monitor. Each colour component, red, green and blue is then photographed in sequence by a camera using conventional film. Output resolution is governed by the output resolution of the monitor and the type of film used. This system is suitable for images containing strong graphical content and bold text. It is often used to prepare 35mm film format presentation material suitable for projection.

Those considering writing images to film should liase with the digital imaging bureaux regarding the best file format, resolution and colour balance for the image file. Most bureaux will take RGB TIFF files, A word of caution - unless the original scanner or capture device is calibrated to the bureau's own colour loop it is virtually impossible to match the full colour gamut and tonal range of the original fle to the output film. However, experience with repeat results and trial and error will assist in obtaining quite good colour fidelity.

## THE PRINTED PAGE

It's possible to take advantage of the wide range of inks and substrates used in the printing industry for those who have a mid-range to high-end image manipulation software, and/or can import images into a professional page layout software such as Pagemaker (Adobe) or Xpress (Quark). Its best to liase with your local printer to discuss what kind of files and output they can handle.

Adobe Photoshop 4.0 allows separation of greyscale images into duotones, tritones and quadtones where two, three or four non-black colour inks are used to print tinted black and white prints with an extended colour gamut and contrast range (see Chapter 13). ColorDrive 1.5 (Pantone) colour management software lets you make separations of Photoshop, Painter and Micrographx colour image file formats into the hexachrome six-colour process. Hexachrome is a colour space using modified CMY, standard black, green and orange, enabling almost twice the colour gamut of most CMYK output.

CMYK colour separations can be prepared using Binuscan's PhotoPerfect Master, which is bundled with some scanners, or the stand-alone ColorPro software. Both

software offer a straightforward method of getting sharp, well colour balanced CMYK output for desktop printers or to output at a local imaging bureau.

**OUTPUT TO SCREEN**

Display of digital images on a computer's monitor is described in Chapter 2 and 3, but PhotoCD images can also be viewed on television screens. Some digital cameras allow images to be exported from a computer for viewing on the camera's LCD screen. Laptop computers can also be linked to digital projectors for a modern take on the old-fashioned slide projector.

# Digital inspiration

IQ Video-graphics started electronic retouching in the late 1980s. This ad is a recent example of its work

Technological, commercial and cultural forces have combined to create a new era in the history of photography. It started in the 1980s when microprocessors began controlling the mechanics of the single-lens-reflex (SLR) camera introducing automatic exposure, autofocusing and sophisticated error correction facilities. But it was the emergence of hardware and software for digital photography in the late 1980s/early 1990s that opened fresh creative possibilities and facilitated the distribution of images. The expansion of the Internet and the World Wide Web continues to fuel the process of change. Photography has been absorbed into the multimedia business, and editorial, advertising, social and experimental photography has diversified into hundreds of different genres and styles.

The first significant explorations of digital photography were in the mid-to late 1980s using high-end imaging workstations, such as Quantel's Graphic Paintbox, Barco's Creator and Crosfield's Mamba. This hardware was the preserve of

retouching bureaux, photographers and designers working for advertising and design agencies so the output was stylistically driven by the sales message. Nonetheless, photographers found themselves drawn into the whole process of conceptualisation, art direction and execution of the brief. Digital comping neatly dove-tailed with the illusions necessary to sell products.

Newspapers also wanted to experiment with the new technology. The London Evening Standard's photographer Ken Towner was first past the post capturing the winner of the 1989 Derby, Quest for Fame, using a Canon RC-760. The image was sent by modem connected to a standard telephone line and was printed in the paper just 45 minutes later. While many regarded this technology as ideal for late breaking news, the general consensus was that portable still digital cameras weren't quite up to the mark as regards print quality.

While press photographers wrestled with the new technology, backroom

people were getting carried away with light-handed retouching using image manipulation software. Digitally retouched photos have appeared in UK national newspapers from 1990 onwards. Broadsheets took the high moral ground, as photo editors from the tabloids revelled in the ease with which they could clone heads to bodies placed in embarrassing situations. The debate continues and even broadsheets are not exempt from succumbing to the digital excesses. The Guardian published a photograph of the Chancellor of the Exchequer, Gordon Brown, in the 1997 budget. While all the other papers had him flanked by aides, mysteriously the Guardian was the only newspaper to have captured Brown alone with the famous red Budget despatch case.

In autumn 1991 there was an early landmark exhibition of digital photography in the UK thanks to the National Museum of Photography in Bradford. David Hockney, who was brought up in Bradford, produced a series of full size colour portrait joiners called Electronic Snaps. He used a Canon RC-470 still video camera, printing the results on a Canon Colour Laser Copier, the CLC 500. These everyday portraits, against one of his abstract paintings, have a lively feel which is accentuated by the strong colours produced by the CLC. Hockney saw the process as an extension of his late 1960s polaroid joiners, and clearly enjoyed breaking new ground with his electronic brush. In the same exhibition the Guardian's Eamonn McCabe used a Sony ProMavica and Canon RC-760 to capture the London Marathon. McCabe, a sports photographer and current photo editor of the Guardian and the Observer newspapers, found the lack of rapid sequential shots a limitation, but nonetheless produced good reportage works.

Digital photography was not just used for straight reportage work. Mike Laye's original picture of the cricketer Mark Ramprakash was given the electronic treatment in the Daily Telegraph's Saturday magazine in late 1991. Ramprakash was montaged into an old cigarette card style background. Celebrating and lampooning those in the limelight was facilitated at the touch of a mouse and comping digital images with graphic elements has become everyday fare in today's newspapers. In the Guardian and Observer alone, digital composites from Steve Caplin, Graham Rawl and Roger Tooth provide a stream of visual satire.

By 1992 the digital image had resurrected another dying art - photography as art-cum-political commentary. Andreas Serrano a black/hispanic/chinese New Yorker, deftly used a Barco Creator workstation to insert faces with black features into portraits from the Dutch artist Rembrandt. This exhibition at the Institute of Contemporary Arts in Amsterdam, juxtaposed the question of Dutch colonialism with its most lucrative commodity, slaves.

The Magnum photographer Chris Steele Perkins parodied the Thatcher years using the theme of adoration. Reworking his reportage shots of Thatcher, Tebbit et al he created a composite digital image entitled, The Adoration of the Maggie, complete with the aforementioned disciples and a halo of Jeffrey Archer angels hovering over a Madonna-like Maggie and child.

The advertising photographer Andreas Heumann was also drawn to surreal and Dadaist themes for inspiration for his early digital imaging work in 1992. Assisted by technician Richard Baker at IQ Videographics, a leading retouching house in London, Heumann created a striking shot of a nude woman, her face wreathed in chiffon, floating in the sky.

"The Strolling Saint" by Mexican photographer Pedro Meyer exploits the new digital technology

"Untitled" by Coneyl Jay - a new breed of photographer exhibited at Colville Place Gallery

Restoration of old, damaged photographs was another niche waiting to be filled by digital photography. Reviving the past or even resurrecting the dead is but a small challenge. In early 1993 Bert Stern set about restoring photographs from a photo session with Marilyn Monroe who had defaced many of the original transparencies taken shortly before her death. Using high-end technology and the best retouching skills the West Coast could muster, Stern saw Monroe's face emerge from the damage. One particular shot reveals a rarely glimpsed Monroe, vulnerable and frightened. Small wonder she wanted to destroy these particular images.

An image called Allegory 1, commissioned by Kodak and created by the photographer Ryszard Horowitz in New York in 1992, provided another milestone. Horowitz shot a number of separate photographs in his studio. He sketched a composite of these photographs before working alongside the RGA studio to create a composite image using the individual elements. Horowitz co-ordinated the expertise of technicians working on high-end Silicon Graphics workstations and Apple Mac computers. At this time it was one of the most complex still digital composites attempted.

David Bailey's first digital image, which appeared on the cover of XYZ magazine (now Creative Technology) in 1993, was captured with a Kodak DCS 200 camera. Bailey chose to exaggerate the effect of pixelation in the portrait of his wife, Catherine Bailey. Despite a gaudy mix of yellows, reds and oranges, the power of the image lies in its simple treatment and the riveting eyes of its subject. The Douglas Brothers, much lauded in the advertising world, produced sepia-toned fashion shots using a Canon ion still video camera. Even rock stars strapped themselves into the digital juggernaut. Dave Stewart of the Eurythmics produced striking images of Mick Jagger with a digital sad clown face and Lou Reed with laser burning eyes.

Those professionals eager to embrace the new technology were first to realise that the role of photographers was being expanded rather than being threatened by the digital age. Nick Knight is a good example and his triptych for a campaign of Jean Paul-Gaultier perfume intertwined a photo of a naked woman and a gleaming spray can with fragmented images showing glimpses of other worlds. It's a clever picture which plays with the pixels.

Throughout the 1990s a number of international photographers placed their faith in digital photography. Pedro Meyer developed his surrealist imagery to new heights. Taking the mixture of fervent Catholicism and the native culture of Oaxaca state in his homeland, Mexico, he created some stunning images. The Strolling Saint is a masterpiece invoking strong feelings of spirituality in a timeless, dreamlike landscape reminiscent of a Dali painting.

American stock photographers such as Eric Meola, a leading exponent of graphic, high colour stock shots, realised the potential for creating new material by combining existing photographs. By the mid-1990s international agencies, such as Tony Stone Worldwide, were creating digital composites to provide newly authored stock shots. Not only did this extend the choice for clients, but it was often considerably cheaper than sending a team half-way around the world.

Advertising continues to be the driving force behind the kind of digital photography we see everyday. The current campaign for Boddingtons beer gives us a glimpse into the power of digital manipulation into realms where a glass of beer has never before metamorphosised into so many similes.

In recognition of the creative advances made by photographers using digital technology the Ilford Photographic Awards created a new electronic category in 1994. Richard Dunn was the recipient of this first award with his image Big Nose. Over the last few years new awards specifically for digital photographic works have emerged from professional bodies and the manufacturers .

From 1995 the emergence of the new media and the Internet has considerably influenced the evolution of digital photography with multimedia combinations of 3-D images, sound, text, and animation for distribution on CD-ROM or transmission via the World Wide Web. In 1995 one of the first worldwide exhibitions of digital photography was held on the Internet by the London gallery and printing bureau, Visualeyes Imaging Services.

The Arts Council's sponsored Photo '98 festival, celebrating 1998 the Year of the Photography and the Electronic Image, attests to the the impact of advertising, new media, the Internet and television on today's digital photographers. Digital photography appears to have democratised the process of visual expression. Photo '98 features work by Martin Parr, Keith Piper, David Bailey, Zharina Bhimji, and fascinating combined media works by the late Helen Chadwick. But the most engaging feature of Photo '98 is the sheer diversity of the exhibitions being staged in cities throughout the UK and especially in Northern England. Many new commissions reveal the broad spectrum of digital influence on art, photography and the new media, creating a pot pourri of styles, commentaries and visually stunning images. Technology appears to have enriched the palette of the photographer.

Photography has always played second fiddle to art, but new galleries backed by entrepreneurs are promoting digital artists who combine photography, graphics and traditional painting techniques. Colville Place Gallery in London, previously the Association of Illustrators' Gallery, has been exhibiting work under the broad banner of computer art showing digital montages, 3-D prints of sub-atomic particles and high-tech interpretations of nature. Will digitally generated originals allow photography to be re-embraced by the art world? Time, the art critics and the punters will pronounce.

Although the digital process is significantly faster than the silver halide darkroom, enabling complex tasks to be achieved in minutes rather than hours or days, a great photograph is still the result of individual talent and technique. The new digital toolbox is a capable assistant, but is not sufficient in itself to create captivating works. As ever the imagingation remains the essential tool.

Photo '98 celebrates The Year of Photography and the Electronic Image

## SURREALISM

The legacy of traditional photography and twentieth century art offers inspiration to those experimenting with digital photography. Surrealism is most relevant to explorations with digital photography in 1990s. Three exemplary works from earlier decades provide food for thought and reveal that today's technology is no replacement for having something to say and saying it well.

### Metamorphosis

The Austrian architect and designer, Herbert Bayer created Metamorphosis in 1936. This photomontage explores spatial relationships of cubes, pyramids and spheres set against a dramatic landscape. It's a fresh image full of vitality, celebrating strong visual language and juxtaposing man's desire for order against the design of nature. Bayer, who was head of the Dorland advertising agency in Berlin, used surrealism in much of his work and was influencing advertising style long before the digital retouchers clicked their magic mouses in the 1990s campaigns.

### Just What is it.....?

In the consumer boom of the 1950s, photographs finally usurped hand drawn graphic designs in the advertising world. The era was satirised by Richard Hamilton's photo collage in 1959, Just What is it that Makes Today's Homes so Different, so Appealing? The picture was hung in the entrance to the Whitechapel Art Gallery's exhibition, This is Tomorrow, organised by a group of architects, artists and critics called the Independent Group, regarded by many as the fathers of British Pop Art.

Some 27 years later Hamilton updated his famous collage using digital imaging technology. The BBC's programme QED, Art & Chips, filmed Hamilton creating a new 90s collage using a Kodak DCS camera and a Quantel Desktop Paintbox. Five thousand copies of the collage were printed on a Canon colour laser copier for viewers to claim.

### Dalivision

Long before personal computers opened up new horizons for digital photography, Salvador Dali had something of a digital premonition. His 1976 Lincoln in Dalivision is a full length nude rearview of his wife Gala framed by tens of square blocks of colour. It is only when squinting or viewing the picture from a distance, that the viewer becomes aware of looking at the face of a former US President. This phenomenon, known as quantising, relies on the inability of the human eye to recognise two spatial frequencies of contrast at the same time. With normal vision the squares of differing contrast are clearly visible surrounding Gala since she creates the strongest spatial frequencies. Blurring vision helps remove these frequencies and the face of Abraham Lincoln emerges. As you distance yourself from the picture the ability of the eye to resolve detail is reduced, so the stronger squares outlining Lincoln's face emerge.

Dali recognised that visual units of squares of different contrast value could be used to create multiple images within one image. The basis of every manipulation made to a digital image relies on changing the absolute number of the squares, their contrast value and how the new arrangement is viewed by the human eye. While it probably took Dali several months to complete his painting it is possible to create many different versions of a digital image in a day.

Richard Hamilton's "Just What is it That Makes Today's Homes so Different, so Appealing?", photo-collage, 1959

## HIGHLIGHTS FROM THE ERA OF CONVENTIONAL PHOTOGRAPHY

Over 150 years of photography offers untold inspiration for digital photographers seeking to make their mark. Here are a few highlights:

1827 The Frenchman Joseph Niepce exposed bitumenised pewter plate for eight hours in a camera obscura to create the world's first photographic image.

1890 - 1900 Felice Beato, an Italian photographer, recorded life in turn of the century Japan, marrying documentary reportage with exquisite hand-coloured portraiture.

1920s - 1930s A particularly fertile period of experimentation occured within the Cubist, Surrealist and Dada art movements. Man Ray was credited with inventing rayographs (phonograms or cameraless pictures) by placing objects directly onto light sensitive paper. He also explored the process of solarisation, exposing photographic paper briefly to a flash of light during enlarging, causing highlight lines around the edges of the subject.

"Gala contemplating the Mediterranean sea which at eighteen metres becomes the portrait of Abraham Lincoln", (Homage to Rothko) 1976 (oil on photographic paper) by Salvador Dali (1904 - 89). Dali perhaps had a premonition about pixels and their role in digital imaging when he used the technique of quantising to make Lincoln's face appear on viewing the picture from a distance.

Photography provided the perfect propaganda tool. During the Stalinist purges darkroom experts contrived to remove Trotsky from virtually every official photograph showing Lenin and Trotsky delivering their rhetoric from the same podium. The skill of photographer, artist and political commentator was honed in the art of photomontage.

**1930s - 1940s** Hollywood employed photographers like George Hurrell to capture the glamour of Greta Garbo, Marlene Dietrich, and Clark Gable, for the film studios' promotions. Photographers to the stars used every trick of the trade to light their portraits to dramatic effect.

**1940s - 1950s** The photojournalist Bill Brandt featured in magazines such as Picture Post, Weekly Illustrated and Lilliput. He documented the British way of life, pre- and post- World War II. His abstract-like nude studies have more than stood the test of time, with some of the original shots being used to advertise Levi jeans in the 1990s.

A typical rayograph or camera-less picture by Man Ray

Post World War II led to other developments in photography as agencies like Magnum confirmed the importance of the camera in distilling images from a palette of world events. Robert Capa's celebrated, and controversial, photograph of a soldier in the Spanish Civil War never fails to hold. Almost every ground rule of good photography is met in this one photograph - riveting subject, dynamic composition, brilliant timing and correct exposure. That's all it takes to acquire iconic status.

In the 1950s photographers experimented with less formalised styles. In the United States, Richard Avedon emerged as one of the world's top photographers capturing the rich, famous and infamous for the glossy magazines of the day. Over the next 30 years Avedon's viewfinder would frame everyone from the catwalk superstars (Dorian Leigh in the 1950s, Jean Shrimpton in the 1970s) to 1960s black leader, Malcolm X.

**1960s - 1970s** One glance at the photographic styles of contemporary magazines and record covers reveals an eclectic spirit. David Bailey stamped his style on the fashion world; Harry Peccinotti created new styles of editorial photography for Nova, the first mass market style and culture magazine in the UK; Don McCullin documented the war in Vietnam.

**1970s** Artists helped push the creative boundaries of photography still further with everything from David Hockney's photographic joiners to Pedro Meyer's photographic surrealism. Advertising also generated some memorable photographs, such as the Saatchi campaign for the birth control pill in 1970, showing a pregnant man courtesey of some extensive darkroom trickery.

**1980s** Magazines such as The Face and i-D popularised street style photography, cross-processed and cross-dressed, with a fading whiff of punk anarchy. Mike Laye, one of the founding photographers on The Face, was an early convert to the wonders of digital retouching. Picture editor-cum-photographer of i-D, Nick Knight, has become one of the most sought-after photographers for the world's fashion labels, and is an adept digital imaging technophile.

**1990s** Photographers revell in a diversity of styles which embrase influences from advertising, photography, graphic design and fine art. Digital photography has undoubtedly liberated photographers from the restrictions of the silver halide darkroom and thereby created an opportunity for limitless exploration of new visual genres. Public scepticism remains about the abuse of digital photography in the publishing industry but this is more than compensated for by digital work by photographers who show respect for the new medium.

# Hot shooting tips

One of the encouraging things about digital photography is how it is attracting not just photographers but computer enthusiasts, film makers, and hobbyists wishing to create digital snaps and simple composites. Whatever background knowledge is present, an understanding of elementary photographic principles, and the limitations of the digital technology, will be of great assistance. This chapter discusses these issues and explains how to get the most out of using sub-megapixel, digital cameras.

Although many mistakes during shooting can be corrected when manipulating or editing an image captured by a digital camera, it saves a lot of time if basic errors are avoided before and during shooting.

## COMPOSITION TIPS
**Images intended to be viewed as a full frame**
Striking photographs contain an interesting subject and deliberately dramatise the presentation of that subject, by carefully selecting the composition elements within the frame.

Select a strong subject

### Tip 1 Look before you click
Take time to weigh up the scene before you lift your camera to frame it. Look for strong visual elements such as shape, colour, contrasting lighting.

### Tip 2 Select a strong subject
Not every subject is photogenic, but if you are able to mentally isolate the most interesting elements it is usually easier to decide where to point your camera and what to place within the frame. Once you've chosen your main subject, make sure it is prominent, and/or fills the frame, so that secondary subjects do not attract too much attention. This is often best achieved by getting physically close to the subject or by using a zoom lense. A depth-of-field control allows you to selectively focus on the subject leaving the background out of focus.

### Tip 3 Centre or offset the main subject in the frame
The rectangular format of most photographs enables you to choose whether you want to centre your main subject or whether you wish to offset it within the frame. This is

a critical decision as it radically affects the dynamic feel of the image. Strong dramatisation is provided by locating your main subject one third of the way into the frame from either edge. Photographers refer to this composition aid as the rule of thirds. It is especially useful for emphasising subjects in the foreground

### Tip 4 Select camera to subject angle of view

Don't shoot every subject from shoulder height while standing up. This is just one of thousands of shooting angles you can select. Experiment with framing your subject from ground level or from a nearby vantage point.

### Tip 5 Consider frame to subject orientation

Most digital cameras use a rectangular image area. Does the subject look better framed in vertical (portrait) orientation or in horizontal (landscape) orientation or diagonally within the frame?

### Tip 6 Consider the lighting conditions

Be aware of strong shadows and highlights when shooting in bright sunlight or low angle lighting. Clouds diffuse sunlight producing more even, lower contrast, lighting. Electronic flash mimics mid-day sunlight so, again, watch out for excessive contrast.

### Tip 7 Consider the direction of the main light source

Light is rarely uniformly distributed, and is often stronger from one particular direction. Observe what effect this has on your main subject, the foreground and the background. Be aware of shadows and/or highlights which can contribute to incorrect exposure of the full frame. Don't worry too much about different types of artificial lightsources, such as fluorescent or tungsten lighting, since colour shifts produced by these sources can be removed during manipulation/editing.

### Tip 8 Avoid camera shake

Picture sharpness is severely affected if the camera moves during the exposure period. In low lighting conditions brace yourself against something solid or attach the camera to a tripod to minimise camera movement.

### Tip 9 Create motion effects: moving the camera

Track the moving subject through your viewfinder, or LCD screen, in a smooth, steady motion, releasing the shutter but continuing the natural arc of the motion. This technique, known as panning, takes time to perfect, but recreates the illusion of movement by freezing the subject sharp while the background is blurred.

### Tip 10 Create motion effects: keeping the camera still

This effect is best achieved in low ambient lighting conditions, or ambient light supplemented with electronic flash. Hold the camera still by hand or by mounting

it on a tripod. As the subject moves through the field of view in the frame click the shutter. The edges of the subject will be blurred and the background will be sharp creating the illusion of movement. Flash can illuminate a moving subject in the foreground and emphasise edge blurring. Experiment with different combinations.

**Tip 11 Incorrect exposure with flash**
This is a common problem with low-end digital cameras. Integral flash systems close to the axis of the lens can cause red-eye effects. Many cameras automatically trigger flash in low lighting conditions causing local burn out in the foreground and complete darkness in the background. Turn off the automatic flash, for indoor shots, then introduce a source of continuous tungsten or fluorescent lighting and place the camera on a tripod. Check the maximum exposure time on your camera as you may need to expose for 1/4 second or longer in low lighting. Again, turn off the autoflash and use a tripod for shooting outdoors in low light.

Symmetry for harmony and balance

**Images intended for montaging**
There are some additional factors to consider when you are shooting images which you intend to use in a later digital montage or composite image. Taking care now saves lots of time later.

An unusual angle of view will focus the viewer

**Tip 1 Produce a rough sketch**
Sketching your basic idea for a montage helps you focus on the important visual elements and the components needed to create the overall effect. If you haven't visualised your outline concept, you won't find it easy to achieve a satisfactory effect. A rough sketch is equivalent to the film director's storyboard describing scenes.

Panning with the camera creates a simulated action blur

**Tip 2 Shooting cutouts**
If you wish to use a subject as a cutout to later paste into a montage, make sure it is an important part, or the main subject, of your frame. Shoot your frame on the diagonal to maximise the dimensions of the cutout, but beware of possible edge distortion of the frame with certain lens systems. Consider how your cutout is lit. Is it illuminated by strong light, causing high contrast, or is the lighting even, and low contrast? Is the light strongly directional? Ideally all the cutouts used in a

montage should be illuminated in a similar fashion as this will significantly reduce work during image manipulation. Another trick for cutouts is to place a uniformly coloured background behind the subject. This facilitates cutting out the subject from the background using image editing tools. Be careful though, since any background will have an effect on the overall exposure of the image. A neutral grey background minimises exposure problems. Fill the frame with the subject to minimise the effect of the background on exposure.

### Tip 3 Shooting backgrounds

You may wish to shoot an interesting frame which can be used as a background for a montage. The type of background you shoot will be determined by your rough sketch concept. Dramatically lit landscapes are fine if you have similar high contrast cutouts to paste in. Evenly lit scenes can often provide a more versatile background which will more readily accomodate a wide range of cutouts. Shooting distance between camera and subject will determine the overall feel of the background. If you're not sure what scale you require, shoot the same scene at several distances, so you can select the best one later.

### Tip 4 Shooting textures

If you wish to have a background texture, rather than an actual scene, shoot at several camera to subject distances to alter the scale of patterns and colour. Whether you shoot in low or high contrast lighting really depends upon the effect you want to produce in your montage. Dramatic high contrast textures can dominate cutouts which are not visually strong, whereas textures with too low a contrast can make cutouts stand out and look awkward.

### Tip 5 Stitching a panoramic view

Special imaging software is available to seamlessly stitch together a series of frames to make a panoramic (see Chapter 7). You can minimise the amount of work required during manipulation by setting your camera on a tripod which ensures that the correct horizon level is maintained on each frame. The angle of view of the cameras lense will dictate how many frames you need to cover an arc of 120 degrees or 360 degrees. Overlap frames by at least half the value of the angle of view of the

lens to minimise subject distortion between adjacent frames. This is especially important for shots with a busy foreground.

## OPERATIONAL TIPS
Most digital cameras function in a similar fashion, though specifications do vary. This section provides an operational check list. Once you are familiar with your camera many of these operations will become second nature.

### Tip 1 Batteries
Batteries are the lifeblood of all digital cameras as most components are electronically controlled. Cameras equipped with LCD screens for previewing frames and captured images are very power hungry. Always take a spare set of batteries or an AC adaptor if the camera is fitted with one. Some manufacturers sell a separate battery pack.

### Tip 2 Additional storage
Sufficient storage space for cameras which download their images to a removable PC card (PCMCIA, SmartMedia or CompactFlash) is really only limited by your ability to afford extra PC cards. However, those storing images in the camera's internal EPROM have limited storage capacity. One solution is to use an inexpensive older style laptop computer (available secondhand for a couple of hundred pounds) with hard disks of between 40Mb to 750Mb capacity, to download images when the camera's memory is full. In an emergency many cameras have a facility to allow you to delete selected images, or all the images, to release storage space.

### Tip 3 Capture resolution
Although many inexpensive cameras offer a choice of resolutions at which to shoot, it's good practice to shoot at the highest resolution possible, even though this means you use up valuable storage space sooner. It keeps more options open when choosing your output device and for maintaining photo-realistic quality. Capturing at less than or equal to 640 x 480 pixels is only advisable if your intended image output is to a monitor or you are prepared to use small images in print.

### Tip 4 Parallax errors
A viewfinder that enables you to look directly through the lens gives an accurate field of view, but a viewfinder that is separate from the lens may introduce a margin of error between the alignment of the image in the viewfinder and that actually captured by the lens/CCD combination. Viewfinders are usually marked with the actual field of view, but test the lens with a variety of shots to check for any parallax errors.

### Tip 5 Exposure control
Most low-end digital cameras have an automatic through-the-lens (TTL) centre-weighted metering system, similar to most conventional compact cameras. These can be fooled into underexposing your subject in strong sunlight or backlighting, or where there's lots of reflective light. This is easily corrected in cameras that are fitted with an exposure lock and/or a manual override exposure compensation of up to +/- 2 stops. You may be able to bracket your exposures taking consecutive frames at 1/2 stop exposure intervals. Where there is limited exposure control you can use fill-in flash reduce the effects of strong backlighting to an object/subject. You can also

experiment with controlling exposure by placing a neutral density filter in front of the lens for TTL metering or over the light metering sensor if it is separate from the lens. This fools the meter into believing the light source is darker than it really is, so exposure times are automatically adjusted. A polarising filter placed can also help minimise possible exposure problems caused by greater than normal reflection off a water surface.

### Tip 6 Checking colour balance

An 18 per cent grey card, such as the Kodak Gray Card, is a useful accessory to carry with you. This card reflects 18 per cent of incident light throughout the visible spectrum. When you photograph the card the actual colour of light illuminating the scene is being recorded. This is a useful reference point to include in the corner of a frame or as a separate shot since it assists in colour correcting an image during editing and printing. For cameras with a manual exposure override the gray card can also be used in conjunction with the camera's TTL metering system to check exposure. Place the grey card in front of the intended subject and check the exposure level. Remove the card and recheck the subject. You will have to decrease your exposure by 1/2 to 1 stop where the scene is brighter than normal (i.e. the exposure measured off the grey card) and increase your exposure by 1/2 to 1 stop if the scene is darker than normal.

### Tip 7 Lag time

Once you've clicked the shutter it takes time for the image to be rendered on the CCD chip, compress the image and write it to the storage medium before the next shot can be taken. This interval varies but is usually several seconds for low-end cameras. If you need to take a sequence of shots, you have to plan for the lag time. Trying to capture fast moving sports means you have to perfect your timing or use more creative techniques, such as panning.

### Tip 8 Light sensitivity

The sensitivity of a camera's CCD chip is measured as the equivalent ISO speed of film Most low-end digital cameras have an equivalent film speed of ISO100 up to ISO400, which is best suited to shooting in daylight. If you have to shoot in low light or at night use a tripod to prevent camera shake in longer exposures. If you need supplementary lighting then more consistent results will be achieved using portable photographic studio spotlights rather than flash, as the latter can easily over- and under-expose if not used correctly.

### Tip 9 LCD screens

LCD screens are lit from the back and so do not read well in strong sunlight where surface reflected light interfers with the image. If your camera doesn't have a protective pull up visor around the LCD screen, simply tape a little velcro around the periphery of the screen and attach a home made black cardboard visor when required. It may a little Heath Robinson, but its effective.

### Tip 10 Downloading images to computer

Most low-end cameras are bundled with a software driver to facilitate downloading images to your computer. If you are shooting with more than one digital camera a

software such as NBA PhotoWallet can be used to download images from most popular cameras, rather than having to use a different software driver for each camera.

### Tip 11 Downloading images directly to a printer

Some cameras permit software to be loaded from the computer to the camera's internal storage device to enable images to be output directly to a printer. This software can take up to 25 per cent or more of the existing storage space which means you can take fewer shots. If you wish to regularly download images directly to a printer it is best to buy a camera which can take removable PC cards to provide extra storage capacity, captures files at resolutions in excess of 640 x 480 pixels and which has good exposure control. You will be downloading raw, unedited, image files, so you need to take good shots.

### Tip 12 Shooting in greyscale

If your camera offers a choice of shooting in colour or greyscale mode, then select the latter to capture greyscale at the same resolution as colour images. If you shoot in colour and convert to greyscale later using an image editing software, you have to discard all the colour information thereby loosing some detail. Whichever route you choose it is possible to re-convert the greyscale image into an RGB greyscale whose R, G or B colour channels can be tinted or colourised independently to produce some interesting effects (see Chapters 13 and 15).

### Tip 13 Knowing your camera's colour profile

Each camera will have a tendency to over or under record certain colours depending on the specification used by the manufacturer to construct the CCD chip and to compress the images. Take a standard colour test chart (available from most high street retailers) and make repeat exposures of the chart in a variety of outdoor and indoor lighting conditions. Get a digital imaging bureaux to make a high-end scan and output of the same standard colour test chart. Compare the colours in the high-end scan with your test images. Using your image manipulation software correct each of your test images to match the high-end scan. Note the levels or settings you used to correct each test image. You'll soon get an idea of whether your camera is under or over recording certain colours, and if the effects are worse under certain lighting conditions.

CHAPTER 13

# Image manipulation: basics

Visual effects that would have taken conventional darkroom technician weeks to accomplish can now be achieved in a matter of minutes. This chapter is about those short cuts and is divided into six sections: start-up; manipulations to the whole image; manipulations to part of the image; greyscale images; filters; and plug-ins. Many of the techniques described are essential to perfecting the art of creating digital montages or composites, which is dealt with in Chapter 14.

The principles of image manipulation are demonstrated using examples from five popular image manipulation software packages. There are four low cost packages, retailing at less than £100: Adobe PhotoDeluxe 2.0, Kai's Power Soap, Micrographx Picture Publisher 7.0 and Microsoft PictureIt!. The fifth package is the world's most popular professional image manipulation software, Adobe Photoshop, retailing at over £400. Photoshop version 5.0 was released to the UK market in mid-1998.

All these applications have menus, submenus, dialogue boxes, tabs, buttons and icons within a graphical user interface. Kai's Power Soap, Micrographx Picture Publisher 7.0 and Adobe Photoshop 5.0 also use special toolboxes from which individual tools can be selected to perform specific retouching or editing tasks.

**START-UP TIPS**
Before you begin to manipulate an image there are two golden rules to observe: copy and crop. Make a copy of your original file and do all editing on the copy. Crop out any unnecessary parts of the image before editing. Re-sizing is also recommended at this stage if you know the type of output device and output resolution required, because re-sizing after editing can cause loss of image detail. If you are uncertain of the output required then re-size later.

**Tip 1** Don't alter your original (archived) images. Always make a copy and work on this file rather than the original. You may want to go back to the original at a later date, make a fresh copy and try another image editing sequence.

**Tip 2** Crop and then re-size your image before you apply any manipulations. There is no point working on unwanted parts of an image, nor on a large file, if you have to substantially reduce its size for the intended output method. For example, if your original file is 18Mb and you wish to produce a 300 dpi 6 x 4 inch dye-sublimation print, you can re-size the image to create a much smaller file of 6.5Mb or less that will still contain enough information to produce a good photo-realistic print. This can substantially reduce the time required to manipulate the image. Refer to Table 2.1 to check the maximum file size against the required output size and resolution.

**Tip 3** Whatever software application you use to manipulate your images check how many levels of undo are available. Software can have infinite undo, multiple undo or single undo. If you've spent hours working on an image and realise that you wish to go back four steps, but are only offered a single undo, you may have to start again. If you have a limited number of undo steps you can always save separate versions of the file following the completion of critical steps.

**Tip 4** Configure your computer and imaging application to automatically save your image file every ten minutes or so. Any information in an unsaved image may be lost if your computer crashes.

**Tip 5** While some software permits you to save each step of an image editing routine, other software doesn't include this facility so it pays to jot down what you did at each step. This can be a useful memory aide if you want to repeat a similar effect on another image.

### Cropping

Most image editing software allows you to crop unwanted parts of an image by using a special tool. When the tool is activated by selecting from a drop-down menu, or a toolbox or a dialogue box, the pointer is usually converted into a crosshair. Click the crosshair and drag it over the image to form a box or rectangle whose outline is marked in dashed lines, defining the area you wish to retain. Click again and confirm the instruction to crop. If you are not happy with the position of the crop lines each one can be individually adjusted by clicking on the line and dragging it to the required position. Some software offers a range of standard cropping shapes including square, rectangular, circular or set template shapes. Others allow you to numerically specify the aspect ratio of the image or to define the width and height of the image in pixels.

Re-sizing dialogue box, Adobe Photoshop

### Re-sizing (re-sampling)

Re-sizing describes the process of changing the physical dimensions or the resolution of an image. When re-sizing involves a decrease in the total number of pixels it is referred to as down-sampling. This results in a potential loss of output image quality. When the physical dimensions of an image are reduced, but the total number of pixels is maintained, there will be an increase in resolution and hence a potential improvement in output image quality.

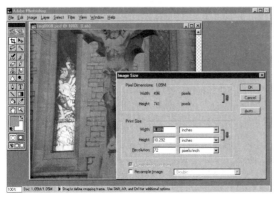

Some software is capable of adding extra pixels, or re-sampling up, by the process of interpolation. Whether this leads to improvements in output quality depends upon the method of interpolation and the proportion of new pixels being added to the existing pixels. All software interpolation can introduce image artefacts as a consequence of the

mathematical and spatial models used to insert the additional pixels. Re-sampling up is generally only recommended when using higher-end software.

Different software offer different re-sizing controls, for example, Adobe Photoshop 5.0, enables you to specify pixel dimensions, output image dimensions and output image resolution. Alter one variable and the others are automatically adjusted. For example, if you maintain the total number of pixels and define the output resolution, the output print or screen size will be reset. Photoshop also allows you to determine the best resolution for an output print of specified dimensions according to the screen frequency of a halftone printer.

Resize an image in Micrographx Picture Publisher 7.0 by selecting the Image menu > Size. You can numerically specify the units in width and height, the width and height scale (as a percentage) or the resolution. Options allow you to maintain file size, allow size distortions or use SmartSizing interpolations software for re-sampling up.

Adobe PhotoDeluxe offers a number of re-sizing options. Click the Get Photo button, then the Touch Up tab > Size/Orientation button. Use the Adjust, Trim and Size tabs to change the dimensions in pixels, for a screen image, or by units of measure, for an output print. There's also a useful Print Preview option which lets you see the size and quality of the image before you confirm the re-sizing command.

Re-sizing is activated in Microsoft PictureIt! by selecting an item in the picture Stack, enabling the whole image or separate picture elements to be re-sized. Once the item is selected the corner handles are dragged to make the image smaller or to enlarge a cropped portion of the image. File size is maintained when you reduce the dimensions of the image, so the resolution is automatically increased. Similarly the file size is maintained for the enlarged crop, by background interpolation. Information on file size, physical dimensions and resolution is not easily available so the degree of control is limited.

Images can be cropped in the Prep Room using Kai's Power Soap, but detailed re-sizing options are not available other than specifying the file format you wish to export the image from the Out Room.

### Changing file formats and file compression

Another consideration prior to applying manipulation is to consider the file format of the image. Manipulations are sometimes applied more quickly to certain file formats. Deciding on which format to use will depend upon how much information you wish to retain with the image. Image file formats which are native to a software application can often contain alot of information relating to editing steps applied to separate layers in the image (see Chapter 14 on using layers in digital montages). For example, in Micrographx Picture Publisher 7.0 rotating a 24Mb composited image through 180 degrees took over 80 seconds in native PP4 format, but only required half the time in TIFF format. This is because the PP4 format retains information on each layer of the composite, whereas all these layers have been merged into one composite image in the TIFF file.

Once you have completed your manipulations you may want to copy the image and save it in another file format for output (see Chapter 2 for file formats). TIFFs are a good , platform-independent format which can readily be converted into CMYK format for printing. GIFs and JPEGs are the popular choice for preparing images for the Web.

A low contrast image (top) shows a limited tonal range compared to a high contrast shot (bottom) with a spread of tones in the histogram

If you are undecided as to which format you will require, keep an archived TIFF file of your manipulated image. You can always re-size, compress and convert this image into other file formats at a later date.

## Zooming

Most image editing software includes a tool to magnify the image. It is advisable to use the zoom tool when you are using pointers (mouse, stylus etc) to select an area of an image, to create a mask or object, or when editing individual pixels. The zoom tool is indispensible for checking the amount of detail within an image.

## MANIPULATIONS APPLIED TO THE WHOLE IMAGE

The prime objective of this section is to create an image file with good contrast, colour balance and sharpness, where minor blemishes, such as dust and scratches, are removed. It's easy to become over zealous when correcting images and end up with a rather garish contrasty, unsharp, image with too much pixel noise. Whatever correction you are applying make your adjustments in small incremental steps, rather than making radical changes and where feasible preview the result before saving the file.

### Contrast and brightness correction

Describing the contrast in a photograph or image is, usually, a subjective process. Photographs are described as flat (low contrast) or contrasty (high contrast), but the same descriptions are also applied to lighting, film, printing paper and the subject of the photograph. Objective assessment is made by measuring the density or dynamic range of a print or film or using a mathematical relationship, such as the gamma and contrast index. Photographs which were originally over- or under-exposed, or whose subject is inherently contrasty, will create digital images of a similar contrast range when scanned. The actual contrast of images captured by a device depends upon the dyanmic range of that device. Devices with a low dynamic range (for example, flatbed scanners are typically D1.8 to D2.0) will show a more limited range of contrast than film scanners (typically D3.0).

Most image manipulation software has a facility for improving contrast i.e. to adjust the lightest and darkest areas of an image. Increasing contrast increases the

differences between the lightest and darkest areas, and decreasing contrast decreases these differences.

Brightness is a measure of the degree of saturation of a colour. Its value is represented by 256 levels of brightness from 0 (black) to 255 (white). Again acceptable levels of brightness depend upon subjective preferences, but the brightness of all the pixels in an image, or individual pixels, is easily assigned to a specific value. Low-end manipulation software tends to offer facilities for automatic brightness/contrast correction or simple sliding scale or numeric controls. High-end software offers a much wider range of options for controlling brightness and contrast.

Adobe Photoshop 5.0: The easiest way to adjust contrast is by using the menu bar. Open Image > Adjust submenu > Brightness/Contrast dialogue box. Drag the slide control of the contrast scale or brightness scale to affect all the pixel values in the highlights, midtones and shadows. Two other options enable finer control of contrast and brightness. The first uses the Image > Adjust > Levels submenu. A histogram in the Levels dialogue box shows the frequency of occurrence of pixels at input levels (the original brightness levels) from a value of 0 (black) to 255 (white). To reduce contrast move the slide on the Input Levels scale just below the histogram to alter the shadows, midtones or highlights independently, or specify the levels numerically in the Input Levels boxes. To increase contrast move the slide on the Output Levels scale or specify numerically in the Output Levels boxes. The second option is to use the Image > Adjust > Curves submenu. In the Curves dialogue box a pointer can be moved on the input levels/output levels graph. This curve can be adjusted visually, and can be specified numerically, for one or three (RGB) colour channels (see below). Numeric adjustment is on a scale of 0 to 255.

Adobe PhotoDeluxe 2.0: Click the Get Photo button > More Touch Up tab > Appearance > Instant Fix then click the button to automatically adjust contrast and brightness. Manual control of contrast is achieved by clicking Appearance > Tune > Brightness/Contrast dialogue box. In the dialogue box move the slide control on the contrast scale or brightness scales or specify numeric values. The new contrast/brightness settings are shown in a preview.

Kai's Photo Soap: The Tone Room offers brightness and contrast sliders. Either you can use a slider which affects all the tones in the image or you can selectively adjust the shadows, midtones and highlights. Even finer tuning is offered via the nine-band equaliser, the Tone Equaliser. Each slider is linked to adjacent sliders in the default Grey (all channel) setting, but you can unlink the sliders to control each colour channel (RGB) independently. A neat feature is the ability to save all the settings so you can batch process images.

Micrographx Picture Publisher 7.0: There are a number of options for altering contrast. Open the Map menu > Contrast/Brightness > Visual. A dialogue box opens showing 9 thumbnails of the image, 3 showing highlight thumbnails with low, medium and high contrast/brightness, 3 showing midtones and 3 showing shadows. Select the thumbnail with the contrast/brightness values required, preview the image and the numeric values are automatically reset. Highlights, midtones and/or shadows can be altered independently. Alternatively you can alter the characteristic curves by using Select Map > Modify Color Maps. Move the pointer on the graph of input and output frequencies or move the slide adjuster on the gamma scale or set the input and output frequencies numerically. Contrast can be adjusted for all colour channels or in separate RGB channels.

The original colour balance

Microsoft PictureIt!: Select Workbench tab > click Paint & Colour Effects >click Brightness & Contrast > click Smart Task Fix for automatic adjustment of brightness contrast and colour. Alternatively adjust manually by moving a marker within a contrast gradient circle or by specifying the position of the marker by a numeric value.

## Colour balancing

It is best to correct brightness and contrast before attempting to change the overall colour balance of an image. The exact methods of colour correction vary according to each image manipulation software. Most use RGB and CMY colour space models but some imaging softwares also offer adjustment using the hue, saturation, and lightness or brightness (HSB or HSL) colour space (see Chapter 2).

Most image editing work is achieved using the RGB colour space and RGB images are exported for viewing on screen or to be written to film. But if images are being printed (on paper) they are usually converted to CMYK (although they will be viewed temporarily on a monitor in RGB). Those wishing to fine tune colour printing of their own images will want to adjust colours having converted the image file to CMYK colour space.

If an RGB image has excessive red then the red can be reduced or the amount of the complementary colours (green and blue) can be increased. An excessivly green image can be corrected by reducing the green or increasing the red and blue, and so on.

Pairs of subtractive CMY colours combine to form an additive colour, so

The curve for the green colour channel has been modified to increase red and blue

cyan and yellow create green, magenta and yellow create red, and magenta and cyan create blue. This is the principle of the colour wheel. A CMY or CMYK image which appears too green (as viewed in RGB colour space) can be adjusted by reducing the amount of cyan and yellow or increasing the amount of magenta. The magenta is the complementary colour and the cyan plus yellow (i.e. green) as the main colour. Increasing the complementary colour makes the main colour less vivid, but decrease the complementary colour and the main colour becomes richer. This principle is used in colour wheels and dialogue boxes with sliders for altering colour balance.

There are numerous ways to reduce excessive or dominant colouration, to increase saturation of all or selected colours, and to compensate for images subject to a colour

cast. Different applications offer various solutions. Some applications offer automatic adjustment of the image by activating buttons, tabs or menus with commands which use preset levels to correct or adjust the image. More sophisticated applications offer precise control by allowing the user to change the characteristic curve (using a Curves dialogue box) of all the colours together or each colour (RGB and/or CMYK) independently. The characteristic curve controls the relationship between the input brightness levels and the output brightness levels. Bottom left of the curve represents the shadows, the central portion the midtones and the top right portion the highlights. All or part of the curve can be adjusted.

Input levels can also be viewed in the form of a histogram with a slider underneath which is used to adjust the output levels. The histogram shows the distribution of pixel values in the shadows, midtones and highlights.

Saturation of colours is usually controlled by operating sliders within a dialogue box, each slider representing Hue (H), Saturation(S) and Lightness(L) scales or a colour wheel where HSL are altered by moving an active cursor (or other symbol).

The following shows some of the options available to adjust colour in the five selected imaging applications:

Adobe Photoshop 5.0: Select from the menu bar Image > Adjust > Colour balance. Click Preserve Luminosity to lock the existing brightness levels. Then use the sliders to correct the Cyan/Red, Magenta/Green or Yellow/Blue balance, or specify their numeric values. It is possible to adjust the CMY/RGB balance of the midtones, shadows or highlights independently. Alternatively adjust the colour balance of the whole image or selected areas using the Levels, Curves, Hue/Saturation, Replace Colour or Selective Colour submenus from selecting Image > Adjust from the main menu bar.

Adobe PhotoDeluxe 2.0: Select Get Photo button > Touch Up tab > Fix Colour > Variations tab. Click the Varations icon. A dialogue box reveals 9 thumbnails, one showing the original image, one showing the corrected image and 7 displaying options to correct colour (you can choose more R, G, B, C, M, or Y). Click the preferred image for automatic adjustment to the new colour levels. An automatic option is available by selecting Get Photo button > Touch Up tab > Instant Fix.

*Original colour balance, Microsoft Picture It!*

*The balls in the colour wheel have been dragged to change the colour balance*

Kai's Power Soap: The Colour Room offers simple or advanced controls. A three slider control uses the HSL colour space and allows sliders to be moved to change the hue, saturation and brightness in the whole image. The 12-band Colour Equaliser enables you to control hue, saturation and brightness in discrete RGB colour bands. An individual band can be adjusted by unlinking the sliders, giving detailed control of a limited colour gamut.

Micrographx Picture Publisher 7.0: Select the Maps menu > Colour Balance > Visual. The Visual Colour Balance dialogue box shows 11 thumbnails, one showing the original image, one showing the modified image and a grid of 3 x 3 images. The latter shows the effects of selecting more R , G, B, C, M, Y and controlling contrast (lighter or darker options). The numeric levels are automatically adjusted when clicking on the selected thumbnail. Check the result by clicking the Preview button before saving. Colour balance may also be corrected by selecting Modify Colour Maps, Hue Shift or Hue Map under the Map menu.

Microsoft PictureIt!: Select the Paint Effects & Colour button > Change colour icon. The colour tool dialogue box appears. Drag the yellow and/or blue balls within the two concentric colour circles to change the hue (H), saturation (S) and brightness (B) of the image or type in a numeric value to fine tune HSB. Alternatively select a colour reference point within the image to which all other colours are automatically adjusted (the yellow and blue balls move to their redefined positions). Getting the best out of the colour tool does require a detailed understanding of how colour works.

**Colour cast correction**

Photographs or images captured under certain lighting conditions can have a colour cast over the whole image. For example, normal domestic tungsten bulbs create a yellow cast, fluorescent lights a green cast, and strong sunsets a red/orange cast. These casts are easily corrected by imaging software using manual selection or automated routines. Colour casts are best corrected manually in Adobe Photoshop 5.0, Kai's Power Soap and Micrographx Picture Publisher 7.0 using the procedure given in the guidelines on colour balance above. Low-end imaging software usually automate the procedure for removing a colour cast.

Adobe PhotoDeluxe 2.0: To automatically remove a colour cast, click Get Photo button > Touch Up tab > Instant Fix button. Click the Instant Fix icon. If you wish to select the amount of colour correction manually use the options under Touch Up tab > Fix Colour > Variations tab.

Microsoft PictureIt!: Select the Paint Effects & Colour button > Correct tint icon. The Correct tint dialogue box displays two options. The Smart Task fix tool allows you to select the whitest part of the image and automatically adjusts all the colours in the image using that as a reference point. Alternatively you can manually remove the colour cast by dragging a yellow ball in a colour ring to a hue approximately matching the colour of the cast. Then drag the slider to the left to decrease the amount of this colour in the image. If you don't like the results with the option selected, click reset and start again.

**Correcting individual colour channels**

There are many options for controlling the colour in one channel (a layer of information in a colour space) without affecting the colours in other channels. Three channel colour spaces include: Red, Green, Blue (RGB); Hue, Saturation,

Lightness/Brightness (HSL/HSB); Cyan, Magenta, and Yellow (CMY) and L lightness, a and b components of CIELab (L*a*b) colour space. Cyan, Magenta, Yellow and Black (CMYK) is a four channel colour space.

Not all software offers the option of controlling channels in all of these colour spaces. Some software use a stand-alone set of menu-driven commands, others incorporate channel control options in the the menu-driven commands for colour balancing and for brightness/contrast control. Adobe PhotoDeluxe 2.0, Kai's Power Soap and Microsoft PictureIt! do not display separate image files of each channel, but only correction using the preset routines for colour balancing and removal of colour casts (see above).

Adobe Photoshop 5.0 displays channels as thumbnails in the Channels palette by selecting Image > Show Channels. Photoshop supports RGB, CMYK and CIELab (L*a*b) colour spaces. It also allows you to store information on manipulation tasks in extra channels called an alpha channels. Alpha channels are very useful for creating masks (see Chapter 14) to protect or isolate areas within an image which can be edited independently. In fact Photoshop can support up to 24 channels in one image file, offering very precise control of editing in each channel.

You can select colour channels for RGB, HSL and CMYK colour spaces in Micrographx Picture Publisher 7.0. Choose Image > Channels > then select the colour space. A cascade of three or four windows appears containing an image of each colour channel. These channels can be edited independently. On completion of editing you can review the result by selecting Image > Channels > Recombine. Alpha channels are also available

Editing colour channels independently is especially important for preparing images for printing as CMYK files. Adobe Photoshop allows you to preview any changes to RGB or HSL files in CMYK mode and can help you identify out-of-gamut colours in your image i.e. those that can be represented in RGB or HSL colour space but that can not exist in the CMYK colour space of your printer.

**Other colour changes**

You can convert colour images to greyscale (see below), invert the pixel values to create a negative of an image, posterise the image by reducing the grey tonal levels to less than 256 levels or by defining a limited colour palette for the image. Posterisation, dithering and colour reduction are used to reduce the file sizes of Web images (see Chapter 19). Some higher-end applications allow you to select colours from within the image and modify just that selected colour, or create a new colour palette based upon specified colour values.

**Sharpening**

Blurring in an image, or lack of crisp definition, can be removed by applying a special filter which allows you to control the brightness values in adjacent pixels. Any area which is perceived as an edge is effectively a boundary between pixels with different brightness, hue and saturation levels. Increasing the difference in brightness gives the impression of a sharper edge.

Low-end software usually offers an option to sharpen or blur the whole or selected parts of an image, but the software automatically controls the setting of brightness levels in adjacent pixels. Mid-range and high-end software allow you to specify the levels and therefore control the effect. For example, Adobe Photoshop 5.0 uses an

Unsharp Mask filter. Select Filter in the main menu > Sharpen > Unsharp Mask. The Unsharp Mask dialogue box offers several options: to specify the increase the contrast (units=per cent); to choose a threshold value for the difference of brightness between two pixels before they are considered to be different and will be treated as edge pixels (units=levels); and to select a radius around edge pixels to control the number of pixels that will be affected by the sharpening (units=number of pixels). A typical specification for preparing a high resolution image for printing would be to increase contrast 200 per cent, set a threshold of 0 (this default value will affect all the pixels in the image) and a radius of 2 pixels.

Choice of threshold level is critical for subject matter in certain types of image If you have large areas of similar tones, such as the skin colour or large blocks of even-toned sky, setting a low threshold value can introduce unwanted tone patches to these areas. This phenomenon is called noise. It can be reduced or minimised by selecting higher threshold levels, between 2 to 20.

### Removing dust and scratches
This process involves the use of a filter which reduces local noise to hide the effects caused by dust and/or scratches. Low-end software enables you to select a menu-driven option to remove dust and scratches from the whole image or part of the image, but the actual process is executed to preset levels. Mid-range to high-end software allows you to specify the size of the difference in levels between adajcent pixels before they are corrected to a specified level. Again it is possible to specify the radius between the edge pixel and adjacent pixels. Hiding the dust and scratches is effectively achieved by locally blurring the image. The degree of blurring being controlled by the radius and threshold settings. If you can't satisfactorily hide the dust and scratches without introducing unacceptable levels of blurring, then it's best to select individual parts of the image where the blemishes are worst and just apply the filter to these parts.

### Other operations to the whole image
There are hundreds of filters which can be applied to affect the whole image (see the separate section below). Aside from basic retouching tools, as described in the previous sections, filters offer an amazing choice of powerful graphic effects which can convert images into new artwork.

### MANIPULATING PART OF AN IMAGE
It is not always necessary or desirable to manipulate the whole image file. This section looks at some of the basic tools used to isolate or work on parts of an image. Many of the techniques in this section are relevant to the process of digital montage or comping, where elements are cutout of one image and re-combined into a new composite image (see below and Chapter 14).

Most applications provide a number of tools which enable you to select specific areas. These tools are available from drop down menus and/or from a toolbox of icons, each icon representing a tool. Which tool you use depends upon what you are trying to achieve. There are a number of tools commonly used for selection.

### Selection tools in a toolbox
Toolboxes facilitate speedy editing and are present in software such as Micrographx

Picture Publisher 7.0 and Adobe Photoshop 5.0. Low-end budget applications tend not to use the toolbox feature, instead selection tools are made available through menus, tabs and/or a toolbar.

**The crop tool is active in the toolbox and a crop area is drawn on the image**

## Hand tracing tools
These tools enable you to draw around the outline of the area you wish to select using your pointer. You select the tool from a menu or a toolbox. The pointer becomes active, changing to a crosshair or other shape, and is positioned where you wish to start tracing your outline. High-end tracing tools provide additional choices to freehand methods. Adobe Photoshop 5.0 offers options to trace straight-edges or to draw smooth-edged paths between selected points on the outline.

Accuracy of tracing is significantly improved by revealing more detail in the image using the zoom tool and by using a graphics pad stylus rather than a mouse, trackball or joystick.

## Cutout marquee
A marquee allows you to select an area within a defined shape (rectangle, square, oval, round, and so on) and drag it to enlarge the marquee or reposition it. A cutout marquee is sometimes used in combination with an edge finder (see below) to automatically select the outline of an object, saving time compared with manually hand tracing around the object.

## Edge finders
Select different areas of contrast or colour by defining the location of the edges of these areas.

## Selecting by colour palette
These tools allow you isolate areas by defining a colour palette. The areas containing the specified colour palette are selected. The magic wand tool and Colour Range command in Adobe Photoshop 4.0 offer control over the selection process using colour.

**Use a tracing tool to select an area**

## Selecting and creating masks
Masks are applied to the parts of the image that you do not wish to change. You select the area you wish to apply the mask by using a tracing or other selection tool. Masks can be inverted or made semi-transparent, depending upon the software.

### Selecting and creating layers

Individual elements in an image can be assigned to separate layers, each layer being a discrete entity which can be edited independently of the other layers. For example you can apply a mask and place this in a layer, then change the colours or sharpness of the masked area. Or you can invert the mask, assign this to a new layer and edit the that area independently. Layers are suitable for any element you wish to add to a digital montage or composite (see Chapter 14).

Layers are usually shown displayed in a special window called a stack. This shows the relationship of the layers to each other. The order of the layers is changed by dragging a layer up or down the stack. If all the layers are opaque then elements represented by layers at the top of the stack conceal parts of layers at the bottom of the stack. Usually the bottom layer is the background element.

### Red-eye removal

Several low-end software packages offer automatic correction facilities for typical problems, such as red-eye, sometimes caused when using flash units integrated with the camera body. Some of the flash light reflects off the back of the retina causing red colouration in the centre of the eye. Software such as Adobe PhotoDeluxe 2.0 and Microsoft PictureIt! automate the process by using a marquee tool to draw a rectangle around the affected eye(s), then selecting a tab or icon which automatically corrects the red colouration. Both applications also allow you to trace around the affected area then apply automatic correction.

### Adding content to discrete areas

A variety of tools allow you to use the pointer to apply corrections and/or colour to discrete areas without needing to select the area before applying the effect. Most of these tools are only available for mid-range or high-end software, but a few are included in low-end software. For example, Adobe PhotoDeluxe 2.0 has a tool for cloning in its Advanced features tab.

### Dodging, burning and sponging tools

Just as you can under- or over-expose a conventional print when enlarging from the negative, you can use dodge or burn tools to lighten or darken a local area. A sponge tool is used to reduce colour saturation.

### Drawing and painting tools

These include a variety of artists tools including pencils, paint brushes and airbrushes for directly applying colour in the style of the individual tools. Some software include options for varying the thickness, shape and pattern of the tool. If you have a stylus and graphic pad the thickness of each tool can be controlled by the pressure applied through the stylus.

These tools are usually selected from a toolbox. Once you've selected the tool you can choose an exact colour to apply from a defined palette or select a colour from within the image. When the tool is active the pointer can be customised to help accurate application. Zooming in also facilitates application.

### Rubber stamp or cloning tools

You can use these tools to duplicate existing objects and/or to remove unwanted

objects. Engage the rubber stamp tool, move the crosshairs of the pointer to the area you wish to sample and click to copy. This sample can then be painted or applied over another part of the image.

## GREYSCALE IMAGES
In the rush to exploit the new technology of digital photography many have overlooked the creative possibilities with the humble greyscale image.

### Capturing greyscale images
A few early point-and-shoot digital cameras (e.g the Pixura Pro, Logitech) could only capture greyscale images. Today almost all digital cameras capture in RGB colour, though some offer the option to capture in greyscale too. Those cameras with colour capture only will restrict the maximum greyscale file size. Greyscale image files are one-third of the size of an RGB colour image captured at the same resolution. If you need to maintain the level of resolution, and hence file size, a better option is to digitise conventional film using flatbed or film scanners which offer the choice of capturing in greyscale or RGB. When digitising film to create greyscale files you can increase the overall capture resolution by a factor of about x3 (x1.75 maximum in any one dimension) without increasing the file size.

### Converting colour images to greyscale
If the original image could not be captured in greyscale you will have to convert an RGB, YCC or other type of colour image file to greyscale. Most software can convert RGB images, but you may need special software to convert other colour file formats.

In a colour image each pixel has a value of brightness between 0 and 255, and a colour whose value is determined by its hue and saturation. Converting the image to greyscale results in the hue and saturation information being discarded. Following conversion each pixel is now represented by one of 254 shades of grey, black or white. The file size therefore decreases by two-thirds.

Not all software can convert RGB images to greyscale. For example, this facility is not available in Microsoft PictureIt!, though greyscale images can be imported into the software for tinting and applying spot colour.

### Tinting greyscale images
There are a number of ways of applying an overall colour tint to a greyscale image. Low-end software tends to offer controls for adjusting colour balance by moving cyan-red, magenta-green and yellow-blue sliders or by specifying numerical values. Other options include the application of set amounts of additional R, G, B, C, M or Y. Special filters can convert the image to sepia tints or apply other aging effects (see below) by setting tints to predetermined values.

More sophisticated control of tinting is found in mid-range to high-end software. Greyscale images can be converted into greyscale-RGB images. The colour in each R, G, B layer can be manipulated independently using curves, levels or other colour adjustment commands, using the HSL model. This gives a high degree of flexibility in the range of overall tints that can be applied. Posterising a black and white image (see filters) and manipulating it using curves can produce some dramatic colour effects and transform an uninteresting image into a strong graphic design.

### Colourising parts of an image
Using a selection tool any part of a black and white image can be colourised independently of the rest of the image. Again, a wider range of results is possible if the original greyscale file can be converted to greyscale-RGB.

Colour can be applied to discrete parts of a greyscale image using drawing and painting tools .

### Applying filters
Filters can be applied to the whole or part of greyscale images in exactly the same way as colour images (see below). You can choose whether you want to use a greyscale file or a greyscale-RGB file depending upon the effect you want to create.

## DUOTONE PRINTING
High-end software enables you to modify greyscale files to create black and white prints on the printed page with a much wider range of tones and subtle overall tints. A black and white print created using black ink is a black monotone. Greyscale images can also be reproduced as monotones using any non-black ink. But most printing presses can only produce about 50 shades of grey per colour, so monotones can lack subtlety and smooth gradations. This problem is overcome by using duotones. Duotones use two non-black inks, one usually dark the other coloured or grey, to extend the range of tones which can be printed. Duotones reveal more depth to highlights, mid-tones and shadows in an image. Tritones using three non-black inks and quadtones using four non-black inks can further extend the gamut or tonal range of the printing device. Tritones are popular for producing sepia effects and CMYK quadtones are effective for producing cool or warm black and white prints with subtle tinting.

To create a duotone image file in Adobe Photoshop 5.0 you convert the greyscale image to duotone mode then specify the ink colours and alter the duotone characteristic curves to suit your creative brief. In practice its not that simple since you need detailed knowledge of the gamut of the output printer, colour palette options, and overprinting methods.

## FILTERS
Fixing a filter to the lens of a conventional camera changes the nature of the photograph. Filters work in a similar way for digital photography. The difference lies in the magnitude of choice of filter types. In conventional photography there are tens of different filters for any one camera system. In digital photography there are hundreds of different types of filters available either as part of a software package or as stand-alone products. Some filters, such as those used to sharpen an image, are included in most image editing packages. New filters can be added to some image editing packages by using plug-ins (see below), some of which are available as shareware or freeware from the Web.

The visual effect of a filter varies according to its method of application at the pixel level and the default levels and thresholds built into the filter. Higher-end software allows the default settings to be modified to produce customised filters, while the settings of filters are fixed in many lower-end software applications.

Filters open up an almost infinite palette of choices from which to apply corrective and creative effects. Filters can be grouped into those which sharpen or blur, add

noise, create distortion, create pixelation, add or render new visual elements, mimic artistic styles, apply textures and apply watermarks or copyright fingerprinting.

Sharpen filters: The contrast between adjacent pixels is increased to give an apparent increase in sharpness. Sharpen filters can be applied to the whole image or to specific parts of the image, such as edges.

Blur filters: Where there are sharp boundaries between groups of pixels of different colour, or between a highlight and a shadow area, blur filters average the value of the pixels to soften the transition boundaries. A filter for removing dust and scratches uses the principle of blurring.

Noise filters: Pixels with randomly distributed colour can be added to an image to produce noise. Noise filters are also useful for blending cutouts or selections into a background by blending and smoothing the edges.

Distort filters: The geometric shape of an image or selection area can be distorted with these filters. Some filters enable morphing, plasticising and/or 3-d effects.

Pixelate filters: Adjacent pixels of similar colours are merged into one group, or larger pixles, which can be represented as squares, halftone dots and other discrete shapes. This is a useful filter for low resolution images which cannot be used to generate photo-realistic quality output.

Render filters: These generate new image elements such as directional lighting effects, customised cloudy skies, and lens flare effects.

Artistic styles filters: This is a diverse group that converts images into artworks. It includes filters that mimic painting styles (such as Impressionist) or techniques (such as palette knife work or colouring with pastels), create solarisation effects, or render an image in a fine-art style (such as bas relief, charcoal drawing and much more).

Texture filters: Enable the incorporation pre-set textures into an image. Some software enables the creation of customised texture filters.

Watermark and fingerprinting filters: These protect images by embedding watermarks and/or digital fingerprinting into the pixel structure.

## PLUG-INS

A plug-in is an application which can be inserted into another software application to extend its functionality. Once a plug-in is installed it usually appears within the interface of the host software in the relevant drop-down menu or tab. In an inspired move, Adobe let other software developers have access to information to enable them to build plug-in software to extend the capability of the Adobe Photoshop application. This has ensured a continuous release of new plug-ins to extend the already awesome image editing power of Photoshop. But it has also spawned lots of Adobe-compatible plug-ins that can be used in other image editing software or as stand-alone products. This is good news for users of low-end image editing software since there are some powerful plug-ins even if you are on a budget. Plug-ins are available as commercial products, shareware and freeware.

There are hundreds of different plug-ins, which broadly cover three categories: manipulation and comping tools; filters for creative effects; and Web images and graphics preparation. Some of the more popular and more interesting plug-ins for for Adobe Photoshop 4.0 are featured below.

## Manipulation and comping tools

Masking aids: Kwick Mask (Collen's Fun Pack), a free plug-in, offers a quicker neater method of selecting areas of colour to remove than Photoshop. Mask Pro (Extensis) is a useful for selecting objects with blurred or fuzzy edges, such as hair or fur.

Proofing colour quality: Test Strip (Vivid Detail) applies colour adjustments in 1 per cent increments to strips in your image, mimicking a darkroom test strip, which can be directly printed to proof the best colour.

General tools: PhotoTools (Extensis) is a comprehensive package allowing you to apply shadows, embossing, glowing edges and other such effects, and has a very flexible PhotoText module for creating some wacky text.

Shadows: Andromeda Shadow (Andromeda) offers very precise control over the creation of directional lighting and drop shadows.

## Filters for creative effects

Aged Film 95 (DigiEffects): Just the job for making today's image look like yesteryear's valuable archive print. Convert an image to sepia or duotone and add scratches, cracks and dust.

Andromeda Three-D (Andromeda): You might only want to use this a few times but its great fun. You can wrap your image around a sphere, cube or other 3-D shape.

Eye Candy (Alien Skin): This is a popular collection of over 20 filters allowing a wide range of effects from drop shadows to glass textures, glowing edges, motion trails and swirl effects.

Furbo Designer (Furbo Productions): Another collection of capable filters that include a good example of glowing edges effect.

Kai's Power Tools (Metacreations): One of the first comprehensive plug-in features for Photoshop, and therefore one of the most widely used, with a marvellous range of filters to modify your images including edge effects, blur, colour saturation, noise, pixel scatter and lots more. It's even possible to create a stereoscopic 3-D picture of an image. KPT are also great for adding smart graphics using the Spheroid and Gradient Designers and the range of textures in Texture Explorer.

Paint Alchemy (Xaos Tools): As the name suggests this application is great if you want to add naturalistic paint effects to your whole image or selections. There's a host of brush sizes and shapes, styles, colours and the opacity of the applied colour can be controlled.

Pen Tools (Wacom): Those using a pressure-sensitive Wacom stylus pad will enjoy this free plug-in which includes features such as 3-D chisel and Super Putty to add effects to an image.

## Web images and graphics

There are a number of plug-ins available to compress or apply index colour to GIF or JPEG images and graphics. Adobe offers its own free plug-in via its Web site (www.adobe.com) to convert images to GIF89a file format. HVS ColorGIF and HVS JPEG (Digital Frontier) and PhotoGIF and ProJPEG (BoxTop Software) enable the specification of defined colour palettes and/or dithering to create good looking GIFs and JPEGs. But if you want to get a better idea of how images will actually look on Mac and PC platforms, then Furbo Webmaster (Furbo Productions) includes a module called Browser Preview which shows the images as they would appear in the popular Web browsers Netscape Navigator and Internet Explorer.

# Image manipulation: digital montage

Throughout the twentieth century the art of photomontage has produced dramatic, provocative and beautiful images (see Chapter 11). The physical process of seamlessly combining photographs once involved long hours in the darkroom and/or lots of delicate cutting and pasting. In less than a decade the software developers have managed to create image manipulation applications capable of highly sophisticated digital montage, also known as comping - a process of combining many images into a composite image.

Parts of an image can be isolated and copied to create cutouts. These cutouts can be incorporated into a digital montage. Each cutout can be resized, rotated, and independently edited using tonal and colour correction, special filters and so on. The edges of cutouts can be blended with the background. Lighting effects can be harmonised between cutouts and the background. In short the limitations imposed by conventional darkroom technology have largely been removed. Digital montage clearly extends the creative boundaries of photography. Nowadays the imagination, rather than technology, is likely to be the most important limiting factor.

Low-end imaging software which facilitates digital montage with the use of layers and tools for cut-outs includes Adobe PhotoDeluxe 2.0, PhotoImpact 3, Picture Publisher 7, Picture It!, Paintshop Pro 4.1.2 and PhotoSuite. Most higher-end software enables sophisticated montage using layers, masks, and a wide range of tools for cut-outs, cloning, painting and drawing accurate lines using a Bezier tool.

## WORKING METHODS

There are many ways to create a digital montage depending upon the software being used and the end effect you are trying to achieve. To minimise errors and save time it is best to plan your montage. The following work sequence is suggested as a framework, but can be modified at any step according to requirements:

### Step 1 Sketch the overall design of your montage

This is the most difficult step since it requires decisions about the conceptual nature of your montage i.e. what are you (visually) trying to achieve? Many of the rules of composition relevant to capturing single images (see Chapter 12) also apply to montage. It is important to have a strong focus within the montage, a dominant element or elements.

### Step 2 Select your background

A good analogy is to consider the background as an theatrical scene to the cutouts (actors) in the foreground. Use the wrong background and the impact and context of the actors is diminished.

### Step 3 Select your cutouts
Refer back to your original concept in Step 1. This will keep you focused on the overall theme of the montage. However, the sketch is a moveable reference point which can be massaged along the way. Certain cutouts which weren't originally included in your sketch may suggest themselves as you proceed with your montage.

### Step 4 Position and resize your cutouts on the background
Image manipulation software which includes facilities for comping allows you to build up a stack of cutouts ontop of the background. Each cutout is represented as an individual layer. Consider the stack as a pile of photographs. The cutout at the top of the pile appears foremost in the foreground while at the bottom of the pile appears behind all the other cutouts, but in front of the background. (Note: this assumes that all your cutouts are opaque. It is possible to render your cutouts translucent, so cutouts can be seen through each other). If you are following the established principle of perspective it is likely that you may wish to resize each cutout as you position it on the background. Foreground cutouts will be of larger dimensions (actual units and pixels) than cutouts in the foreground or background. You may, of course, wish to distort perspective to suit your concept.

### Step 5 Apply contrast/colour corrections to each cutout and the background
If you want consistent colour or tonal settings throughout the montage you may want to select the most important cutouts, or the background, and correct these first. Use these settings to adjust the other cutouts and/or the background. At this juncture you can also experiment with different settings for cutouts and/or the background.

### Step 6 Apply special effects to cutouts and/or the background
For example, if you want consistent lighting, say from the right side of the montage, you can use special filters and tools to introduce highlights and drop shadows.

### Step 7 Apply corrections or special effects to parts of the montage
Mask the areas you do not wish to affect, then apply the the required treatment to the unmasked areas. The converse process can be used if it is easier to select the area for treatment.

### Step 8 Resize the montage
Once all your editing is completed resize the montage image file to suit your output requirements.

### TIPS FOR MONTAGING
As even the simplest of montages may involve tens of different editing steps there are also some general tips which can save time and effort.

**Tip 1** Always keep copies of the original background and cutout image files. You never know when you may want to retrieve them for reworking or creating new montages. Its useful to catalogue backgrounds and cutouts in separate folders from your original images.

**Tip 2** Prior to making alterations to cutouts or backgrounds find out how many

undos are available for your software application. If you only have one level of undo, it is best to make a copy or each element in the montage at every couple of edits before you apply the next series of edits.

**Tip 3** Take notes about each edit you make with each cutout, background or complete montage. While mid-range and high-end software generally allow you to store the sequence of manipulations you applied to individual elements in a montage, low-end software often doesn't have this facilitiy. Without notes you soon get confused as to how you achieved a particular effect. This also becomes a good memory aide for re-creating effects you used in previous montages.

**Tip 4** Save your montage image file frequently. You can configure your computer and software to automatically save the current file at a defined time interval.

**Tip 5** Large image files require lots of computer memory to maintain acceptably fast processing times. Keep the overall file size of your montage to the minimum necessary to fulfil your output requirements. If the image file is getting large you can resize the background and individual cutouts as you insert them. If you can handle the image file without incurring excessive delays in processing then resize the montage when you have completed your editing. High-end software such as Live Picture 2.6 and Macromedia xRes largely overcome this problem by working on low resolution copies of each montage element. When you have finished editing the software recombines the montage into a high resolution image file using information from the low resolution files.

**Tip 6** Keep it simple. Experiment with plain, evenly lit backgrounds before progressing to backgrounds with complex illumination. Concentrate on inserting a few bold montage elements and hone your editing skills before experimenting with multi-element montages.

**Tip 7** Minor adjustments to discrete parts of a montage are often best made using tools controlled by your pointer. This is the equivalent of hand retouching of conventional prints. Higher-end software has a diverse range of tools to facilitate dodging, burning, cloning (rubber stamping), smudging, air brushing and erasing

## BEYOND THE BASICS
### Creating backgrounds
If you are using your own images to create backgrounds for your montage then bear in mind some of the tips on general photography and shooting with digital cameras in Chapter 12. If you are going to regularly experiment with montaging, it may be more convenient to buy royalty free stock shots of backgrounds and cutouts (see Chapter 17) or source material from the Web (see Chapter 19).

### Creating and positioning cutouts
Most of the methods for selecting parts of an image described in Chapter 13 are suitable for creating cutouts. Replace mouse pointer with a graphics pad and stylus (Wacom are the leading manufacturer) if you are going to do regular cutout work. A stylus and pad will save lots of time when tracing the outline of a cutout.

A cutout marquee is useful for dealing with well defined geometric shapes. An edge finder is particularly useful for creating a library of clip art. Photograph objects intended for clip art against a single colour background - try using a contrasting colour or a neutral grey - and, where possible, a continuous lighting source rather than flash. The accuracy with which the edge finder will automatically trace an outline for the cutout depends upon how the software differentiates between pixels in areas of different contrast. Selection of areas according to defined colour palettes, such as provided in Adobe Photoshop 5.0,

**Stong back-grounds set the mood**

provides another method of making cutouts from your photographs of objects against single colour backgrounds.

It is possible to rotate and flip cutouts just in a similar fashion to whole images. Tools are usually selected via a toolbox or from tabs or drop down menus. Sometimes is is possible to control the angle of rotation in degrees and to specify the exact location of the cutout within the montage using x and y co-ordinates.

Cutouts of complex objects and people can take alot of time to make. Royalty free stock shots and clip art offers a simple, cost effective, solution. Prior to purchasing make sure that the resolution of the original images is sufficiently high for the intended output requirements.

### Using layers
To facilitate comping several images into a new image, software can allocate a layer to individual cutouts and the background. The layers are usually held in a window called a stack, the uppermost in the stack being in the foreground and the lowermost being the

**Manikins are ideal subjects for cutouts**

background. The relative position of the layers can be be changed by dragging the selected layer to a position higher or lower in the stack. Adobe PhotoDeluxe 2.0, Adobe Photoshop 5.0 and Microsoft PictureIt! display a palette showing thumbnails of each image in the stack and use drag and drop for altering the relative position of the layers. MicroGraphx Picture Publisher 7.0 defines all cutouts, graphical shapes, and text as objects rather than layers. These objects float on top of a base image (the background) and their relative position is controlled by the object manager window (similar to a stack).

All the information pertaining to individual layers in a montage is usually

maintained in the native file format for each application. When converting to another file format, such as TIFF or JPEG, theses layers are merged into the background and the layer information is lost. For example, in MicroGraphx Picture Publisher files containing objects can be saved using PPF or PP5 file formats. When this file is converted into another format objects are combined with the base image. It is therefore good practice to keep the original montage in the native format and save a copy to another format for exporting to the intended output device.

Cutout of manikin head is pasted in position

Those wishing to experiment with complex montages need to use a software application which can handle multiple layers. Inevitably this requires alot more computer musclepower, so 16Mb to 32Mb of RAM should be regarded as the minimum memory requirement. Adobe Photoshop 5.0 supports up to 100 layers per montage and has a special adjustment layer which enables colour and tonal correction to all the layers underneath. Each layer can be repositioned, duplicated, and independently edited within the montage. The opacity of each layer can be controlled. And there's a vast choice of layer blending modes which enables you to define how pixels in a selected layer and the underlying layers are mixed together. Since complex effects are generated it is always useful to take notes.

### Creating text and graphical objects

Incorporating text and graphical objects into a montage takes digital photography into the realms of graphic design. Most image editing software include a range of text fonts and sizes. Selection of the text tool from the toolbar or toolbox generates a dialogue box where the text is entered. The font, style and size can be specified and a text colour selected from a separate colour palette. Text should be treated as a separate layer. It can be aligned and sized within the montage and modified by applying special effects. Low-end software tend to place the text on a transparent background within the text layer, but with higher-end software hundreds of text styles and display options are possible. Text can be embossed, backed with drop shadows, distorted, subject to a colour gradient and much more. New text fonts have to be imported to the application if the fonts bundled with the software limit choice.

A second manikin cutout is flipped to create a mirror image.

Most paint applications, which combine image editing and graphic design

features, (such as CorelPaint, MicroGraphx Picture Publisher 7.0, JVSC PaintShop Pro 4) offer sophisticated drawing and paint tools for to create customised graphical objects, for use as cutouts in a montage. It is possible to create different shapes and control the texture, opacity and the edge definition.

Much low-end image editing software includes free images and clip art, but the range can be quite limited. This can be overcome by using royalty free clip art or downloading clip art from multimedia libraries on the Web.

### Applying drawing or brush strokes

Taking a leaf out of the many graphic design applications which recreate the effects of hand drawing or painting, most image editing software includes tools to enable you to draw and paint with individual lines, blocks of colour or special effects. The range of tools will vary with each software, but most have a facility to apply brush strokes. Usually the width and shape, colour and texture pattern and edge effects of the brush can be defined. Graphic detail can be added to a montage by painting in with individual brush strokes. Check before applying lots of strokes how many levels of undo apply. Each brush stroke can be undone using some software, other software will only undo all the stokes applied in one editing action by the selected brush.

### Borders, frames and templates

Low-end image editing software usually includes a range of ready-made borders, frames and templates. Select the desired border or frame and drop an image or montage into it. Images or montages can be inserted into standard templates for business cards, greeting cards, invitations, calendars and e-mail postcards. Software wizards are used to guide the user through the process of importing an image into the template. Background colours of the template and text can usually be modified as required.

Higher-end image editing sofware enables customisation and saving of templates using the layers facility. It's possible to produce more complex designs than with the ready-made templates. A significant advantage of making customised templates is the subtle control of the opacity of layers and the use of masks to allow gradient colouring over parts of the template.

CHAPTER 15

# Digital fun

**Original,
coloured,
posterised**

This chapter explores some quick and easy results using just a small selection of creative tools available in today's image manipulation software. Most of the final images were created within minutes rather than hours. It is this speed that facilitates exploration of fresh ideas and allows rapid reworking if the original concept doesn't work out.

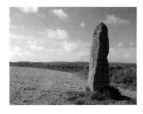

The images in this chapter were created using Adobe PhotoDeluxe 2.0, Adobe Photoshop and Microsoft PictureIt!, but many of the techniques described below can be replicated using common image editing software packages. Each package offers a slightly different range of tools and creative opportunities

### COLOURISING BLACK AND WHITE IMAGES
Converting colour images to black and white then hand painting can transform an ordinary snapshot into a much more atmospheric image.

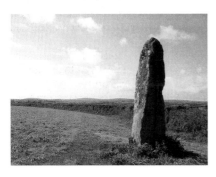

**Step 1** Before converting to black and white correct the colour manually or automatically to set the best colour levels.

**Step 2** Convert to greyscale (black and white).

**Step 3** Select the tools for hand colouring. This selection normally activates a colour picker and brush dialogue box. Select the first colour by clicking on the picker and choose the width and style of brush you wish to use in the dialogue box. Zoom to 100% or higher magnification to facilitate application of the colour with the brush. A pressure sensitive pad and stylus provides much more control than a mouse, but is not absolutely essential. Apply your second colour and so on.

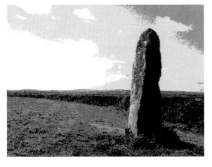

**Step 4** This final manipulation creates a much more graphic style of image. Select a filter to posterise the image and choose Levels 3 in the dialogue box. This filter significantly reduces the colour gamut, simplifying shapes and outlines.

## CREATING ARTWORKS WITH FILTERS

Most image manipulation software includes a dozen or so filters, but there are hundreds of plug-in and stand alone filters to choose from and assist with converting your images into unique works of art .

**Step 1** An original 35mm colour transparency was scanned using an Epson FilmScan 200.

**Step 2** Remove the background behind the ladies in the carnival procession by using the selection tool then apply a colour gradient (lime green through to purple).

**Step 3** Apply the pencil filter specifying the pencil line width and hardness, or.....

**Step 4** Apply the posterise filter instead, specifying the number of levels (in this case Levels+2).

The original image

The image is modified with a gradient fill

A pencil filter is applied to the gradient fill image

A posterise filter is applied to the gradient fill image

## CREATING FUNKY POSTCARDS

Images can be output to a dye-sublimation printer such as the FargoFun directly onto special postcard sized paper. A number of inkjet printers can print to 6 x 4 inch glossy paper suitable for making into postcards. Usually its the simple ideas which work best.

Beware....
mad cows
on the road

### Mad cows

**Step 1** Use a selection tool to draw around the outline of the cow. Save the selection as a separate layer or cutout.

**Step 2** Paste the cutout onto the original image and repeat until the herd of cows walks out of the frame.

### Hairdo

**Step 1** Photograph a manikin's head, or a ceramic figurine (this avoids the problem of model release forms and minimises copyright problems).

**Step 2** Use a selection tool to draw around the outline of the head and discard the background.

**Step 3** Fill the background with a solid colour or an abstract pattern.

**Step 4** Hand colour with a base colour (in this case lime green) to create the hair and clothes.

**Step 5** Highlight hair with a second colour (in this case orange) to provide new detail and complete the image.

Digital
hairdo.
Painting
with colour
can be fun

The
original
greyscale
montage
(left)
A duotone
using a
Pantone
dark brown
and orange
(right)

A tritone
using a
Pantone
dark
brown,
orange and
yellow
(left)
A quadtone
adding a
Pantone
red to
richen the
tones
(right)

## TONE RICH BLACK AND WHITE PRINTS

It is possible to massage atmosphere into rather flat, uninteresing black and white prints by creating prints with enriched colours. This process is achieved by specifying the exact colour of the printing inks or proportions of CMYK inks. This provides a number of creative options for those using desktop inkjet or other CMYK printers. Creating duotones, tritones and quadtones is the digital equivalent of using toners in colouring conventional silver halide photographs.

A quadtone using equal parts of CMYK giving a neutral result (left) A quadtone showing a reduction in C and M giving a cooler result (right)

**Step 1** Use an original black and white photograph or greyscale image, or prepare a montage and convert to greyscale.

**Step 2** Create a duotone by converting the image from greyscale to duotone mode and selecting two ink colours from the colour picker in the duotone dialog box. Adobe Photoshop allows specification of Pantone solid colours which are given a code or number. Two colours, Pantone 4975 CV dark brown and 143 CV orange were chosen for the duotone.

**Step 3** Create a tritone by adding a third colour, again using the dialogue box to specify the exact colour. The illustrated example uses Pantone 129 CV yellow.

**Step 4** Create a quadtone by adding a fourth colour, in this case Pantone 032 CV red.

Alternatively quadtones can be created by taking the original image and specifying the proportion of C, M, Y and K inks. The illustrations above show a CMYK image where C=M=Y=K=100 percent. and another image where the proportion of yellow and magenta has been reduced producing a much cooler image. In this case C=100 per cent, M=60 per cent, Y=60 per cent and K=100 per cent.

The left-hand corner is missing and a number of blemishes disfigure the original print

The rubber stamp tool helps fill in the missing part (left) Contrast is increased and colour improved in the final image (right)

### RESTORING AN OLD FAMILY ALBUM
Cracked, scratched, and defaced prints are the perfect subject for instant restoration using the digital wizardry of image editing software. An old print from the author's family album has a corner missing and is torn and covered with numerous scratches.

**Step 1** Scan the print or you can even use a digital camera to copy it. In the latter case use even, diffuse, daylight rather than direct lighting.

**Step 2** Add new pixels to the area of the image which is missing by using the rubber stamp or cloning tool. First zoom to 200 or 300 per cent. Select the rubber stamp tool from the toolbox then use Alt click to select the point from which you wish to copy pixels, select the size and type of brush (in the brush dialogue box) and move the tool to the required position. Move the rubber stamp over the area you wish to

introduce the cloned pixels. It is better to cover small areas rather than tackle larger ones. Reselect the sampling point and relocate the rubber stamp to continue the process. Use smaller sized brushes when working near edges.

**Step 3** Use the rubber stamp tool to cover other blemishes such as spots, small tears and so on.

**Step 4** If there are scratches all over a print it may be easier to select and apply a dust and scratches filter to the whole image, though this can reduce overall sharpness.

**Step 5** Adjust contrast and brightness. To match to the original scanned image display both the original image and the active image window side by side. It is easier matching this way with the images side by side, in the same colour space, rather than trying to compare the actual print with the active image on the monitor.

**Step 6** Adjust colour balance by matching against the image of the original scan on the screen.

# Copyright protection

Copyright confers certain rights by law to the creator of a photograph, work of art, literature, a piece of music or a design. In the UK copyright is covered by the Copyright Acts of 1911, 1956 and 1988 and by European Union law. Copyright law gives the creator of a photograph or digital image the right to copy, distribute, sell and/or create derivatives of the original. Copyright can be assigned from the creator to a third party.

Commercial photographers and photo libraries earn a living by selling licences to others to use their copyright photograph or image. They licence people to copy the image for editorial, advertising or other purposes. This licence usually applies to a specific use for a specified number of times in a particular print or broadcast medium at an agreed cost. Royalty free photographs or images are copyright, but are supplied for repeat usage for a fixed fee, though restrictions of use do apply. Copyright law is generally well observed in the media and publishing industries where photographs and images are regularly used.

Copyright law is most effective within national boundaries, though international copyright laws are recognised by countries that signed the 1971 Berne Convention. The Internet and the daily usage of digital photography make copyright abuse or piracy difficult or impossible to control as images are sent across national borders.

## COPYRIGHT AND DIGITAL IMAGES

Digital photography has also thrown up issues about who owns the copyright of a modified digital image. Just how far you have to modify an image before it becomes your copyright is being tested under case law in the UK and elsewhere. The general consensus is that if you intend to publish someone else's image that you have altered, it may be best to contact the creator of the original image to seek their approval before publishing. Legal interpretations of how far you have to alter an image before it becomes a totally new image (and therefore your copyright) are bound up in the subjective decision as to whether the part of the image from someone else's copyright was a substantial or significant part in your new image. For a digital montage where many elements are used from different copyright sources the problems become even more intractable. Avoidance is therefore the best policy. Using images from royalty free or copyright free sources is one way of avoiding confrontations over copyright.

The nature of digital data means it is possible to make an exact copy or clone of a digital picture. This characteristic facilitates the copying and sharing of data between different computers, storage media, software applications and documents. But the same characteristic makes it easy for illegal copies to be made and passed off as the original. Computers make it easy to abuse copyright.

This problem is not unique to digital images. Photographers have always supplied original negatives, transparencies and prints to those wishing to use or reproduce

them. Copyright information is usually written onto protective mounts or on the reverse of prints, and copyright is protected by the third party agreeing not to copy the material other than for the purpose for which it has been licenced. Trust and professional etiquette generally maintains a reasonable degree of protection for the owner of the copyright. However, the situation is very different with digital images, whose very nature permits rapid and widespread distribution of many copies of the same image to remote computers over telephony networks or via CD-ROM or other storage devices. A prime example is the daily distribution of digital images from photo news agencies to newspapers, television and other publishers.

The problem of copyright abuse has led to the development of software to embed copyright information within a digital image. With the expansion of the Internet, for image display and distribution, software developers were further encouraged to develop techniques for protecting copyright.

## SOFTWARE FOR COPYRIGHT PROTECTION

Any photographer intending to send their digital images to a third party, or publish them on the Web, would be well advised to consider if they need to protect their copyright by adding extra information to each digital image. This can be done in a number of ways.

1 Images can be encrypted with a code so that they can only be opened or viewed when the user inserts the right code or password.

2 Watermarking involves embedding information within the digital image which may be visible to or hidden from the viewer and can be applied to all or part of the image. Logos, signatures or other symbols can be placed within the image. These are a deterrent rather than a secure solution, since people can remove visible watermarks using image editing software.

**Digimarc's Batch Embedding Tool for copyright protection**

3 Hidden watermarking or digital fingerprinting tends to be more secure. Watermarking is applied to one information channel (usually a colour channel, red, blue or green) or to individual pixels throughout the image. Software developers use their own proprietary techniques to hide the watermarks. Some embed a string of up to 1,000 random numbers, others embed a signature comprising random pixel noise and details provided by the copyright holder. Hidden watermarks are generally quite robust and are not degraded by re-sizing, compressing, cropping, or rescanning.

4 Digimarc (Digimarc Corporation) is integrated into Adobe Photoshop 5.0 and is available as a plug-in to Adobe Photoshop 4.0 and any application that supports Photoshop plug-ins and uses digital fingerprinting to protect images.

Subscription to a service run from Digimarc's Web server allows a licencee of the software to trawl the Web to check for any unauthorised use of his/her copyright images. To date this seems to be one of the more advanced systems for preventing and checking for copyright abuse.

5 Images written to Kodak's Pro PhotoCD and PhotoCD Portfolio II discs can be encrypted to only permit viewing of thumbnail images when the user has the correct code. Encryption is applied to the luminance channel of the YCC colour space image. The low resolution images in the Image Pac, up to BASE resolution, are also protected by a small watermark.

## OTHER FORMS OF PROTECTION

Even if images are not protected by encryption or watermarking, it's possible to minimise the risk of copyright abuse by keeping the file size small and entering information in the file header. As a general rule files less than 500Kb in size can only be reproduced photo-realistically at actual sizes of between 2 x 3 inches by 3 x 4 inches on the printed page or as a digital print. Larger reproduction degrades the image quality. Files less than 250Kb are only really suitable for reproduction or display on a monitor or screen. Files less than 50Kb can only be displayed on a monitor as small screen images or thumbnails.

Many image file formats permit text information to be entered in a sub-file called the file header. This is usually accessed in an image editing application by selecting the File > File info menu. Essential data to include in the file header is the name of the photographer and/or the name of the copyright holder, the international copyright symbol ©, the date the photograph was taken or the image captured.

## OTHER RIGHTS ASSOCIATED WITH DIGITAL IMAGES

In addition to the rights of copyright there are other rights which are associated with a photographic work, including digital images. Under the Copyright Act (1988) in the UK the creator of a photograph or digital image has the right to be identified whenever the work is published in whatever media, irrespective of whether he/she still owns the copyright.

When photographing people for images which will be used for commercial purposes permisson is needed from the people concerned to use that image. This permission is granted only if a model release form is signed by the parties concerned. Standard copies of these forms can be obtained from the Association of Photographers and other professional photographers' organisations.

Whatever rights the photographer or people included in a photograph might have, it is common sense not to use the images in a libellous, obscene or otherwise damaging way. Those who have been offended can take legal action against both the photographer and the publication.

CHAPTER 17

# Picture sources for digital images

A camera, scanner or other capture device isn't essential to enjoy digital photography. Many commercial photo and multimedia libraries have vast archives of digitised images and clip art from which images can be sourced. Another option is also available, for those connected to the Internet, and it's free. Images can be downloaded from the Web. The only proviso with all these options is the observance of copyright restrictions (see Chapter 16).

## PHOTO LIBRARIES

There are hundreds of photo libraries in the UK which earn a living from charging a copyright fee for a licence to publish their photographs. The British Association of Picture Libraries (BAPLA) has over 300 members who hold the copyright to an estimated 800 million historical and contemporary photographs. Contact the library and explain what is required. It will decide whether it wants to licence the image and if it wishes to apply any restrictions on how, when and how often the image may be reproduced. Some photo libraries are a little cautious of enquiries from private individuals, but don't be put off. If the usage is bona fide and their terms are acceptable this provides a unique image from which to start the creative process. Another way is to ask if a photo library sells any royalty free images distributed on CD-ROM (see below).

Photo libraries maintained by public bodies, such as museums, government departments and libraries, also hold copyright photographs. Such sources tend to charge more modest fees for a copyright licence to reproduce their photographs compared to their commercial counterparts. Sometimes a copyright licence is given free of charge, although the photo library may still specify restrictions of use.

### Royalty free stock images and clip art

Commercial photo and multi-media libraries maintain huge databases of images taken by professional photographers. Those libraries that have digitised part of their collections may sell CDs containing royalty free images i.e. there is a once only payment for the original image but no repeat usage fee. Material includes quality stock shots (landscapes, people, places, objects etc) and clip art (textures, objects, logos etc). Images typically vary between 6Mb to 18Mb, so everything from screen images to photographic quality prints can be made from these files. Higher resolution image files, up to 72Mb, are available, but such images require lots of computer processing power. Most CDs contain 100 images or so, with each image normally compressed to about 6Mb.

The royalty free image business has boomed in the 1990s, with thousands of CD-ROM titles available. Naturally the subject material and quality of the scans varies enormously. Images scanned onto PhotoCD tend to be less expensive than those

digitised by high-end drum scanners, but are fine for general digital photography purposes. Leading royalty free stock libraries include:

**Corel Sampler III royalty free images**

Corel Stock Photo: This group offers over 400 titles, each CD selling for about £20, but there is substantial discounting when buying lots of titles. Corel covers most stock themes including landscapes, people, transport, abstracts, lifestyle, travel, business and so on. Subject coverage is worldwide with a North American bias. With such a large range of titles there is something here for everybody.

PhotoDisc: Image quality is generally higher than most royalty free stock libraries as images are drum scanned. There is a choice of over 100 titles covering the usual stock themes, but some interesting special collections are worth considering including art backgrounds, Retro Americana and the Signature Series. PhotoDisc also produce ready-made cutouts against a white background which are ideal for using in digital montages CDs cost between £140 to £225. And you can search the whole database of 27,000 images from one CD-ROM using the Image Finder 98.2 search software which retrieves the thumbnails. Once you've found the image you want you have to contact PhotoDisc to purchase it or buy a CD-ROM.

MetaCreations: The creators of Kai Kruse's stable of image manipulation software products also produce several volumes of images at £100 per CD. Cutouts are facilitated by the inclusion of ready-made clipping paths.

Cadmium Systems are leading UK distributors of royalty free images but most computer warehouse dealers offer a range of CDs. You may want to buy individual royalty free images. The best way to do this is to download images directly from the companies' Web site. Payment may be required before you can download a high resolution image.

Royalty free images are often included in CD-ROMS stuck on consumer magazines. The quality of images varies considerably and restrictions of usage may apply.

**PhotoDisc Image Finder 98.2 CD-ROM with 27,000 thumbnail images**

### DOWNLOADING IMAGES FROM THE WEB

The Web contains an incredible diversity of photographic works covering every conceivable subject, such as: photojournalism; portraiture; historical, nature, travel, and science photography; material from commercial photo libraries; and work from amateur and professional photographers. It is estimated that there are 10,000 to 15,000 Web sites dedicated to photography, catering for every visual taste. A companion book, The Cyberpix Guide, published by Guardian Books in 1997 has over 400 of the best photo sources on the Web.

Web images tend to be quite small, varying between 10Kb to 400Kb (0.4Mb), and are usually stored in GIF or JPEG file format. As such they are only really suitable for screen display, low-end printing, or for use as cutouts in digital

montages/composites. Occasionally it is possible to download JPEG files over 2Mb size, which extends the printing options and potential output size when printing. See Chapter 19 for downloading images from the Web.

**Warning: Use of other people's images**
    Whenever using someone else's images they must not be used for any purpose likely to be deemed libellous or obscene. Whether the photos are copyright or not, or whether usage is paid for or not, every photographer who created an original photo has moral rights protecting them from use of the photo in a way in which they don't approve. The simple rule to follow for those wishing to publish an image which was originally obtained from a copyright source or downloaded from the Web, and then subsequently manipulated or edited to produce a new image (in which the originator may have copyright), is to contact the copyright holder and ask permission. In most cases reasonable requests are unlikely to be refused. It is worth noting that copyright of composite images is a legal minefield.
    Royalty free images are great for removing the risk of inadvertently abusing someone's copyright and significantly reduce costs compared to one-off uses of copyright material. There are no restrictions for those creating digital prints to hang on the living room wall, Most images are licensed for editorial and advertising, but

Sample images from Corel whose range extends to over 400 CD titles

PhotoDisc
Image
Finder
screen
shots
showing
the
Extensis
Portfolio
3.0 search
software

extra payment may be required for the commercial production of posters, greeting cards and so on. Check with the supplier of the images if in doubt.

Copyright and other issues are covered in more detail in Chapter 16.

# Online image distribution

Since the mid 1980s techniques have been developed to distribute digital still images online, rather than using transfer storage media. Rapid distribution of images is essential to the world's news photo agencies and in the printing industry and it is here that the leading edge image distribution technology is found. Images can be transmitted from one computer to another using standard or digital telephone and satellite networks. Aside from speed of transfer online distribution confers many other advantages. Remote users can search and view archived databases of images, examining screen resolution images before requesting downloads of higher resolution images. A news agency can display a daily electronic bulletin board of images to subscribers who, subject to submission of the correct passwords, can download the high resolution image. Commercial printing companies can receive digital files directly from their clients, and return a digital proof directly to the client for approval. The emergence of the Internet has added further impetus to the technology of online image distribution. Images can be sent with e-mail messages, displayed on Web pages or held in databases on servers which can be accessed via the Internet (see Chapter 19).

There are hundreds of different systems for distributing images between computers. Wide area network (WAN) distribution involves a number of image file formats, file transmission protocols (a protocol is a signalling and data packaging language), software applications, and hardware. The most popular options for distribution between two computers is the use of a standard (analogue) telephone line with a modem or a digital telephone line with an ISDN (Integrated Standard Digital Network) card. Distribution within a local area network (LAN) used by a business often uses an ISDN line connected via a router to control how individual computers on the network can communicate outside the LAN.

## ANALOGUE TELEPHONE LINE PLUS MODEM

A modem connects a computer via a serial port to a standard analogue telephone line. Data is transferred by the modem via the serial interface one bit at a time and converted to a continuous analogue signal so it can be carried in a similar fashion to a sound frequency. Before data can be transferred between a computer and a remote computer, the modems at each computer have to establish how they are going to communicate and verify that data has been sent and/or received.

Modems are supplied with software which controls the operational characteristics of the modem. The most important characteristic is the file transfer protocol which determines how parcels of data are sent and the messages used by computers to indicate successful transfer of data. Two open standard protocols are Xmodem and Zmodem. Xmodem sends data in blocks of 128 bytes or 1,024 bytes, checking each time a block of data has been sent. Zmodem chooses the block size according to the

quality of data transmission on the telephone network. It will select a smaller block size if the line quality consistently degrades. This reduces the amount of data that has to be sent again if a block is not received intact. Usually you also have a choice of sending the data in Mac or PC bytes.

Modems typically have maximum data transmission rates of 14.4 kilobits per second to 33.6Kbs, though 56Kbs modems are now emerging for the consumer market. A modem transmitting at 33.6Kbs is capable of sending up to 4,200 bytes (4.2Kb or 0.0042Mb) per second. This equates to 0.25Mb per minute. In reality such data transfer rates are never met, since signals confirming the sending and receipt of blocks of data and poor telephone line conditions reduce the theoretical maximum transfer rate. Even with the fastest modem it can still take up to five minutes to send a 1Mb image file.

The only way of increasing transmission speeds is to compress the information in the original image file. Image file formats that offer high compression ratios, such as JPEG, are therefore a popular choice for modem transmission. A 1Mb JPEG file can be compressed to 200Kb without significant loss of quality resulting in an 80 per cent reduction in modem transmission time.

Most private Internet users receive and transmit data via the Internet using modems connected to analogue telephone networks. Images displayed on Web pages or attached to e-mails are deliberately kept small, between 10Kb to 100Kb, to encourage rapid transmission and display on a user's screen. Image files held in a database on FTP or Web servers, made available for free downloads, are typically 50Kb to 400Kb up to 2.0Mb. Download times via the Internet can be significantly slower than direct modem to modem transmission because the individual blocks of data can travel on completely different routes through the Internet, which is in itself a network of networks. The server at the Internet Service Provider (ISP), which connects private users to the Internet, may also wait to receive all the blocks of data before transmitting the entire file to your computer. Typical data transfer rates are therefore often in the order of 1Kbs to 3Kbs even for a 28.8Kbs or 33.6Kbs modem.

When the file size exceeds three or four megabytes it is generally not practical to send files using modem to modem transmission without incurring hefty telephone bills. A better option is to use ISDN.

## DIGITAL TELEPHONE LINE PLUS ISDN CARD

Telephone companies have been progressively updating their networks to better cope with data. Special telephone lines, designed to carry digital rather than analogue data, are linked to digital telephone exchanges. Integrated Standard Digital Network (ISDN) is an international standard for telephone lines which carry data at transmission speeds up to 64Kbs (56 Kbs in the USA). ISDN-2 lines have higher transmission speeds, up to 128Kbs which equates to 0.96Mb per minute or up to four times faster than a 33.6 Kbs modem.

Those wanting to use ISDN cards must check with their local telephone company that there is a digital exchange to which the ISDN line can be connected. Currently an ISDN-2 line costs between £100 to £200 to install plus quarterly rental plus phone bills, so the costs are only justified with a lot of image transmission traffic. The good news is that costs are falling so ISDN connection for direct computer to computer transmission and connection to the Internet is becoming cheaper.

Before connecting a computer to an ISDN line, software and an ISDN PC card

must be installed in the computer. The card functions in a similar way to a modem, enabling the computer to read and send digital data. The software controls the communications protocols between the home computer and the remote computer, and contains facilities for maintaining an address book, a log of transactions and a security-based administrative system.

In the UK there are two proprietary software systems that are popular, 4-Sight International's ISDN Manager and Hermstedt's Grand Central software. 4-Sight, founded in 1991, has the lion's share of the UK market because the ability of its software to function with a wide range of PC cards. 4-Sight ISDN Manager 4.0 can be used with NuBus or PCI cards on Apple Mac's MacOS, PCI cards on IBM-PC compatibles using Windows 95, and is compatible with most other PC cards in Europe and the USA.

Development of proprietary systems in different countries has created problems for transmitting images by ISDN. Most ISDN users in Germany and central Europe use Hermstedt's Grand Central or Grand Central Pro software. France is dominated by SAT/Sagem's EasyTransfer software using Planet2 PCI cards. Although all ISDN software can use some similar PC cards, until late 1997 the software used different protocols and therefore could not communicate with each other. Effectively this meant that 4-Sight ISDN Manager users in the UK couldn't send files by ISDN to European users unless they equipped themselves with the same software. In 1998 Hermstedt launched the Grand Central Pro software which was compatible with 4-Sight's ISDN Manager 4.0. 4-Sight is following suit by upgrading its latest versions of ISDN Manager to be compatible with Hermstedt and SAT/Sagem software. Any prospective user of ISDN would be advised to check the inter-operatiblity between the different software and card systems, and whether file transfer between Macs and PCs is possible. Costs to install software and a card(s) vary between £600 to £1,500.

## IMAGE MANAGEMENT AND DISTRIBUTION SYSTEMS

Photographers wishing to set up their own online image distribution system can do so for a modest investment. An individual can set up their own online image library or businesses can use an online facility to distribute images to remote users. Users can connect to these systems using modem or ISDN, though the latter is a more sensible option if image files larger than screen resolution are going to be regularly downloaded by the remote user. The following image cataloguing software can all be scaled up from amateur to professsional systems: Image AXS Classic (Digital Arts & Sciences), K5 Photo (Keybase), Photo Album (Image Resource) and Cumulus Desktop (Canto). Most systems enable customisation of access and security, including passwords and unique user identities.

In the 1990s publishers of newspapers and magazines have increasingly viewed their digital image databases as a valuable resource whose management can improve workflow and productivity, and generate new revenue. Publishers tend to use sophisticated high-end image management systems which facilitate internal and external online distribution of multimedia, including images. Popular systems include Fastfoto (Picdar), Mediasphere (Cascade) and Phrasea (Comtec).

CHAPTER 19

# The World Wide Web

The World Wide Web is the Internet service which has caused so much excitement during the last few years. This is where multimedia content (images, audio, video and text) can be viewed and downloaded. At the click of a mouse the World Wide Web, aka the Web, or WWW, reveals between 10,000 to 15,000 sites specifically related to photography. The Web hosts an amazing virtual exhibition of conventional and digital photography, an encyclopedia of technical knowledge and a superb contact point for manufacturers, dealers and retailers. It is a source of inspiration, and a resource from which free software, reviews of the latest technology and technical advice can be downloaded.

As digital photography continues to merge with the computer and multimedia industries, the Web has become an important vehicle for the distribution of images and information. The Web is one of the best places to keep abreast of the fast changing digital world.

## GET CONNECTED

All that's required to connect to the Web is a standard analogue telephone line, a modem, an Internet Service Provider (ISP) and Web browser software, and a personal computer which meets the minimum system requirements defined in Chapter 3.

### Modems

Modems convert analogue signals from a telephone line into digital data and visa versa. Modems and computers communicate with each other using protocols which arrange how to send and receive data (see Chapter 18). Popular modem models include those manufactured by Hayes, Motorola, and US Robotics. Data transfer speeds are improving all the time but typcially models are capable of transmitting at 28.0Kbit/s (Kbs), 33.6Kbs or 56Kbs and are available as internal or external versions.

### Internet Service Providers

A subscription with an Internet Service Provider (ISP) or Online Content Provider (OCPs) is required to connect to the Internet. These companies provide a wide range of services for their customers ranging from online information to Internet access, e-mail services, and provision of storage space for personal and company Web sites. Big players in the OCP league include America OnLine (AOL), Microsoft Network (MSN) and CompuServe.

ISPs and OCPs are connected to the Internet via high speed, highvolume digital telephone links. Once a connection is made with an ISP/OCP it is possible to access the Internet. The ISPs/OCPs store data on powerful computers called servers and, as users access the Web, data which is downloaded is stored in temporary caches.

There are hundreds of ISPs in the UK and many consumer magazines produce

regular listings, ranking them in terms of service and reliability (see Appendix IV). Some of the ISPs who set up in 1994/95, including Demon Internet, Pipex Dial, and Rednet feature high in the rankings alongside relative newcomers, such as BT Internet. Average subscription charges are £8 to £15 per month.

## Web browsers

ISPs or OCPs provide software package on CD-ROM. The package normally comprises a software suite of popular applications and a utility to enable dial-up access to the ISP/OCP from a computer. Depending upon the software in the package it's possible to access a variety of Internet services, the most popular being e-mail, the Web, Usenet, Telnet and File Transfer Protocol (FTP). A Web browser is needed to access the Web. Netscape Navigator 4.0, Netscape Communicator 4.01 and Microsoft Internet Explorer 4.0 are the most popular Web browsers and one of these is usually included in the ISP's or OCP's software package. All these browsers support GIF and JPEG image file formats. PNG, FlashPIX and other image file formats can be supported by using Web browser plug-ins.

The photography Web page on the popular Internet directory Yahoo

## SEARCHING THE WEB

Each page within a Web site has a unique reference called a Uniform Resource Locator (URL) which comprises a string of characters defining the protocol, the domain, the document or user identity, the individual folder or file, and the page language. For example, the URL for the home page of the popular Web search engine, Yahoo, is:

http://www.yahoo.com

where http is the protocol, domain is a three part string comprising the top domain com, followed by the company yahoo, and the host computer is called www. This address can be extended to access a particular folder and individual documents, to read as follows:

http://www.yahoo.com/Arts/Photography/

Arts is the folder and Photography is the relevant file. Sometimes the file can be followed by a sub-file reference and the string html or htm which refers to the Hypertext MarkUp Language (HTML) used to describe Web pages.

Usually the prefix http:// is omitted from a Web address since it is taken as read. Occasionally other prefixes will be used, such as ftp://. These are specified below where relevant.

## Web search engines and hypertext links

It is estimated that the Web comprises tens of millions of individual Web pages. Finding information in this vast virtual library is facilitated by search engines and hypertext links. Enter a simple text query in a search engine and it will retrieve a list of Web pages relevant to a query. Each Web page is identified with a line of text which is underlined. This is a hypertext link. Clicking on this link takes the Web browser to a new page. Within this new page there will be other hypertext links can be followed, ad infinitum. Hence a web of links, the World Wide Web.

Yahoo Arts & Photography (www.yahoo.com/Arts/Photography) is one of the best photography search engines on the Web, with over 80 subject categories and nearly 3,000 sites listed for photography. UK Plus (www.UKplus.co.uk) and Yell (www.yell.co.uk) are two respectable directories for the UK which have a growing number of entries for photography.

It is possible to search the Web for images using Yahoo Image Surfer (www.yahoo.com/isurf.html) and Lycos Pictures & Sounds (www.lycos.com/lycosmedia.html). It can be a little hit and miss since the search engine examines the HTML image tag to see if its relevant to the search query.

## WEB RESOURCES
### Web 'Jumping Off' points

In the true pioneering spirit of the Internet philanthropic individuals spend hours compiling lists of sites just so others can save time and telephone costs. These sites are known as jumping off points. Photo Exhibitions & Archives (www.algonet.se/~bengtha/photo/exhibits.html) is Bengt Hallinger's personal list of over 700 photography sites in 19 categories.

### Freeware and shareware

This is where everyone's eyes light up. The quality of the freeware and shareware does vary and its not always guaranteed to be virus free, but its a no cost or low cost option that is a godsend to the budget conscious. There are lots of specialist sites that just offer shareware and freeware, such as Jumbo (www.jumbo.com) and Rocketdownload (www.rocketdownload.com), but its also available directly from the software developers. A few interesting examples follow:

1 Pixfolio Image Catalog System 2.0 shareware provides a simple tool for managing images (www.rocketdownload.com/details/grap/pixfol).
2 Aladdin's Stuffit Expander is a utility to decompress image files archived as Stuffit (.sit) files on FTP or Web servers (www.aladdinsys.com/expander/expander1.html).
3 WinZip is a utility for PC users with Windows 3.1 or Windows 95 to decompress image files archived as ZIP (.zip) files on FTP or Web servers (www.winzip.com).
4 PaintShop Pro 4.12 is a popular shareware image editing and paint application for Windows 95/NT 4.0 and is available from JASC (www.jasc.com/pspdl.html)
5 Adobe's free plug-in for converting images to GIFs and JPEGs for Web sites (www.adobe.com).
6 Kwik Mask is a free plug-in to speed up mask selection is available from Colleen's Fun Pack (pw1.netcom.com/~kawahara/photoshop.html)
7 Pen Tools from Wacom, manufacturers of the graphics stylus pad, is a free plug-

The George Eastman House Museum has brilliant 19th and 20th century works

in to create chiselling and other strange pen effects (www.wacom.com/pentools). 8 Image AXS CE is a free cut-down version of the Image AXS image management software (www.dascorp.com/products/iaxs/)

**Image manipulation and image cataloguing software**

1 Adobe Photoshop, publishers of the world's most popular image editing application, Adobe Photoshop (www.adobe.com).

2 Image Alchemy is a good site for Photoshop tips and links to Photoshop plug-ins (http://imalchemy.com/).

3 Microsoft's Picture It! is a low-end image editing application with lots of easy to use templates, borders and funky text fonts (www.microsoft.com/pictureit/).

4 Corel Corporation offer Photo Paint 7 image editing and graphics application plus royalty free photo source (www.corel.com/).

5 Image Resource reveal their consumer edition, Photo Album and professional edition, Digital Catalogue, image cataloguing and management software (www.imageres.com/).

6 Extensis' Portfolio multimedia cataloguing software is suitable for images, video files and sounds (www.extensis.com/products/Portfolio/).

7 Digimarc Corporation's Personal Lite software for digital copyright protection of images using watermarking and fingerprinting techniques (www.digimarc.com).

8 PhotoEnhancer Plus 3.2 image editing software plus free download of FlashPix Viewer to view FlashPix images is available from PictureWorks Technology (www.pixworks.com/).

**Photographic inspiration**
The Internet directory Yahoo and selected jumping off sites will point Web surfers to virtual exhibitions of digital and conventional photography. There are thousands of sites to accomodate a diverse audience. A few gems include:

1 The International Museum of Photography at George Eastman House was created by the founder of Kodak. This web site contains some remarkable archival and contemporary photography from around the world (www.eastman.org).

Silicon Graphics Image Gallery

Our image gallery features high-quality graphics and 3D images created on Silicon Graphics

Image Galleries:
General Images

**2** Silicon Graphics Image Gallery displays stunning images created on powerful Silicon Graphics workstations (www.sgi.com/Fun/free/gallery.html).

**3** Photo '98 is a 12 month virtual exhibition of UK digital photography celebrating 1998 as the Year of Photography and the Electronic Image, sponsored by the Arts Council (www.photo98.com/about/default.htm).

**4** ZoneZero is an inspired e-zine covering all aspects of conventional and digital photography which showcases exhibitions and works from professionalsin the Americas and rest of the world. Its pages are full of stimulating debate.

*Photo '98 celebrates UK and inter-national photo-graphy in a year long event*

### Royalty or copyright free images

**1** PhotoDisc is the world's largest photo library of royalty free images (www.www.photodisc.com/).

**2** The FTP server at the Swedish University Network has a good selection of JPEG images (http://ftp.sunet.se/pub/pictures/).

**3** The US Library of Congress, Prints and Photographs Division has an interesting and wide ranging selection of copyright free pictures of American life (http://lcweb.loc.gov/rr/print ).

**4** Another useful database of free GIF and JPEG images, the Wuarchive Index of Images, is stored at Washington University's server at St Louis, USA. (http://wuarchive.wustl.edu/multimedia/images/).

### Manufacturers

Web sites of some of the leading manufacturers (see Appendix I for telephone contacts) include:

Agfa - www.agfahome
Apple Computers - www.apple.com
Canon - www.canon.com
Casio - www.casio.com
Epson - www.epson.com
Fuji - http://home.fujifilm.com
Kodak - www.kodak.com
Nikon - www.klt.co.jp/Nikon
Olympus - www.olympusamerica.com/digital/dhome.html
Polaroid - www.polaroid.com/digiworld/index.html
Ricoh - www.ricoh.com
Sanyo - www.sanyo.co.uk
Sony - www.sony.com

*ZoneZero - a photo e-zine creating debate*

## VIEWING AND SAVING IMAGES FROM WEB PAGES

There are a number of ways of viewing and saving images from Web pages. Gifs and Jpegs are supported by Netscape and Internet Explorer and, providing the display images option has not been turned off, will automatically display in the browser window. Other image file formats can be viewed and downloaded using Web browser plug-ins.

Before double clicking a thumbnail to view a larger image, it pays to check the file size. If its over 100Kb and the download speed at that site has been slow, bookmark the site and go back later. Click on the image, holding the mouse down and a drop down menu appears. Select Save this image as..., and specify the folder on the hard disk where the image will be saved. A dialogue box with a graphical bar shows the image downloading.

Those who don't have an image editing application to read Gifs and Jpegs can make a screen grab of the image in the Web browser, having maximised the browser window. Maximise the viewing area in the Web browser by selecting Options and by turning off some of the default toolbars. The screen grab can be viewed in PICT format on the Mac OS and in BMP format in Windows.

## PREPARING WEB IMAGES

Small files are quite acceptable for displaying images on the Web. Typically, Web images are between 10Kb to 400Kb. These files are between one to two orders of magnitude smaller than files sizes needed to generate photo-realistic digital prints.

In theory the maximum file size required for a full screen image on an SVGA monitor (800 x 600 pixels) displaying 24-bit colour (16.7 million colours) is 1.44Mb. Similarly the maximum file size for a VGA monitor (640 x 480 pixels) displaying 24-bit colour is 0.92Mb. However, these images are far to large for rapid download by today's modems. The solution is to compress the image or reduced the colour palette displayed. If the aforementioned files were reproduced in 8-bit colour (256 colours) they would be much smaller, 430Kb for SVGA and 280Kb for VGA monitors. Even these files are considered large for Web pages. Many Web page designers believe that the file size of an entire Web page should be between 30Kb to 100Kb, because of the current limitations in transmission speeds of modems and telephone networks. Often the designer will embed small thumbnails of between 5Kb to 50Kb size within the Web page. If the user wishes to view a larger image, the usual practice is to click a thumbnail image to reveal a larger screen resolution image, between 50Kb to 500Kb. In this case the thumbnail is an image map, with an embedded hypertext link, which links to the larger image on another Web page.

Preparing images for Web pages is always a compromise between maximising the display image size and minimising the download speed and rate of display on the monitor. Two image file formats, GIF and JPEG, have emerged as a popular solution for Web images. Both these file formats are supported by the two most popular Web browsers, Netscape Navigator 4.0 and Microsoft Internet Explorer 4.0.

Different image manipulation/editing software will suggest a different sequence of steps to convert images, but some general guidelines apply. Whatever the intended file format  always prepare Web page images from the largest original image file, preferably a 24-bit RGB colour file. Resize the image to the required dimensions (in pixels) and specify the output resolution. Many images are displayed within Web pages at one-eighth to one-quarter page size which equates to 75 x 100 pixels or 150

x 200 pixels for an SVGA monitor, at a resolution of 72 dpi. Once an image is the correct size, reduce the colour bit-depth and save in the desired file format. Many applications and/or Web browsers will display a preview of the prepared Web image to allow the quality to be checked.

Indexed colour image files, using a palette of Web safe colours (colours that most monitors will consistently reproduce as intended) are another option. This is the best method for ensuring colour fidelity for graphics, such as logos, or images where exact reproduction is critical

### Using GIFs

There are several types of GIF, but all of them support 8-bit colour (256 colours) and use lossless compression, so they open quickly on a display screen or monitor. This limited colour palette makes GIFs suitable for line drawings and graphics with strong shapes and a few colours, but makes it difficult to reproduce certain photographic subjects. Images with graphic content, such as single objects with a plain background, are fine, but landscapes with subtle tones, or images with a lot of detail, are not always suitable for presentation as GIFs.

GIF27a and GIF29a are the original formats developed by the online information service, CompuServe. Both types are can be interlaced so the image is initially displayed in low resolution and gradually sharpens to the full resolution. Interlacing is usually specified in most image editing/graphics applications in the Save As dialogue box. A newer type, GIF89a, is often used to create logos and animations using its ability to specify a selected colour as a transparent layer. The RGB value of the colour can normally be set to specific values using a colour circle and/or numeric settings.

### Using JPEGs (JPGs)

The JPEG file format offers 24-bit or 8-bit colour, lossy compression and interlacing, but does not support transparent colours like the GIF89a. High compression ratios, up to 100:1, can be achieved but as information is discarded quality can suffer, giving poor results in high contrast areas and sharp edges. Consequently JPEGs are generally better at reproducing the smooth colour tone gradation of images than the sharp, solid shapes of graphic designs. Interlaced JPEGs, known as Progressive JPEGs, display faster than the same size GIFs.

### Other formats

PNG offers 24-bit or 8-bit colour, loss-less compression and interlacing (progressive display), and can also include information on brightness. PNG is a suitable alternative to GIF, giving a cross plaftorm file format which can be supported by common Web browsers and an increasing number of image editing applications.

FlashPix, Kodak's proprietary image file format, is not widely used at present but has several interesting features which could make it more popular. The FlashPix file is a hiearchy of files of different resolutions. The smallest file is suitable for inclusion in Web pages. It can be used as an image map to link the user to the higher resolution files which can be viewed using the special FlashPix Viewer software.

**Image editing software for Web images**

Most mid-range and high-end image manipulation software packages now include facilities to prepare images for Web pages. PhotoImpact 4.0 and Picture Publisher 7.0 are particulary useful low-end applications.

There are some useful Photoshop plug-ins for preparing Web images. PhotoGIF and ProJPEG (Box Top Software) are capable options. And productivity tools, such as DeBabelizer 1.6.5 (Equilibrium) or Graphics Converter 97 (IMSI), enable batch conversion of archived images to create Web images.

**Web authoring**

There are many Web authoring applications which assist in the design of pages and to import images that don't require any knowledge of HTML code. Entry level software products offer ease of use, an image editor, an image mapper and some site management or diagnostic features. Three leading products are FrontPage 98 (Microsoft), PageMill 2.0 (Adobe), and HotMetal Pro 4.0 (SoftQuad).

Those who don't feel ready to tackle Web design can consider MiniCat 2.1 (ProStar) which facilitates setting up image and text catalogues for downloading to floppy disks or a Web page.

CHAPTER 20

# The future

The impact of the Internet on digital photography has been significant and it is likely that it will become an even more important vehicle for image display and distribution. The digital still image is already an integral part of multi-media content delivered by conventional media (print, broadcast) and the new media (the Internet, CD-ROM). Digital and Web TV is set to straddle the divide between conventional and new media, so as we enter the new millenium the way we use digital photography for pleasure and business could radically change.

## DIGITAL CAMERAS

Size does matter in the battle for the new digital markets. Manufacturers of basic consumer cameras are attracted to the small is beautiful route. Without the need to have a bulky film chamber, it has been possible to design pocket-sized digital cameras. Sony's ultra-compact DSC-F1, launched in 1997, had the technophiles drooling at the mouth, and confirmed that tiny is sexy.

But small bodies need big CCD chips to attract more demanding digital photographers. Kodak dominates the market with its DCS range of digital still cameras packing 6 million pixels (the EOS DCS1 and DCS460), but these gadgets are strictly for professionals who can afford the £15,000 plus price tag. So its no suprise that Kodak recently introduced a 2 million pixel camera, the Kodak/Nikon DCS 320 Pronea 6i at the more modest price of a few thousand pounds.

IMAGEK - digital film for SLR cameras. Too good to be true?

The manufacturers have confirmed there is a burgeoning market for the mid-range megapixel digital cameras. This year has seen the release of several new models including Fujifilm's MX-700, Ricoh's RDC-4300, Kodak's DC220, Konica's Q-M100, Nikon Coolpix 900 and Olympus' Camedia C-840L, capable of producing photo-realistic prints up to 7 x 5 inch or larger in 24-bit colour.

With an eye on both ends of the market the Dutch multi-national Philips has developed the world's largest CCD at 86 x 110mm with 66m pixels, each measuring 12 x 12 micrometres. Simultaneously it released the world's smallest pixel at 2.4 x 2.4 micrometres, a boon to those developing minature and spy cameras.

Hundreds of millions who own a conventional SLR camera will welcome the news that several manufacturers are

trying to develop digital camera backs fitted with a CCD chip which can replace the existing film backs. This most logical of developments must reconcile the small size of existing CCDs with the size of a 35mm film frame, and the consequent problems of doubling (or more) the focal length of interchangeable lenses used by SLRs. Kodak has cracked this for professional cameras with the launch of the DCS520 whose two megapixel chip is the same size as a 35mm frame. If the cost of CCDs is significantly reduced by bulk manufacturing this technology should trickle down to the consumer market. A company called Imagek in the USA (www.imagek.com) is convinced it has developed a solution called EFS-1 (the Electronic Film System) which uses a 1.3 million pixel CCD which slots into the film plane of a conventional SLR. However, to date this system has not yet been introduced commercially and remains to be tried and tested. Ensuring compatibility with existing SLR cameras could present further problems.

Digital camcorders offer another viable means of capturing digital still images at the same time as making the family video, or the low-budget film which sweeps the awards at Cannes. Existing models feature between x10 to x20 optical zoom with a x24 to x100 digital zoom range, but their capture resolutions are limited by the 500 lines of the Digital Video signal standard and the small CCD chips, which vary between 180,000 to 420,000 pixels. It will be interesting to see whether manufacturers target the more discerning digital photographers who demand higher quality, by introducing larger CCDs and offering the option to switch between video and still capture.

Perhaps the more radical developments will emerge from the software developers rather than the hardware manufacturers. In late 1997 a Californian company called FlashPoint released Digita, a cross-platform, hardware-independent operating system for imaging devices. Kodak, Minolta and Sharp are already on board, having signed licencing agreements with FlashPoint. Digita has the potential to make the computer redundant. Using Apple Computer's QuickTime Image Capture (IC) Technology, it is possible to edit, distribute and print images directly from Digita. The operating system comprises the Digita OS to control the camera's functions and an integrated Digita Desktop application tailored to the Macintosh and Windows environments. FlashPoint is hoping that Digita will be able to forge a world standard for camera operating systems.

## SCANNERS

Affordable desktop film scanners already offer high capture resolutions in excess of 2,820dpi, which is more than enough for most amateur digital photographers, so it's difficult to see how manufacturers can significantly improve this technology. In future competition should ensure that even budget models have 36-bit, rather than 24-bit, colour depth capture.

In the competitive marketplace for flatbed scanners it is reasonable to expect more innovation. In the not too distant future 36-bit, 1200 x 600 dpi capture will become standard for an average desktop scanner. Interpolation software, already capable of increasing file sizes one hundred fold, may improve and simultaneously reduce the effects of artefacts which can be a problem when high ratio interpolation is applied.

Some manufacturers have looked at the efficacy of having one machine to scan, print and copy. An example of a three-in-one machine includes Hewlett Packard's Office Jet Pro 1150C which is capable of scanning in 24-bit colour at 1,200 dpi, rapid

colour copying and printing at 3 ppm colour and 8ppm black and white. This route may be taken by other manufacturers offering a desktop solution for low-volume printing and copying of photographs and other artwork. The main problem will be not to compromise scanning, copyring and printing quality if these devices are to compete with single-purpose machines.

Capture resolutions continue to increase for desktop flatbed scanners. This year saw the launch of the Umax PowerLook 3000 scanner with a true optical resolution of 3048 x 3048dpi, and a dynamic range of 3.6D, for £8,000. True, not many amateurs will want to scan original photographs to create digital image files of hundreds of megabytes in order to print a 48-sheet poster for an advertising hoarding, but this technology will eventually trickle down to the budget flatbed scanners. Expect significant improvements in the ability of budget scanners to record a larger range of contrast.

## PRINTERS

Printing directly from digital cameras or transfer media is set to become more popular. Fujifilm was the first to introduce a thermal-autochrome printer, the NX-5D, capable of reading images from SmartMedia cards and producing A6 size prints. Printers targeted at the instant print consumer market currently include basic features to optimise colour saturation and skin tones, but can be expected to include many more editing features in the future as the in-built software and hardware capability is expanded.

Variable dot-size inkjet technology has been the recent buzz. This technology is a significant improvement because it permits even closer mimicking of true halftone printing for magazines and newspapers than is currently achieved using today's desktop inkjets.

Hexachrome printing, using six colours, rather than the traditional four of the CMYK process, offers an increased gamut and hence greater subtlety of tone. Hexachrome's colours are a modified cyan, magenta and yellow, black and a special green and orange. This effectively permits printing of up to 90 per cent of the Pantone solid colour range compared to about 50 per cent for standard CMYK. Currently the hexachrome printing process is the preserve of commercial printing companies and output bureaux, but a bold manufacturer may introduce hexachrome to the desktop and in doing so offer more realistic colour reproduction.

Within a few years it is likely that an increased volume of manufacturing of photo-realistic quality desktop variable dot inkjets, thermo-autochrome and laser (RGB) photographic printers will make them as cheap as today's budget inkjets.

The choice of papers for printers has grown significantly in the last eighteen months. Various claims are made by the manufacturers as to the archival quality of their papers. Ultra violet stability is the big problem at the moment. Not only will the memories fade but the digital prints will too. Protective coatings and the use of light-stable dyes or silver halide based pigments requires further research.

Of course there are other printing options. Why bother to have a printer at home when images can be sent via the Internet to a local photo lab and sent back via snail mail as glossy prints? Networking via the Internet or the Web for consumer digital printing is likely to grow as more households get wired. Since March 1998 Kodak has been trialling the Kodak Print Network in the USA linking consumers with retailers and photo-finishers. Film is dropped in at the local photo lab which develops

it and returns the image files via the Internet. Images can be manipulated and sent back to the photo-finisher for output. Kodak's original slogan from the 1940s "You click and we'll do the rest" takes on a new lease of life.

## IMAGE EDITING SOFTWARE

The launch of Adobe Photoshop 5.0 in mid-1998 maintains Photoshop's position as undisputed king of workaday professional image editing. But Photoshop's crown is being eyed-up by potential usurpers. Photoshop works with bitmap-based image files, so each pixel affected by a manipulation has to be redrawn when the image is saved. Applications which work with vector-based image files, whose contents are mathematically described offering resolution independent files, are much faster at applying modifications to an image. Applications such as Live Picture, Sartori and xRes, which use proxy models to speed up editing prior to rendering the completed image, are likely to be made available in cut-down, consumer edition, software packages. This will be a boon to amateur digital photographers working with limited memory resources.

Low cost image editing applications abound and each package has its merits, but none manages to produce the comprehensive user-friendliness of Metacreations' Kai's Power Soap. The big question is whether other software developers will take a screen grab or two out of the Metacreations' package and upgrade their GUIs to make them more intuitive. A few lessons can also be learnt from the comprehensive range of plug-ins that has emerged for Photoshop over the years. Some plug-ins have simply transferred the visual language of conventional photography to the digital environment. Vivid Details' Test Strip is an admirable example this approach and provides a good way of colour proofing desktop digital prints.

As more homes plug into the Internet, it can be expected that image editing software in the future will have facilities for editing images in Web safe colours and exporting them as e-mails and for posting to Web sites.

Image compression using fractal image transform technology may also find a wider usage. Fractal Image Files (FIFs) contain image data as mathematical descriptions rather than pixels, so the viewer can zoom into an image without experiencing a loss of quality. Already FIFs are being used on the Internet using Iterated Systems' Fractal Viewer. Kodak's FlashPix file format, supported by the Digital Imaging Group (DIG) formed in 1997, a consortium of 30 or so of the world's electronics and IT companies, also supports zooming using the file's hierachical image pac structure. Live Picture, the software developers which provided much of the background work for FlashPix, is incorporating the file format in its software in the belief that it will form the backbone of future online multimedia systems.

## IMAGE STORAGE

Just as the floppy disk suddenly had its storage capacity doubled overnight, from 0.7Mb to 1.44Mb by the arrival of the double density disk, so other storage media are already following the same trend. Toshiba were the first to ship double density SmartMedia cards with 16Mb capacity, in the first quarter of 1998, but other companies are bound to follow, and the capacity of PCMCIA and CompactFlash cards is sure to increase. But these PC cards are expensive relative to their storage capacity and cheaper solutions such as Iomega's new 40Mb Clik disks could provide a serious challenge.

PC card storage pales into insignificance when compared to the mother of all transfer media the Digital Video-ROM (DVD-ROM) capable of storing 14 gigabytes on one disk! This is over twenty times the capacity of CD-ROM, CD-R and CD-RW media. But DVD-ROM will take time to penetrate the marketplace since most CD-ROM drives are unable to read these discs. A few MultiRead specification CD-ROM drives are emerging from manufacturers such as Philips and Ricoh and these are capable of reading all CD and DVD-ROM discs.

**MULTI-MEDIA**

DVD-ROM will enable publishers to include whole image databases to accompany text and audio content. Theoretically every entry of a dictionary or encyclopedia could be accompanied by a digital image. Literary works may include options for the readers to pick their favourite plot, with relevant images being displayed as the text is browsed.

Many online multi-media developments can be expected. British Telecom initiated a trial in spring 1998, called Home Highway, to test high-speed domestic telephone line connections to the Internet. One of the world's top ten companies believes the future is delivery of multi-media content down their telephone networks. It is conceivable that disparate members of the family can meet either side of a virtual white-board or video conferencing centre when the need for a little domestic bonding takes hold. While few sit down to watch their favourite Webcast (live broadcasts on the Web) on a Web TV today, it could be commonplace in a few years time. Digital images will form an essential ingredient in this heady brew.

Digital TV is also poised to create yet more competition to deliver high quality images into the home. In a similar way that the Web seems to have provided a niche for every frustrated publisher in the world, digital TV looks set to create a gold rush for prospective broadcasters. However, there is a restraining factor. Content, and quality content at that, is what really matters.

**CONTENT**

This is a fitting juncture at which to leave speculation on the future of digital technology and what it may mean for digital photographers. Whatever technology is harnessed to create the digital images of the future, measured judgements can, and will, be made about the quality of the content of the image. Creating a digital family snapshot and cloning the dog's head onto your mother-in-law may be an amusing way to spend a lazy Sunday afternoon, but broadcasting it to your personal Web site may not pull in many punters. After all, content is king.

# Glossary

**1-bit colour:** A 1-bit colour digital capture device or image records or represents two colours, usually black and white. Each individual picture element (pixel) can only record two colours.

**8-bit colour:** An 8-bit digital capture device or image records or represents 256 colours. Each picture element (pixel) can record 256 colours or shades of grey.

**24-bit colour:** A 24-bit digital capture device or digital image records or represents 16.7 million colours, or 8-bit colour (256 levels) for each of the red, blue and green, additive, components of RGB colour space. Each picture element (pixel) can record 16.7 million colours.

**A** **accelerator board:** A printed circuit board with microprocessor which can be connected to a computer's existing motherboard to speed up the processing of data. Also known as accelerator cards, expansion boards, or, graphics accelerator/card for enabling faster re-display of graphic files, including images.

**access time:** The time taken to retrieve data from a computer's memory or from any storage device. Typcially access times for computer memory RAM are between 10-120 nanoseconds, for hard disks between 1-100 milliseconds and for CD-ROM drives between 120-800 milliseconds.

**active-matrix:** A particular type of liquid-crystal display (LCD) using a transistor for each cell within the liquid-crystal layer. An active matrix produces brighter, more accurate colours than a passive matrix where multiple electrodes pass through the entire liquid crystal layer.

**adapter:** Extra peripheral devices or hardware can be connected to a computer by installing special printed circuit boards or interface cards using expansion slots connected to the motherboard.

**algorithm:** Defines a set of explicit instructions to perform a particular series of computations or steps using a computer programming language.

**aliasing:** The square or rectangular shape of picture elements (pixels) can produce jagged edges (jaggies) when representing curved or diagonal lines in low resolution bit-mapped images or fonts (typefaces) on monitors and/or printers.

**analogue data:** A black and white photograph is an example of analogue information, being a continuous, infinite, range of grey tones from black to white.

**analogue signal:** A continuously variable signal, such as a voice on a telephone line or a picture transmitted to a television, or a video recording displayed on a TV or monitor.

**analogue to digital converter:** A device enabling analogue data (signals) from a photograph or video to be converted into digital data which can be stored in a computer. Converters are generally built into most digital hardware.

**anti-aliasing:** On low resolution monitors or printers curved or diagonal lines in bit-mapped images or fonts (typefaces) are often displayed with jagged edges (jaggies). Anti-aliasing uses special software to introduce intermediate shades in adjacent pixels whose effect reduces the apparent sharpness of the edge, thereby smoothing the jaggies. Printers may have software installed which enables even smoother curves to be printed by varying the dot size. This process is known as smoothing.

**application:** A computer program or suite of programs that can be used to perform specific tasks. There are tens of thousands of different applications today. Many are dedicated to specific tasks such as word processing, image editing, preparation of spreadsheets for business management, database management, and electronic communications. Complementary suites of applications are sold as one package, suitable for a variety of tasks. For example, office administration packages such as Lotus 1-2-3 and Microsoft Office.

**archive:** A database of files held on a computer and/or connected storage media. Digital image archives are a feature of many photo libraries, the images often being archived on CD-ROM or hard disks or optical tape.

**array:** A single row of Charged Couple Devices (CCDs).

**artefact:** A permanent, unwanted, degradation of part of the data contained in the pixels of a digital image. Certain image capture, manipulation or output devices can induce artifacts as a consequence of the technology used.

**ASCII American Standard Code for Information Exchange:** A standardised binary code (1 and 0) used to represent text characters and formatting and numbers.

**aspect ratio:** Is the fixed ratio of the width and height of an image. Monitors and TVs tend to display in an aspect ratio of 4:3, whereas conventional 35mm film negative has an aspect ratio of 3:2 and 5 x 4" film is 5:4. High definition TV has an aspect ratio of 16:9. The aspect ratio of an image can be changed to create distortions.

**asynchronous transmission:** Digital data sent via telecommunications systems is sent in asynchronous mode, in which single bytes of data are transmitted in a continuous stream, each byte being identified by a start bit and a stop bit.

**avatar:** A pseudonym or a virtual personality for online communication.

**B**  **back-up:** Copying computer files from one storage device to another is the process of backing-up the data. Back-up is recommended as an insurance policy against permanent loss of data if one storage device malfunctions.

**backbone:** A series of high speed telephone lines or wires that create a route for transmitting high volumes of information within a network.

**background processing:** Any computer which will execute two tasks simultaneously is processing data in the background. This ability is determined by the hardware and software configured for that computer.

**banding (see contouring):** Is produced when an output device, such as a monitor or printer, can not display smooth graduation of colour, but produces distinct bands visible to the human eye.

**bandwidth:** Defines the amount of data, measured in bits per second (bit/s or bs), which can be transmitted along a connection per unit time. An ordinary telephone line carrying analogue sound data has a bandwidth of 9,600 bit/s, which is expanded to 28,800 bit/s, or higher, by attaching a modem which compresses and decompresses data. Digital telephone lines have a minimum bandwidth of 56,000 to 64,000 bit/s (56 kbit/s to 64 kbit/s).

**BASE resolution:** Is the resolution, 512 x 768 pixels, at which images are scanned and transferred to Kodak's PhotoCD.

**BASIC Beginners' All-purpose Symbolic Instruction Code:** One of the computer languages developed in the 1960s which offered a simple programming language. Today software developers use Visual Basic, a descendant of BASIC.

**batch processing:** Is a complete set of instructions or program which doesn't require input from the user but is executed automatically. Copying data files to another storage device, scanning to preset colour levels, are typical batch processing exercises.

**baud:** When one bit of data is sent as one discrete signal, the data is signalled at a rate of one baud. At transmission speeds in excess of 300 bit/s, several bits of data can be encoded onto one baud.

**bay:** A floppy disk drive or CD-ROM drive occupies a bay within the box containing a personal computer's electronics, such as a desktop box, mini tower or maxi tower. Additional drives can be fitted if there are free bays.

**BBS Bulletin Board System:** Personal computers linked by a modem to a telephone network can access electronic boards on remote computers for messages, viewing images, playing games and/or uploading/downloading software.

**beta version:** Software developers prefer to test their latest product using independent consultants and/or in the marketplace, prior to commercial release. This is a beta test and the software is known as the beta version.

**Bézier curve:** A smooth curve mathematically described by reference to points, each of which is the midpoint of a straight line. The shape of the curve is controlled by changing the co-ordinates locating each point. Bezier curves are used in many graphics and imaging applications.

**binary:** A two digit numbering system usually represented by the numerals 1 and 0, or levels such as on/off, high/low etc. Binary code is a string of binary digits used to represent digital data in computers.

**bit-depth (bits per pixel):** A greyscale (black and white) image contains 8-bit colour depth, equivalent to 254 shades of grey, plus black and white. A one-bit image, such as a line-art drawing, would only show two colours, black and white. Bit-depth increases exponentially so a red-green-blue image shows 3 x 8-bit colour depth, known as 24-bit colour, equivalent to 16.8 million colours. As the human eye can differentiate between 3.75 million different colours, 24-bit colour is more than satisfactory for viewing images. Imaging bureaux and commercial printers use 32-bit colour depth to represent the cyan-magenta-yellow-black (CMYK) colour space, to enable four-way colour printing to paper.

**bit-mapped font:** Each individual type character when represented as a pattern of dots (synonymous with pixels) on a grid is known as a bit-mapped font. As the font size is increased the edge of each character can appear jagged as the limited resolution of the output device (monitor or printer) reveals the individual dots. A bit-mapped font is termed non-scalable.

**bit-mapped graphic:** see bitmap

**bit:** A bit is a binary digit (0 or 1), the basic building blocks of digital information. Eight bits equate to one byte, a unit of measurement of the amount of information in a digital file.

**bitmap:** An image comprising rows of dots or individual picture elements (pixels). Each pixel, usually square or rectanglular in shape, occupies a specific location on a grid. The colour value can vary from 1-bit per pixel (black & white) to 24-bit (red, blue, green x 8-bit per pixel), 32-bit (cyan, magenta, yellow, black x 8-bit per pixel) and 36-bit. Bits per pixel is the same as bit-depth.

**bookmark:** An address of a Web page saved to a special file within the browser software enabling the user to conveniently recall the address and re-visit a site.

**Boolean operators:** Certain search engines look for records in a database using keywords which are part of the index with each record. Specification of the search query can include keywords with Boolean operators, such as 'and', 'not', '*', which specify the relationship between keywords, thereby narrowing or expanding the search.

**boot:** The process of loading the operating system software of a computer. When new software is installed on the hard disk of a computer it is usually necessary to re-boot the computer so that the operating system can identify the new software.

**brightness:** Individual pixels in a digital image can represent 256 levels of brightness between black (0) and white (255).

**browser (Web):** Software which permits information transfer and viewing of multi-media sites on the World Wide Web. Popular browsers include Microsoft's Internet Explorer and Netscape's Navigator.

**browser caching:** Web browsers can speed up retrieval of pages that have already been accessed during an online session by retrieving them from the cache on a computer's hard disk rather than from the (remote) server.

**bubblejet printer:** Canon's proprietary printing technology whereby the ink is heated, forms a bubble at the heating element which bursts on vaporisation and is applied to the paper. Bubblejets are a specialised form of inkjet printer.

**buffer:** An area of temporary storage of data in a computer's hardware or software.

bug: Consistent malfunctions in hardware or software are known as bugs. Bugs can cause a program to stop or crash a computer's operating system.

**bundled software:** Software supplied with a new computer is known as bundled software. This often includes the computer's operating system software, word processing and office management applications.

**bus:** The main electronic components of a computer are connected via a special circuit called a bus. Most PCs today are equipped with 32-bit or 64-bit buses capable of transferring 32 or 64 bits of data concurrently along 32 or 64 separate circuit wires. The speed of data transfer, or clock speed, is measured in megahertz (Mhz). Clock speeds for a bus are not necessarily the same as those of a computer's microprocessor. IBM-PC compatibles and Apple Power Macintosh/PowerPCs have PCI buses, earlier Apple Macintosh have a system called NuBus.

**byte:** One byte is equal to 8-bits of (digital) information and is a measurement of memory or storage space in a computer. One kilobyte (K or Kb) represents 1,000 bytes; one megabyte (Mb) is one million bytes; one thousand megabytes equals one gigabyte (Gb).

**C**  **cache:** Any area of a storage device which facilitates high speed retrieval of data which is currently being worked upon or data to which frequent access is required. The cache can be located in random access memory (RAM) or the hard disk. Typical cache sizes are 256 kilobytes or 512K.

**calibration:** The process of adjusting the colour in one device to match the colour in another device or to match it with a standard colour reference system.

**capture device:** Any device which is capable of converting light into electrical pulses and thence into digital information.

**card:** Is a special printed circuit board which fits into the expansion slot of a computer's main printed circuit or motherboard. Cards are designed to perform specific tasks, for example: a graphics card which controls the resolution and colour display on a monitor; a sound card which maximises the quality of audio files.

**CCD array:** A linear arrangement of Charged Couple Devices (CCDs) used in flatbed scanners, photocopiers, and lasercopiers to convert light energy into electrical impulses.

**CCD chip:** A group of Charged Couple Devices (CCDs) arranged in an area array (grid) or linear array to capture light and convert it to digital information. In digital and video cameras the CCD chip replaces the silver halide film of conventional cameras.

**CCD:** A charged couple device (CCD) is a light-sensitive integrated circuit which generates (analogue) electrical currents according to the amount of light received.

**CD Compact Disc/Disk:** Digital data is encoded onto a plastic disk using a laser beam. A wide variety of formats are used for recording different types of data and for reading in different types of CD-drive or CD-player. CDs can store up to 650Mb of information.

**CD-R Compact Disk-Recordable:** A CD to which data can be written once only, but that can be read many times.

**CD-ROM Compact Disk-Read Only Memory:** Is a special type of compact disk (CD) which stores data as ROM, Read Only Memory, up to a total of 650 megabytes per disk. Special drives are required to read the data on a CD-ROM. Typically CD-ROM drives operate at data transfer speeds of 1.8Mbs to 3.6Mbs referred to as x12 to x24 respectively. See also CD-R, CD-RW and PhotoCD.

**CD-RW Compact Disk-Read Write:** A CD to which data can be read and written many times. Old data is erased by a laser beam which briefly heats the recording layer preparing it for new data to be encoded.

**channel:** Images contain data from different colour channels. An image on a monitor has three addititve colour channels (red, green and blue), whereas an image on the printed page usually has four subtractive colour channels (cyan, magenta, yellow and black). Certain file formats, such as Photoshop, can hold information on an image in up to 24 channels.

**chip:** A group of integrated circuits or microprocessors which control data manipulation and management in a computer.

**chroma:** A combined measurement of the saturation and hue values of a colour.

**CIELab:** A colour space defined by the Commission Internatonal d'Eclairage (CIE) based upon Luminance (L), 'a' colours (green to red) and 'b' colours (blue to yellow). CIELab is a larger colour space than RGB and CMYK, so is often used to translate between these colour spaces in colour management systems.

**client-server computing:** The Web is a large network comprised of servers (computers which store and manage data) and clients (computers which access and/or process the data). Servers are powerful computers maintained by online services, Internet Service Providers and, occasionally, individuals. Clients are usually personal workstations, such as PCs or Macs, in the home or office.

**client-server system:** A powerful central computer (the server) is linked to a network of personal computers (clients) enabling each client to perform operations on a central database(s) using the same program or suite of programs.

**clip art:** Graphic files, and sometimes small images, which are supplied on CD-ROM or via the Web for insertion into word processing documents, Web pages and other page layouts involving graphic elements. Clip art is supplied by commercial companies or is available free via the Internet.

**clock speed:** A clock is a special circuit which generates a continuous stream of electric pulses, measured in megahertz (Mhz). The clock speed defines the minimum time required by a computer's microprocessor (central processing unit, CPU) to execute an instruction. Typical clock speeds are between 100Mhz to 300Mhz. The actual time required for a particular instruction depends upon a number of variables such as the speed of the computer's main circuit (bus), any expansion buses, and the rate of data transfer from different drives and/or other peripheral devices.

**clone:** A PC whose functions and appearance mimic those of an original model. IBM-PC compatbles are clones of the original IBM-PC, using the same hardware components and operating system software. IBM-PC compatibles are manufactured by Hewlett Packard, Compaq, Dan, Gateway. Apple Macintosh compatible PCs have included Umax, Motorola (as StarMax) and Power Computing.

**CMS Colour Management System:** This describes any software application that improves colour fidelity between a capture device (camera, scanner) a viewing device (monitor, TV) and an output device (printer, monitor).

**CMY colour space:** Cyan, Magenta, Yellow are the three primary colours which can be mixed to create new colours using the principle of absorption or subtraction of light. For example, coloured cyan (blue) dye/ink/paint mixed with yellow produces green as the incident light is absorbed and the reflected light is in exact proportion to the cyan:yellow ratio.

**CMYK colour space:** Information on the tonal range of four colours, cyan (C), magenta (M), yellow (Y) and black (K), is held in the CMYK colour space. Each colour is usually represented as 256 shades or 8-bit depth colour, giving 32-bit colour for a CMYK image file. This colour space is favoured in the printing industry where the best tonal range and depth of shadows is usually achieved by using four coloured inks. CMY colour space can not generally provide sufficiently dark blacks, so a black ink (K) is also applied.

**colour correction:** Colour images can be corrected against known colour standards or bvy using colour management systems. Colour casts introduced by artificial light (tungsten, fluorescent) can be corrected by applying standard image editing software filters.

**colour fringing:** Colour filters in front of the pixels of a CCD can cause false colours to be recorded when compared to the original subject.

**colour resolution:** see also bit-depth. High quality scanners or digital cameras have a higher colour resolution or range of bit-depth image capture. For example, a monochrome digital camera captures at 8-bit depth and provides a resolution of 256 shades of grey. Most scanners and professional digital still cameras capture at 24-bit depth, equivalent to 8-bit depth in each of the three colours, red, green and blue. High quality scanners used in the printing industry capture in 32-bit depth, or 8-bit depth in each of four colours, cyan, magenta, yellow and black.

**colour space:** Colour can be mathematically described using a space which defines the elements that make up each colour. Colour spaces typically used in digital imaging include greyscale (black, greys and white), RGB (red, green, blue) and HSB or HSL (hue, saturation, brightness) for images viewed on computer monitors, YCC (a proprietary space used by television and Kodak's Photo-CD) and CMYK (cyan, magenta, yellow and black) used for printing images onto paper.

**colour trapping:** Mis-alignment or registration of individual dots of coloured ink during printing can produce white lines around an object. The process of adding extra colour to eradicate these white lines is called trapping.

**CompactFlash:** A PC card, varying between 4Mb to 24Mb capacity storage, suitable for using with digital cameras and laptop computers.

**compatible:** A term used to describe a personal computer, peripheral device, software program/application or file format that can function in a similar fashion or can be exchanged for each other without affecting functionality. An IBM-PC compatible has the same functionality as, and is compatible with, an IBM-PC.

**comping:** Is the process of making a composite digital image using several or many images or parts of images.

**compression software:** Reduces the number of bits of information, and hence the size of an image file, which permits faster transmission of the file, reduces storage requirements and the time taken to display the file on a monitor.

**compression, of data:** Digital data is compressed to reduce storage requirements or minimise the time taken to transmit it via networks. There are dozens of different methods of compressing data. Lossy compression methods discard unwanted data; an operation which is irreversible. Image files are often compressed to reduce their inherently large file sizes. Common compression file formats for images are JPEG (lossy) and TIFF (lossless).

**continuous tone colour:** Any image that contains in excess of 3.8 million colours will appear to have a continuous range of brightness and colour tones to the human eye. A digital system that reproduces 16.8 million colours (24-bit colour), representing 256 shades of each red-green-blue (RGB) colour combination, is referred to as reproducing continuous tone or true colour.

**contouring:** Perceptible bands of different brightness in an image, caused by devices with low capture, display or output resolutions. Also known as banding.

**contrast:** Measures the absolute variation in, and spatial distribution of, brightness in a digital image. Brightness is measured in 256 levels and can have a value of 0 (black) or 255 (white). The ability of a device to record contrast is known as its dynamic range. Subjective descriptions applied to photographs or images include low or flat contrast, contrasty, etc.

**convergence:** Red, green and blue colours are additive colours combined within individual pixture elements (pixels) on a computer monitor or television screen to create exact colour shades. The accuracy of the alignment or registration of each colour beam on each pixel controls the relative level of sharpness or convergence.

**CPU Central Processing Unit:** The CPU in a personal computer is a single chip (microprocessor) which translates, interprets and executes instructions received as digital data. It communicates with and transfers data between itself and all other internal circuits, devices and external devices.

**crop:** The process of outlining and removing unwanted parts of an image or graphics file enabled by specific tools in software programs/applications.

**cropping tool:** A digital tool for selecting and discarding unwanted parts of a digital image.

**CRT Cathode Ray Tube:** The images displayed on most computer monitors and televisions are formed within a CRT. In colour monitors three electron guns each continusously send out a single beam through a mesh or wire grid. As the beam falls onto red, blue and green phosphors coating the inside of the screen they are excited to produce colours visible to the human eye. The phosphors are re-excited or refreshed between 60 to 90 times a second to give the appearance of a continuous image.

**cursor:** A small vertical bar, arrow symbol, cross, or rectangular box, whose position on a monitor screen can be controlled using a pointing device such as a mouse, joystick, pen and graphics tablet, or a keyboard.

**cyberspace:** A term coined by William Gibson in his novel Neuromancer, published in 1984, to describe the information stored on all the computers of the globe which defines its own virtual reality.

**D** **daisy chain:** Peripheral devices, such as scanners and removable disk drives, connected with a SCSI interface can be linked in a continuous chain.

**DAT Digital Audio Tape:** Magnetic tape suitable for long-term archiving of digital data.

**DCS Digital Camera System:** Kodak's proprietary system for high-end digital still cameras which use a CCD chip inside a modified conventional camera body suitable for accepting Nikon or Canon SLR lenses. Captured image files vary between 4.5Mb to 18Mb.

**default:** An operation which is pre-set by the manufacturers of a computer's hardware or software, but whose setting can, usually, be changed by the user.

**deselect:** The process of cancelling an operation or command by removing a highlight from a text string, removing a check or tick from a dialogue box, and so on.

**device driver:** Software that ensures communication between a computer and a peripheral device, such as a digital camera, scanner or printer.

**dial-up:** Connection of a remote computer workstation, via a telephone network, to databases stored on other computers or servers.

**dialogue box:** A special window in a graphical user interface which prompts the user for information and/or commands.

**digicam:** A digital camera capable of capturing individual frames or images. The camera is portable and records images at relatively low resolution. It is generally a point-and-shoot, low-end capture device.

**digital cameras:** The film plane in a digital camera is replaced with a Charged Coupled Device (CCD) chip which comprises an array of CCDs. Each CCD is made of millions of elements or pixels. An electrical impulse is produced in each pixel element according to the amount and quality of light striking it. Software in the camera converts the electrical impulses into binary data which is stored internally on a hard or removable disk, or is exported directly to the hard drive of a computer.

**digital data:** A transmitted signal usually represented by two (binary) digits, 1 and 0. As information is moved around a computer, digital camera, scanner, or printer, it is transmitted as a digital pulse or signal, either 'on' or 'off'.

**digital image:** Is a sampled facsimilie of a photograph or a real scene which is stored as binary data on a hard disk, CD-ROM, floppy disc, optical-magnetic tape or other suitable digital storage media.

**digital still camera:** A digital camera capable of capturing individual frames or images as analogue data and converting them to digital data. Cameras may be operated as portable or stationary devices, and may record at high resolution (high-end capture) or low resolution (low-end capture).

**digital still video camera:** A digital camera which records data as analogue video data from which individual still frames or images can be isolated.

**digital:** Data recorded in the form of digits. All computer data is represented by the binary digits 0 and 1. Digital data is not continuously or infinitely variable, but is a number of finite samples of data.

**digitise:** The process of converting analogue data, which is continuously variable, into digital data, which is represented by code comprised of two (binary) digits, 0 and 1. During digitisation the analogue original is sampled, a numerical value assigned and converted into binary data. The binary data is assigned specific co-ordinates in a grid. When all the data is assembled on this grid it forms a digital image.

**DIMM Dual In-line Memory Module:** A 168-pin memory module for increasing a computer's RAM.

**directory:** A specific folder containing files (of information) on a computer.

**disc:** A description usually applied to storage media, such as a laser disc or compact disc (CD), in which the data is encoded by laser either by creating tiny pits or aligning crystals within a reflective layer.

**disk:** A description usually applied to storage media, such as a floppy or hard disk, in which the data are is magnetically encoded onto microscopic iron particles within the coating of the disk.

**display screen:** A monitor on which digital data can viewed as graphical and text elements. The actual image on a monitor can be created by a cathode ray tube, a liquid crystal display (LCD) or thin film transistor (TFT) display.

**dithering:** The process of simulating continuous tone progressions within an image system that uses a limited colour palette. It makes the colours blend easily into each other, reducing sharp edges, by using patterns of the available colours to produce a new colour. Diffusion dithering uses a random spatial distribution of pixels.

**domain:** Is a unique location of a computer on a network. In the case of the Internet, a global network of networks, domains are hierachical with the highest level being the country or type of organisation (company/organisation/educational establishment), followed by actual name of the company/organisation/individual, then the individual host name. The lowest hierachical position can also be referred to as the domain name. Popular domain names included in a Web address are .com, .org, .net and .edu.

**dot pitch:** The actual distance between individual pixels on a monitor measured in millimetres. Most PC monitors have a dot pitch of about 0.28mm, but high resolution graphics monitors feature dot pitches of less than or equal to 0.25mm, producing sharper images.

**down-sampling:** Refers to the process of re-sizing an image by reducing the total number of pixels.

**download:** The process of copying a file from one computer to another computer over a communications link or network.

**dpi dots per inch:** Is a standard measurement of output resolution, or number of dots of ink per inch, that can be printed on a page.

**drag:** The operation of holding down the button on a mouse to move a file, folder, text or graphic to a new location on the desktop, hard disk or within a file.

**driver:** A small software application called a utility, which instructs how the computer should communicate with an external device such as a digital camera, scanner or printer.

**drum scanner:** Original photographs are fixed to a transparent drum which rotates and is scanned by a CCD chip or array to capture high resolution image files.

**DTP Desk Top Publishing:** Any system which allows images, text and other multi-media files, to be placed in a page-lyout or designed in-house and prepared for printing.

**duotone printing:** Prints made by using two non-black inks, one is usually dark and the other is coloured or grey, to extend the range of tones which can be printed for greyscale images.

**DV Digital Video:** A worldwide standard format, with 500 lines of horizontal resolution, for recording moving images and sound.

**dye-sublimation printer:** Printers in which the ink is vaporised by heat enabling transfer of ink from special ribbons to the surface of the paper.

**dynamic range:** A measure of the ability of a device to detect and/or record contrast from very light, Dmin, to very dark, Dmax. Digital cameras, scanners or other recording devices that have a dynamic range of 3.0 can record a similar contrast range to film.

**E** **e-mail:** electronic mail distributed from one computer to a remote computer via powerful computers called servers connected to telephone networks.

**EPROM Erasable Programmable Memory:** A read-only-memory (ROM) chip to which data is written once. This data can not be subsequently modified but can be read and/or erased. Memory is permanent even when power is turned off. Digital cameras use EPROM for storing images.

**EPS Encapsulated PostScript:** Graphic files in PostScript fomat, including image files, can easily be transferred to a wide range of other applications, such as word processing and page layout software, using the special instructions contained within an EPS file. All the original image data is retained.

**error diffusion:** A means of extending the printed colour range or gamut by the precise placement of discrete dots of quick drying ink.

**ethernet:** A computer and peripherals network linked by cabling which enables very high rates of data transfer, up to 10 million bits per second.

**expansion card:** A computer's capability can be expanded by installing special printed circuits to provide extra memory, to accelerate graphics or other data handling, or to connect additional peripheral devices. Most PCs have between three to eight expansion slots to which new expansion boards can be fitted.

**export:** The transportation of data between computers, devices, applications, or file formats, is the process of exporting.

**extension:** A program which is automatically activated when a computer's operating system is switched on. Extensions are used in the Apple Macintosh OS.

**FAQ Frequently Asked Questions:** The questions most commonly asked by those **F** seeking answers to information technology problems.

**field:** A video signal is stored in two separate fields (each field composed of horizontal lines at a defined resolution) which are combined or interlaced to produce an image on a suitable viewing device.

**FIF Fractal Image Format:** An image file format from Iterated Systems which uses fractal compression routines based upon mathematically described vectors rather than bitmaps. FIFs permit zooming into the image without loss of detail.

**file formats:** A digital image file can be stored in different types of format. Certain formats are proprietary to certain software and computer platforms, others are cross-platform compatible. Some formats, such as GIFs and JPEGs, are better for displaying on Web pages. Choosing the correct format depends upon the intended use of that image file.

**file server:** A computer which stores large numbers of files, usually in a database, which can be shared with computers on a local or wide area network. The Internet is an example of a wide area network (WAN).

**file size:** A digital image file becomes larger as the information stored becomes more complex. Image information is measured in kilobytes (K or Kb) or megabytes (Mb). Typically a Web image file is 10K to 150K, a file scanned from a 35mm negative or transparency is 6Mb to 18Mb, and a 5 x 4 inch film is 72Mb to 270Mb or greater.

**file:** Digital data held in a discrete unit on a stationary storage device, such as a computer's hard disk, or on a removable storage device, such as a floppy disk. Files can also be transmitted from one computer to another using modems and/or networks. Files can contain one type of data, such as text, sound, images or several types of data, as in a multi-media file.

**film recorder:** A device that can convert digital images back into conventional, silver halide-based, transparency or negative film.

**filters:** Software which alters the information of individual pixels to create a new visual effect. Filters can be used for sharpening, distorting and hundreds of creative effects, such as posterising, solarisation, and so on.

**fingerprinting:** A method of incorporating unique data in the pixels of an image which is invisible to the viewer but enables it to be identified at a later date.

**FireWire:** A high-speed interface capable of downloading digital data from a peripheral device, usually a camcorder or DV camcorder, to a computer at up to 25Mb per second.

**FITS Functional Interpolaring Transformation System:** A file format capable of storing information about an editing sequence applied to an image. See IVUE file format.

**flash memory:** Is a special type of microprocessor (chip) which does not require an electrical power source to retain data. Flash memory is used in lots of digital cameras to store images.

**flatbed scanner:** A device for scanning photographic and artwork originals which are laid flat whilst an optically-based system, incorporating a CCD array or CCD grid, moves over, or scans, the original.

**floppy disk (disc):** A flexible plastic disk coated on either side with a thin layer of magnetised iron particles, which stores digital data. The 3.5 inch, 1.44Mb, floppy disk, in which the flexible disk is encased in plastic, has become a universal standard, Other sizes include the 3.5 inch, 120Mb, LS-120 disk and the 5.25 inch floppy.

**folder:** An icon on a graphical user interface (GUI) which represents the location of files and/or applications.

**font:** A unique designed set of text characters, or typeface, at a specific size. Fonts vary in height, width, and pitch (number of characters per inch). Some fonts retain their design as they are scaled up or down in size (scalable fonts) using object-orientated graphics files, wheares bit-mapped fonts can not be scaled.

**FPX FlashPix:** A cross-platform file format comprising a hierachical system of image files, developed by a consortium of Kodak, Hewlett-Packard, Microsoft and LivePicture, for use in online and offline multi-media.

**fractal compression:** Is a form of image compression which uses mathematical descriptions and enables images to be viewed by zooming-in without experiencing a loss of quality. See FIFs.

**frame (video):** The data in a video file is composed of two separate fields, each field occupying the odd or even line scans on a display screen. The two fields make a complete frame as they interlace at the frequency of the line scan.

**frame grabber:** Analogue signals from an image capture device are digitised by special hardware called a frame grabber.

**frame:** Web designers sometimes use frames within the main window of a Web browser to sub-divide different parts of a Web page. Usually the frames each have their own independent bars for scrolling to view the information therein. Split-frames or three-way frames are the most common types.

**freeware:** Software available free of charge.

**FTP File Transfer Protocol:** A method of transferring files from one computer to another using a special set of protocols (rules) to exchange packets of information. FTP is frequently used on the Internet to download software applications or large data files.

**G** **gamma:** Defines how the digital data held in a file is displayed on a monitor. An ideal gamma range for viewing images is between 1.8 to 2.2.

**gamut:** Is the number of colours, or tones, which can be recorded, displayed or printed on a particular device or system.

**geek:** a software or computer crazy individual who displays nerd- or idiot-like behaviour. Occasionally successful computer industry entrepreneurs are referred to as geeks.

**GIF Graphics Interchange Format:** An 8-bit (256 colours) image file format often used for displaying images on Web pages or online databases.

**Gigabyte Gb:** One thousand megabytes (precisely 1,024Mb). A unit of storage.

**Gopher:** This is a navigation tool, utilising a menu system, to find specific documents on servers which hold FTP data on the Internet.

**gradient:** Represents an area infilled with colour or greyscale tones whose hue and/or saturation changes from one side to the other in a smooth gradient.

**graphics accelerator:** A special microprocessor located on an expansion board which takes over from the central processing unit (CPU) of a computer when graphics files have to be processed. Graphics accelerators are essential for the operation of graphical user interfaces (GUIs), allowing the CPU to process the non-graphical data.

**graphics:** Pictorial information presented on a computer's monitor. Graphics files contain bit-mapped graphics, described by a geometric arrangement of picture elements, or object-orientated graphics, described by mathematical vectors.

**greyscale (grayscale):** A digital image only containing shades of grey, black or white. An 8-bit grayscale image contains 256 levels of grey i.e. black, white plus 254 greys.

**grey (gray) level:** A measure of 256 possible levels of brightness within an individual picture element (pixel) of a digital image, varying from 0 (black) to 255 (white).

**GUI Graphical User Interface:** An interface that uses icons or symbols, menus and windows to display information and present command options for the computer user. Operations are executed by the computer when a command option is typed on the keyboard or a pointer/cursor is activated over a graphical element on the interface. Apple Computers developed a much praised GUI in 1984 which became the inspiration for similar types of GUI now used in the operating systems of most PCs. Popular operating systems using a GUI include Mac OS 7.0+, Mac OS 8.0, Windows 3.0+, Windows 95 and Windows NT.

**H**

**halftone:** A system of printing dots of variable size to simulate a continuous tone photograph. Light projected through a negative or positive film passes through a line screen and forms dots on a plate used for applying ink to paper. A line screen of 85 lines per inch has an output resolution of 84 dots per inch. Most newspapers and magazines use halftone printing to recreate photographs.

**hard copy:** When a digital file is output onto printed paper it creates hard copy which may be digital or analogue in composition.

**hard disk:** A magnetic disk capable of storing large amounts of digital data. Most computers are fitted with a hard disk varying in capacity between tens of megabytes to 8.4Gb or more.

**hardware:** The collective term for equipment used in computing and digital photography.

**HDTV High Definition Television:** Is the new, higher quality, US video standard which has over twice the resolution of the NTSC video standard. HDTV resolves at 1,125 lines compared to 525 for NTSC. The resolution of the HDTV standard varies slightly in Europe and Asia.

**high-end retouching station:** Powerful personal computer workstations used by digital imaging bureaux and commercial printers. These workstations are equipped with a lot of memory (RAM) and storage capacity to edit large image files. Leading brands include Barco, Mamba, and Quantel.

**high-end:** Devices capable of capturing, manipulating and/or outputting high resolution image files.

**histogram:** The distribution of grey or colour tones in an image can be represented graphically by a detailed bar chart.

**home page:** The opening page of a Web site, where the main content of the site is introduced, with written or graphical hypertext links leading to other parts of the site.

**host computer:** Provides processing services and stores data for other computers on a network. With reference to the Internet, a host or host computer, is a domain name that has a specific Internet Protocol (IP) address. Popular host names include: www, host, mail, ftp, ns, www2, www1 and gopher. A domain, or domain name is a specific server that provides space for the records of the host. Domains may have sub-domains. See domain and URL.

**HSL/HSB Hue Saturation Lightness /Hue Saturation Brightness:** A colour space described by the Hue (H), Saturation (S) and Lightness/Brightness (L/B) regarded as the closest approximation to the colour space of human vision.

**HTML Hypertext Markup Language:** The basic software language for writing a Web page.
**HTTP Hypertext Transport Protocol:** The set of rules for moving hypertext (HTML) files around the Web.
**hue:** An exact colour or tone usually defined on a colour wheel.
**hypertext and hypertext links:** Within the body of text, or in specific hotspots (such as graphic icons or images), hyptertext contains special instructions (hyperlinks) which automatically link the user to other Web pages. This ability to link one page with another on the same or a different site (in another country) has created a world wide Web of links. All information on the Web is presented in hypertext format.

**IBM-PC compatible:** A computer that can mimic the operations, use similar applications and connect to the same peripheral devices as an IBM PC.
**IBM-PC:** International Business Machines (IBM) established this trademark in 1981 when it manufactured the first personal computer (PC). All IBM PCs can use DOS operating system software, some use IBM's own operating system, OS/2.
**icon:** Graphical user interfaces (GUIs) use small graphical symbols called icons to represent individual files, folders, storage devices, peripheral (devices), or applications on the monitor of a computer.
**IDE Integrated Drive Electronics:** An interface circuit controlling the rate of data transfer between a computer's microprocessor (CPU) and any disk drives.
**image browser:** A simple application for cataloguing and viewing images.
**image editing (processing/manipulating):** Describes the process of altering any component of an image (for example, size, resolution, file format, colour balance, contrast) using special software applications/programs.
**image map:** Any graphic or image, within a Web page, containing the relevant hypertext language, which can be clicked to link to another Web page.
**image tag:** The text caption associated with an image in a Web page is surrounded by Hypertext Markup Language, the whole being called an image tag.
**import:** Data brought into a file from another file, application, device or computer.
**indexed colour:** A customised colour space of a palette of up to 256 colours often used for standardising logos and images on Web pages.
**ink-jet printer:** Digital images are converted to dots of ink on paper by the process of a printing head ejecting drops of ink. Ink-jet printers vary from budget low resolution desktop printers to very expensive high resolution proofing and large format devices used by the printing industry.
**input device:** see capture device
**Intel:** A trademark for microprocessors manufactured by Intel. IBM PC and IBM PC compatibles tend to use Intel microprocessors. The Intel Pentium is a fast microprocessor used in many modern PCs.
**interface:** Any software or hardware which facilitates or controls movement of data between the computer and any peripheral devices, or between the computer and the user. A graphical user interface (GUI) permits the user to communicate by clicking icons or other graphics symbols and/or by typing commands on a keyboard. A parallel interface or port permits communication between a computer and a printer. A serial interface or port permits communication between a computer and a pointing device, such as a mouse.

**interlacing:** A technique of displaying images on a screen by re-writing or refreshing the pixels on alternate lines. The rate of refresh makes the image appear whole, but it is a composite image comprising two fields of information. Interlacing also refers to the display of an image on a monitor when opened in Web browser software. File formats which support interlacing initially appear at low resolution but as more information is downloaded the image is re-rendered at higher resolution. Also known as progressive downloading.

**Internet Explorer:** The proprietary Web browser software designed by Microsoft and launched in 1996. The current version is 4.0.

**Internet, the:** A network of over 60,000 computer networks (latest estimate) connected by the telecommunications systems of the globe using a set of rules called Transfer Control Protocol/Internet Protocol (TCP/IP). This protocol enables millions of computers to transfer data between each other along ordinary and digital telephone lines.

**interpolation:** A process for improving the visual appearance of an image by adding additional information. Software inserts new pixels with a specified colour value between adjacent pixels. Such interpolation appears to increase the original resolution.

**ISDN Integrated Standard Digital Network:** An international standard for digital telephone lines capable of carrying data at transmission speeds of up to 56Kbs or 64Kbs.

**ISO (International Organisation of Standardisation) speed:** The sensitivity of photographic film to light is defined by the ISO speed. A fast film, ISO800 to ISO3200, requires less light than a slow film, ISO25 to ISO100, to be correctly exposed, but slower films record finer detail.

**ISO 9660 format:** A cross-platform format for CD-ROM and CD-R.

**ISO rating:** The light-sensitive response of CCD chips in digital cameras is rated in an equivalent scale to the ISO ratings of conventional photographic film, which measure the speed with which the film reacts to light. Typical consumer digital cameras have equivalent ISO ratings of between ISO100 to 400, whereas professional digital cameras tend to have a wider range between ISO100 to 1,600.

**ISP:** Internet Service Providers link individual and corporate subscribers to the Internet via a dial-up service. ISPs typically have powerful host computers or servers which store and process information, and provide access to a range of facilities on the Internet. Proprietary information is also usually available to subscribers to each ISP. Most ISPs charge a fixed monthly tariff to subscribers.

**IVUE:** An image file format used in high-end image editing applications which uses FITs technology to speed up the time taken to edit images. FIT files store the instructions.

**J**

**jaggies:** A jagged edge created by the visibility of the square or rectangular pixels in low resolution images on a monitor or a printer. Jaggies are usually more visible on curves than straight edges.

**Java:** Sun Microsystems developed the Java programming language which permits inter-operability between different computer platforms and operating systems. It is one of the most versatile languages in computing and so has been widely adopted by the Internet community, especially as mini-programs or Java Applets within Web pages, to create more stimulating multimedia content.

**JPEG Joint Photographic Experts Group:** JPEG is one of the most widely used image file formats. It can be compressed up to to one-hundredth of its original size. Compression is lossy so some image degradation can occur. A popular format for the digital imaging industry, Web page design and electronic image distribution.

**K** **Kbit/second (Kbs):** A unit of measurement of the speed of transmission of digital data.
**kilobit:** One thousand bits (1K) of digital information (1,024 bits exactly). A measurement of computer memory, storage space or file size.
**kilobyte Kb (K):** Approximately one thousand bytes of digital information (1,024 bytes exactly). A measurement of computer memory or storage space or file size.

**L** **LAN Local Area Network:** A group of computers linked by cable that permits digital information exchange between computers.
**landscape orientation:** Is when the long axis of a rectangular image file or photograph is aligned horizontally.
**laser printer (laser copier):** Data in digital files is converted into a laser beam which exposes an electrostatically charged drum. The drum attracts fine particles of toner which are then deposited onto opaque or transparent paper.
**Layers:** A layer is a discrete entity within a digital image which can be edited independently of the rest of the image.
**LCD Liquid Crystal Display:** A screen attached to some digital cameras to enable preview of pictures before capturing and/or review of the images after capture.
**LED Light-Emitting Diode:** A semiconductor that emits a bright light when connected to a power supply. LEDs are used to indicate that an operation has been activated on an item of hardware.
**link:** An electronic connection, or hotlink, between two Web sites, defined in Hypertext Markup Language, the universal language of Web pages.
**lossless compression:** A non-destructive method of reducing the size of files, by avoiding repetition of similar data, without loss of quality compared to the original file when it is decompressed. Compressed files save storage space, but usually require the same amount of memory to open them as the original file. Also known as run-length encoding.
**lossy compression:** A method of reducing the size of files by discarding data which can induce a loss of quality, compared to the original file, when it is decompressed. The higher the compression ratio, between orginal to compressed file, the more likely there will be a reduction in quality. Compressed files save storage space and can usually be opened using smaller amounts of memory.
**low-end:** Devices capable of capturing, manipulating and/or outputting low resolution image files.
**lpi lines per inch:** A description of output resolution in the printing industry. For example, newspapers are generally printed at 80lpi to 133lpi, whereas glossy magazines tend to be printed at higher resolutions of 150lpi to 200lpi.
**LZW (Lempel-Ziv-Welch) compression:** A lossless file compression algorithm to reduce the amount of data in image files, such as used in the TIFF file format.

**Macintosh:** A trademark for a series of computers manufactured by Apple **M** Computers since 1984. The Mac, as it is colloquially known, uses an operating system with a graphic user interface (GUI) which is intuitive and user friendly.

**manipulation:** Is the process of changing the digital information within an image using software. Many of the manipulation processes mimic those used with conventional silver halide photographs, such as dodging, burning, distorting, toning, photomontage and colour changes. Digital manipulation is very fast compared to the equivalent process in the darkroom. Manipulation can be achieved at the level of each individual pixel.

**marquee:** Image editing tasks, such as cropping, cutting or masking elements in an image is facilitated by a selection tool called a marquee which outlines the object with a dotted line.

**mask:** Areas in an image to which you don't wish to apply an editing instruction can be masked by identifying the area with a dotted line using a selection tool, or by specifying cutoff levels within the colour information for the smallest picture elements (pixels).

**matching:** A term applied to the data supplied when search results are displayed with a per cent figure indicating how close the retrieved data is to the requested search term. An exact match is 100 per cent.

**megabit:** One thousand kilobits or one million bits of digital information.

**megabyte Mb:** Approximately one million bytes of digital information (1,048, 576 bytes exactly). It is a unit of measurement of the size of a file, a computer's memory or a storage system.

**megapixel device:** Is a digital camera, or other capture device, with a CCD of equal to or in excess of approximately one million pixels (1,048,576 pixels precisely).

**memory card/module:** A device for storing data temporarily (for example, RAM) or permanently (for example EPROM, flash memory and ROM). Computers tend to use RAM, which is activated when the computer is switched on. Digital cameras and other peripheral devices use fixed permanent memory cards or removable cards, such as PCMCIA or CompactFlash.

**memory:** Data and software is stored in a range of microprocessors, chips and storage devices. Existing data can be retrieved and new data can be written to memory. Random Access Memory (RAM) only stores and handles data when power is supplied. Other types of memory, such as EPROM, ROM, and peripheral disk drives, retain data even when the power supply is removed.

**micro-dry printer:** Printers which use solid sticks of ink which are liquified upon heating and transferred to paper.

**microprocessor:** A single chip of semiconductor material forming an integrated circuit which comprises the central processing unit (CPU) of a computer. The heart of processing operations within a computer. Intel and Motorola are two of the largest manufacturers of microprocessors. IBM PC and IBM PC-compatible computers often use Intel microprocessors. Apple Macintosh PCs use Motorola microprocessors.

**Microsoft Windows:** Is a trademarked operating environment using a graphical user interface (GUI) and DOS-based operating system software. Software applications used in Windows mirror the Windows GUI look and feel. Windows has three different versions, Windows 3.0+, Windows 95 and Windows NT, the latter being a stand-alone operating system not dependent on DOS.

**mirror sites:** Information stored on a host computer or server can be replicated on another host computer or server in a different geographic location. This is known as a mirror site, and is designed to speed up local, regional or national access to that information across telecommunications networks.

**modem:** A modem converts digital data in a computer into analogue data which can be carried as sound over ordinary telephone lines. Conversely incoming analogue data is converted back into digital data. Currently typical modem speeds are 28.8Kbits/s to 56.0Kbit/s.

**moire:** Misregistration of the ink dots in halftone prints creates a visible pattern or moire effect which interfers with the visual content of the photograph.

**monitor:** The screen connected to a computer on which all text and graphics data is displayed. Also referred to as the display screen. Monitors may capable of displaying data in two colours (monochrome) or colour. The quality of a monitor's display depends upon its physical construction, the video adaptor/card installed and the video standard supported.

**monochrome:** A system that can only display two colours, one light, one dark.

morphing: A special software process which enables one shape to be converted or merged into a different or distorted shape. Morphing can be applied to still frames, video or moving pictures.

**motherboard:** The main printed circuit board of a computer which holds the microprocessor or Central Processing Unit (CPU).

**Motorola:** A company specialising in the manufacturing of microprocessors frequently used in Apple Mackintosh and Hewlett Packard PCs.

**mouse:** An input device, connected to the computer via a serial port, which controls the movement of a pointer or cursor on a monitor's screen.

**MPEG Moving Pictures Expert Group:** A file format for digital video and audio data which enables high compression of data.

**MS-DOS Microsoft Disk Operating System:** An operating system software designed by Microsoft for IBM PC and IBM PC compatible computers. The functionality of MS-DOS is controlled by the user by typing keyboard commands. As users have demanded more intuitive graphical user interfaces, MS-DOS has disappeared into the background of new operating environments such as Windows 95.

**multi-media:** Digital content represented by text, graphics, images, and sound.

**MultiRead specification:** A worldwide standard for CD-ROM drives enabling them to read CD-ROM, CD-R, CD-RW and DVD-ROM.

**multi-tasking:** The ability of a computer's central processing unit (CPU) to work on more than one task, or to execute several instructions, simultaneously.

**N** nanosecond: One billionth of one second.

**native:** A file format or software routine which is exclusive or proprietary to a particular software application.

**nerd:** A term of abuse, meaning a sad introverted individual fascinated by computers and the Internet, or a term of pride, meaning a clever cybernaut who surfs the Information Superhighway.

**Netscape's Navigator:** Currently the most popular softwre browser on the Web, with over 70 per cent of the Web user market. Navigator's main rival is Microsoft's Internet Explorer.

**network:** An interconnected system of computers which can share data, software applications, and peripheral devices, such as printers.

**newsgroup**: A collection of articles, known as postings, around the same subject or theme, found on Usenet, a particular part of the Internet. Currently, it is estimated there are over 9,000 newsgroups.

**noise:** The addition of pixels with randomly distributed colour creates local noise in an image. This can be used to blend and smooth edges.

**NTSC National Television Standards Committee:** A video output standard for TV monitors of 525 lines resolution displayed in 60 fields, used predominantly in the U.S.A. See HDTV and PAL.

**NuBus:** Apple Computer's trademark for an expansion bus in Apple Macintosh computers which enables fast data transfer.

**object-orientated graphics:** Lines and shapes in graphics files defined by software applications using mathematical vector descriptions, rather than simple xyz co-ordinates. **O**

**OCP Online Content Provider:** These are private companies or organisations which provide online services to subscribers who obtain information by connecting to a private network via a direct dial-up telephone link. Usually the online service is also linked to the Internet through security firewalls to protect the private network. America Online, Compuserve, Delphi, Prodigy and Microsoft Network (MSN) are some of the largest global online services.

**OCR Optical Character Recognition:** Software which is able to differentiate between text and other graphical or image subjects and accurately reproduce the text. OCR software is used in operating monitors, scanners and printers.

**open architecture:** The IBM PC is an example of open architecture system design where the specifications are made public so that third party developers can design complementary hardware or software that uses the functionality of the open architecture.

**operating system:** Software that controls the main functionality of a computer's hardware, and provides an interface through which the user can instruct the computer. Software applications rely on the operating system software to translate instructions between the application and the computer.

**OS/2:** A trademark operating system software designed by IBM and Microsoft capable of multitasking, using virtual memory, and for later versions, the automatic installation and configuration of PCMCIA cards.

**out-of-gamut colours:** These are colours which can not be represented by the output device (monitor, printer). The device will select the closest colour to the out-of-gamut colour it can.

**output device:** A printer or monitor which creates a visual reconstruction of computer data, or a removable storage medium which permits transference of data from one computer to another.

**output:** A digital file may be output from a computer to: a digital storage device (transfer medium) such as a CD-ROM or floppy disc; a digital printer to paper; a photographic printer to paper or film.

**P** **page (Web):** A single page of a document on the Web which can contain text, graphics, images and sound.

**paint program:** An application for creating or editing bit-mapped graphics files, including images, which uses tools for drawing lines or shapes, for infilling with colour, for applying brush strokes and other similar artists techniques.

**PAL Phase Alternating Line:** The video output standard for a TV monitor producing 625 lines displayed in 50 fields, widely used in the UK and Europe.

**palette:** The range of colours which can be represented on a monitor, printer, or an original photograph, artwork or print.

**parallel port/interface:** A system of connectors using multiple, parallel wires and multiple pin sockets to enable transmission of data between a computer and a peripheral device. Each parallel wire transmits one bit of data at a time, so the entire interface can transmit many bits simultaneously. Parallel ports/interfaces are used to connect printers and monitors where large volumes of data must be transmitted.

**passive-matrix:** A liquid crystal display (LED) screen in which the display in individual rows of pixels is controlled with a single transistor. Active-matrix LCDs are brighter and sharper than passive-matrix because individual pixels are controlled by individual transistors.

**paste:** The insertion of text or graphics from a temporary buffer storage into the current, open, file.

**PC:** The abbreviation for personal computer. The Apple Mac, IBM PC and IBM PC compatibles are all different types of personal computer.

**PCD:** The proprietary file format used for storing images on PhotoCD. The PCD file is actually an Image Pac of five or six images of different sizes arranged in a hierachical system.

**PCMCIA Personal Computer Memory Card International Association card:** A PC card introduced in 1989 by a consortium of 25 IT companies offering a storage capacity varying between 4Mb to 340Mb for use in digital cameras and laptop computers.

**PDF Portable Document Format:** A file format designed by Adobe to maintain page layout and design of the original application which created the file. It is a useful cross-platform file for transferring documents across networks.

**Pentium:** A fast, powerful, microprocessor manufacturered by Intel. Pentium microprocessors are fitted to many IBM and IBM PC compatibles.

**peripheral/peripheral device:** A description of any type of hardware, such as a digital camera, scanner, printer, modem, removable hard disk drive or CD-ROM drive, which can be connected to a computer. Most peripherals are external to the base unit of a PC, though some peripherals are now regularly fixed within the unit, such as CD-ROM drives, and drives for removable storage media, including Zip, Jaz and/or Syquest drives.

**photo-realistic:** A description generally applied to digital prints where the quality is equivalent to that produced by conventional silver halide photography.

**PhotoCD:** A proprietary system developed by Kodak for storing scanned images on a special CD-ROM, each scan comprising an Image Pac of five or six images at different resolutions.

**PIC:** A proprietary graphics file format used within Lotus 1-2-3's spreadsheet software application.

**PICT:** A proprietary file format for low resolution bitmapped and object-orientated graphics, used on Apple Macintosh computers. PICT II is the current version supporting 24-bit colour. This type of image can be displayed on the monitor using the Mac OS operating software.

**PIW Photo Imaging Workstation:** A proprietary scanner and CD-writer used by Kodak to write images to a special CD-ROM called a PhotoCD.

**pixel (PICture ELement) :** The smallest block of information in a digital image which records colour, brightness and saturation. Pixels are usually square or rectangular, and are usually arranged in a grid. The higher the quality or resolution of an image, the greater the number of pixels in the image file, and the larger the file size (in kilobytes or megabytes). Pixel is also the term given to the minute light sensitive receptors in the Charged Couple Device (CCD) chip in a digital camera, and to the phosphor based receptors in a computer or TV monitor which are excited by an electron beam(s) to form an image.

**pixel count:** The total number of pixels in an image.

**pixelation:** The individual pixels in an image are large enough to be seen by the human eye, revealing a grid of coloured squares. This phenomenum is observed when small image files, of inherently low resolution, are reproduced on a monitor, or printed on paper, at large output sizes.

**platform:** Refers to the type of computer system, for example Apple Macintosh, IBM PC, IBM PC compatible, and Unix.

**plug-in:** An application which can be inserted into an existing software application to add extra functionality. Plug-ins are often used in image editing software and within Web browsers.

**PMS Pantone Matching System:** A trademarked colour matching system to enable calibration between monitors and printers and to check colour fidelity within the PMS colour space.

**PNG Portable Network Graphics:** A platform-independent file format which offers 8-bit to 24-bit colour depth, progressive display and lossless compression. Currently it is under-utilised on the Internet, but is likely to become more popular as more software applications are developed and distributed.

**POP Point-of-Presence:** The exact telephone number(s) which can be dialled to access a network. Most Internet Service Providers (ISPs) provide local POPs for subscribers to access the Internet at local call charge rates.

**port:** A connection through which data is transfered between the central processing unit (CPU) of a computer and a peripheral device. A port is also referred to as an interface.

**portrait orientation:** Vertical alignment of the long axis of a rectangular image file or photograph.

**posterise:** A technique for averaging areas of colour in an image file, by reducing the colour range or gamut, to emphasise graphical shapes and create a more poster-like effect.

**PostScript:** A page description language created by Adobe to convert digital files into a suitable format for outputting to high quality digital printers. The appearance of graphics, images and type are precisely controlled by the PostScript language. Typical desktop publishing(DTP) software, including Adobe Photoshop, Adobe Illustrator, Quark Xpress and Adobe Pagemaker, is designed to accept PostScript files.

**PowerPC:** A trademark for a special microprocessor (chip) which uses RISC (Reduced Instruction Set Computer) architecture, jointly developed by Apple Computers, IBM, and Motorola. RISC microprocessors can execute instructions at very high speeds. Latest versions of the PowerPC chip, the Motorola 604, fitted to Apple's PowerMac range of PCs operate a 64-bit data transfer system.

**ppi pixels per inch:** A measure of the resolution of a digital image capture system. The greater the ppi, the higher the resolution and the finer the detail which is recorded.

**PPP Point-to-Point Protocol:** Part of the Internet protocols (sets of rules) which permit communication between dissimilar modems or transmission/receiving devices.

**printer driver:** Software which enables the operating system of a computer to communicate with a printer. Printer drivers vary according to the type of printer and the brand name.

**printers for graphics:** The following devices are most suitable for printing graphics files, including images: ink-jet, laser, thermal, thermal wax and dye-sublimation printers. Quality of printing varies from excellent photo-realistic results to rough photo-like proofs.

**program:** A set of commands or instructions which instruct a computer to execute specified functions. Programs are written in programming languages, such as BASIC, FORTRAN or C. Operating system and application software contains one or many programs.

**protocol:** Protocols interpret incoming data from a communication system, and arrange outgoing data, by defining the data flow in terms of format, packaging, running order and error correction.

**PS/1 and PS/2:** Trademark for IBM's personal computers launched in 1990 and 1987 respectively. PS/2 IBM PCs can use OS/2, DOS and Windows applications.

**Q** **QuickDraw:** Apple Computer's trademark for a system which permits rapid redrawing of graphics using object-orientated, rather than bit-mapped, technology. QuickDraw is an essential part of the Apple Macintosh graphical user interface (GUI).

**QuickTime:** Apple Computer's trademark for an extension used in their System 7 operating software. Multimedia applications often use QuickTime to display digital video and other data which includes a time element.

**R** **RAID Redundant Array of Inexpensive Disks:** An interconnected group of hard disk drives often used to store large databases where fast retrieval of data is required.

**RAM Random Access Memory:** The temporary memory created within a computer when it is switched on. Large amounts of RAM are needed to handle large data files. RAM and data files are both defined in kilobytes or megabytes. Static RAM (SRAM) operates at higher access speeds than EDO RAM or Dynamic RAM (DRAM). Video RAM (VRAM) is RAM dedicated to displaying data on a computer's monitor.

**raster graphics:** Also known as bit-mapped graphics, are files made up of rows of dots or pixels. The location, size and colour of each pixel is controlled by the type of file format. A raster image is a bit-mapped image.

**re-sampling up:** The process of adding extra pixels to an image by using software. See interpolation.

**re-sizing:** The process of atering the resolution or the horizontal and vertical dimensions of an image. Execution of this process involves sampling the data and/or compressing it to reduce the size of the file.

**real time:** Instantaneous processing of data and/or display of the results on a monitor, printer, or any other hardware.

**refresh rate:** The frequency with which an image on a cathode ray tube (CRT) monitor is re-written by transmitting a new beam of electrons. Refresh rate is measured in hertz and is typically between 50 to 80 hertz.

**removable cartridge:** A portable hard disk contained in a plastic or metal casing. Typical trademark examples include Jaz, Syquest and Zip cartridges. Storage capacities typically vary from 40Mb to 1Gb.

**removable storage media:** Media which can store digital data. The media can be physically transported and be re-connected to computers for downloading the data. See transfer media.

**render:** The process of re-displaying an image on a monitor after an editing step has been applied to the file.

**repro:** The process of taking a conventional photograph, graphic or text, scanning it to produce a digital image file, separating the image into components of cyan, magenta, yellow and black, and preparing plates for printing with four coloured inks onto paper.

**resize:** The process of changing the dimensions and resolution of an image and hence the arrangement and number of pixels within the image. Resizing can also be applied to text documents and active windows in graphical user interfaces (GUIs).

**resolution:** A measurement of the amount of information a system can record and/or reproduce, or a digital image file can contain. Higher resolutions generate finer detail. Units of resolution include dots per inch (dpi), lines per inch (lpi), pixels per inch (ppi), or horizontal pixels multiplied by vertical pixels.

**RGB colour space:** Red, green, blue are the primary colours used to create the colour spectrum found on TV and computer monitors. This is an additive process using transparent colours of light.

**RIFF Raster Image File Format:** A format often used for images due to be output as greyscale rather than colour prints.

**RIP Raster Image Processor:** Files described in a page description langugage, defining the spatial relationship between graphics and text, are converted by a special processor before being sent to the output device, usually a high-end imagesetter or printer.

**ROM Read Only Memory:** This type of computer memory can store new data which can be read at a later date, but can not be subsequently amended or updated. ROM remains even viable after the power has been switched off. Many digital cameras use EPROM in which to store captured images. CD-ROMs are a compact disc storage medium to which data can be written once, but read many times.

**root directory:** Is the directory or folder within which all other directories or folders are nested in a hiearchical structure.

**sans serif fonts:** See serif fonts.  **S**

**saturation:** A measure of the purity of a colour, usually expressed as a percentage. For example 100% saturation is a vivid, rich, fully saturated colour with no grey, 0% is grey and 10% to 20% is a dull, lacklustre, colour showing poor saturation.

**scalable font:** See TrueType.

**scanners:** Devices which convert the analogue data of photographs and artwork into the digital data of image files. The amount of information recorded depends upon the exact method of data conversion, the quality of the CCD scanning array and the number of sampling points which determine the input resolution.

**screen grab:** The process of capturing the full screen graphic or image on a monitor and saving it as a bit-mapped file using the operating system software.

**screen resolution:** Computer monitors generally have an output of 72dpi, which equates to viewing resolutions of 640 x 480 pixels for a standard Video-Graphics Array (VGA) monitor, 800 x 600 pixels for Super VGA, and up to 1600 x 1200 pixels on a 21 inch monitor.

**screen saver:** A utility program which protects monitors from degradation. Images constantly projected on a monitor can burn out the phosphors, so screen savers introduce to a moving image after a preset time.

**SCSI Small Computer Systems Interface:** A high speed parallel port/interface permitting transmission of data up to 32 megabits (4Mb) per second and capable of connecting up to seven peripheral devices.

**SCSI-2:** A higher speed version of SCSI capable of transmitting data at 10Mb per second.

**search engine:** A software tool for locating digital files, user identities, documents, or other data, held within a database of such records. Two types of seaches are common, free text using natural language, or keyword, using specially defined words in an index attached to each record. The software generally searches for similar words as defined in the search query entered by the user.

**seek time:** The time taken for the read/write head of a disk drive to move into the correct position ready to read/write data.

**separation areas:** Discrete entities within a digital image which can be edited independently of the rest of the image. See layers.

**serial port/interface:** Transmits data one bit at a time between a computer and peripheral devices, such as modems, pointers (mouse, trackball, graphics pad). Serial ports contain a line for transmitting data, one line for receiving data and several lines for ensuring smooth data flow.

**serif fonts:** Typefaces in which vertical strokes are finished with a short horizontal line. These horizontal lines are absent in sans serif fonts.

**server:** A computer that stores files and programs which can be accessed by other computers (clients) on a client-server network or networks. Servers can also control the use of peripheral devices, such as printer, on the network.

**shareware:** Software which is distributed free of charge for a trial period. It is often a cut-down version of a full commercial software package.

**ShockWave:** Software which allows sophisticated presentation of multimedia data within Web pages permitting real-time animation, videos and movies. ShockWave plugs-in to the Web browser software. It has significantly improved the entertainment value of multi-media content on the Web.

**SIMM Single In-line Memory Module:** Random Access Memory (RAM) contained within a 30-pin module which is fitted to a computer's motherboard.

**single-shot (see triple-shot):** Images are captured by one exposure of the CCD chip or array.

**site (Web):** The location on the Web where a specific electronic publication, written in the language of the Web, Hypertext Markup Language (HTML), is found. A site usually comprises a home page with an introduction or contents listing, plus other linked pages.

**SLR single-lens-reflex:** This most popular camera design incorporates a facility to view pictures directly through the lens by using a mirror. The mirror is moved out of the focal path of the light when the shutter is tripped.

**SmartMedia:** A PC card varying between 2Mb to 16Mb which can be fitted to a digital camera or laptop computer to enable data storage and/or downloading data.

**smoothing:** A technique used in image editing software to reduce contrast and to simulate an out-of-focus effect by averaging the values of colour, brightness and saturation of adjacent pixels. The size of the groups of pixels can be defined to control the contrast and soft focus effects.

**software:** A collective term for programs, computer languages and data which control the functionality of computer hardware. Systems software controls basic computer workings. Software applications perform related groups of tasks, viz.: word processing, image editing, page layout, spreadsheets.

**Sony Mavica:** The world's first digital still video camera, the MAgnetic VIdeo CAmera (Mavica) launched in 1981.

**sound card:** Digital reproduction of sound is enhanced by connecting a sound card, or specialised printed circuit board, to the motherboard of a computer.

**SQL Structured Query Language:** A language for making searches on a relational database where data is held in tables which can be cross referenced and from which sub-sets of data can be extracted.

**startup disk:** This is usually the hard disk of a computer which holds the software for the operating system. Applications can be located a startup folder on the startup disk so that they are automatically opened when a computer is switched on.

**storage:** A computer holds data in temporary storage, Random Access Memory (RAM), or in permanent storage, such as hard disks, floppy disks, CD-ROM, and removable hard drives.

**surf:** Cyberspeak for the action of jumping from one Web page to another and another, ad infinitum, riding the digital wave (of information).

**SV Still Video:** Light entering a still video camera is converted by a transistorised pick-up device to an analogue signal which is recorded on special a floppy disk or memory card.

**SVGA Super Video Graphics Array:** A video standard for computer monitors featuring a minimum resolution of 800 x 600 pixels and 24-bit colour (16.7 million colours).

**syntax:** Rules governing grammar and spelling in a computer language.

**Syquest cartridge:** A proprietary removable hard disk of 40Mb, 80Mb, 120Mb, 270Mb or 1.5Gb storage capacity.

**System 7:** A trademark of Apple Computer, defining their operating system software, now superceded by Mac OS 8.0.

**TCP/IP Transmission Control Protocol/Internet Protocol:** A transmission standard **T** for digital data which uses a group of protocols used to allow information to be transferred across telecommunications networks and the Internet. This protocol defines how data is sent and received over a telecommunications network.

**Telnet:** This special Internet tool allows access to host computers by remote users, mimicking the interface and functions of the host computer. Users can access databases directly, as if they were physically present at the remote location.

**template:** A standard page layout or graphical layout which can be edited by a user. Templates are often found in word processing, graphic design and image editing software.

**terabyte:** Approximately one thousand gigabytes or one million megabytes. A measurement of an amount of digital data or storage space.

**TFT Thin Film Transistor display:** A very bright colour-rich flat screen, of higher display quality than a Liquid Crystal Display screen because the red, green and blue light componenets are controlled by independent transistors for each pixel.

**thermal dye-sublimation printer:** A medium to high resolution printer which produces a coloured print by overlaying semi-transparent inks onto paper. Simulated continuous tone colour is created by the action of varying the dot intensity of dyes and the ability of the dyes to vaporise at high heat and diffuse into special paper or transparency material.

**thermal wax transfer printer:** A low to medium resolution printer which uses heat to transfers wax-based coloured inks to paper or transparency materials. Resolution is dependent on the number of heating elements per unit length. Each colour, in the CMYK system, is layed down one after the other.

**thermo-autochrome printer:** A medium to high resolution printer which converts digital data into a red, blue and green laser beam to expose a donor paper impregnated with coloured silver-halide based dyes, producing continuous tone prints.

**thumbnail:** A low resolution image file, of 5Kb to 15Kb size, used to show a small visual example of the original image file. Thumbnails are typically displayed as postage-stamp size images on computer monitors and as a tool to quickly search databases. Clicking on a thumbnail often retrieves a larger screen resolution image file, from the database, which contains more detail. Certain image file formats support a thumbnail version of the file.

**TIFF Tagged Image Format File:** A cross-platform image file format often used for archiving and printing of high resolution images. It is the standard file format for high resolution bit-mapped graphics. TIFF files must be converted into other formats before printing.

**toolbar:** A linear group of buttons designated with an icon, which is activated by clicking with a pointer or mouse, controlling specific functions in an image editing software application.

**trackball:** A rotating ball which moves a pointer on a monitor screen.

**transfer media:** See removable storage media.

**Triple-shot:** Images are captured by three exposures of the CCD chip or array. The first exposure captures Red light, the second Green and the third Blue light. See single-shot.

**true colour:** Any system that supports 16.8 million colours, i.e.24-bit colour, supports true, continuous tone, colour.

**TrueType:** An open industry standard trademarked scalable font or typeface whose size can be scaled up or down on a monitor and a printer without further hardware or software support.

**TWAIN:** A protocol or signalling language for communication and the exchange of data between personal computers, software applications and peripheral devices, such as digital cameras and scanners.

**Typeface:** A specific design of type or font.

**Undo:** A command to reverse the last editing command applied to an image. Some applications permit multiple undo.

**U**

**UNIX:** A multi-user operating system used in business, scientific and educational industries which is well adapted for network use, giving a flexible, secure and powerful system. NeXTStep is a UNIX graphical user interface (GUI).

**unsharp masking:** A process to re-arrange pixels, and adjust the information in each pixel, to generate an image which appears sharper, with more detail. It can be performed during or after scanning, using hardware and software technology.

**upgrade:** To improve the performance of a computer by adding more memory, storage space and/or peripheral devices. The term is also applied to software when a old version can be upgraded to a newer version.

**upload:** To send a copy of a file from a user's computer to another computer using a telecommunications network.

**UPS Uninterruptible Power Supply:** A device which will protect the data on your computer in the event of a power surge or power cut.

**URL Uniform Resource Locator:** The exact address of a Web site as defined in a string of characters. Typically a string comprises: the defining protocol, the part of the Internet, the name of the company or organisation, the geographic location and specific user and/or file names. For example - http://www.ukplus.co.uk/index.html is the IP address of the UKPlus directory, a private company, in the UK, on the Web, accessed using the Hypertext Transfer Protocol (HTTP). Part of the string refers to the domain , or domain name, of the computer where the information is stored: 'uk' refers to the top domain name, 'co' a sub-domain and 'www' the host computer name. See domain and host computer.

**Usenet:** A global system of over 15,000 newsgroups, each with a defined subject area and list of members, which discuss topics by placing messages on bulletin boards. Usenet can be accessed via the Internet, but some Usenet groups are on private networks.

**user friendly:** A term applied to an easy to use menu-driven or graphical user interface (GUI). User friendly hardware or software is designed to be used by inexperienced operators.

**user interface:** A user may interact with a computer's interface by typing commands, by selecting from a menu of options by keyboard commands or a mouse pointer, and/or by selecting and activating graphical icons and windows. A graphical user interface (GUI) utilises all these options.

**utility:** An application that manages a specific task within a computer's operating system software or other software applications.

**uudecode:** A set of applications for encoding binary data as ASCII text which is used to encrypt files for transmission over networks.

**V**  **vector-based applications:** Software applications which permit the user to work with graphical shapes such as lines, arrows and fills for discrete areas, rather than using tools which give softer artwork, such as rubbers and brushes. Vector graphics are described mathmatically rather than being described by points on a grid, as for bit-mapped graphics.

**vector:** Data contained in a one-dimensional structure such as a row or column.

**VGA Video Graphics Array:** An international standard to define the display of data (images, text, graphics) on television, video and computer monitors. VGA monitors have a resolution of 640 x 480 pixels with up to 16-bit depth colour or 320 x 200 pixels with 8-bit colour (256 shades).

**video accelerator:** A microprocessor designed to be able to rapidly process graphic data.

**video adapter:** The quality of a monitor's display, the speed at which images can be redisplayed is controlled by a special expansion board/card called a video adapter.

**video card:** Special microprocessor hardware inserted into computers and monitors to increase the number of colours which can be displayed and speed of conversion of digital data into visual, red, green, blue, data.

**video frame grabber:** Software and hardware which enables individual frames of a video to be digitised and converted into a still digital image.

**video standards for monitors:** Video Graphics Array (VGA) and Super VGA (SVGA) are the two main international standards, supporting monitor graphics resolutions of 640 x 480 pixels and 256 to 32,000 colours, and 800 x 600 pixels and 16.8 million colours respectively. See also HDTV, NTSC, PAL video standards for television.

**virus:** Rogue commands or instructions that can duplicate and attach themselves to software applications and operating systems. Viruses may be harmless or can erase data and crash applications and/or operating systems.

**VRAM Video Random Access Memory:** A special type of memory located on the video adaptor to control the display on a monitor. VRAM is a form of Static RAM.

**W**  **WAN Wide Area Network:** A group of computers connected to telephone or satellite networks, enabling data, resources, databases, applications and peripherals to be shared. The Internet is a public WAN, an intranet is a private WAN.

**watermarking:** The process of altering the pixels in an image to produce a visible watermark to protect images from copyright theft.

**Web browser:** Software which permits the downloading, display, storage and/or printing of multi-media content from the Web.

**window:** A rectangular frame within a computer interface that displays the current digital file or document. Many graphical user interfaces (GUIs) can display multiple windows, but rarely more than one or two can be active at any one time.

**Windows 95:** An operating environment introduced by Microsoft Corporation in 1995 using 32-bit processing and an architecture which recognised when new devices are added to the system, making it a plug n' play system. The background operating system is MS-DOS.

**Windows NT:** An operating system introduced by Microsoft Corporation in 1993. It can run software applications written for DOS, OS/2 and Windows based operating systems.

**wizard:** An on-screen guide which uses dialogue boxes to provide shortcuts or automatic execution of a task in a software application or operating system.

**word processing:** a software application for text input, editing and style formatting.

**workstation:** a powerful personal computer capable of very high speed processing of data.

**WWW, W3, World-Wide-Web:** The part of the Internet which comprises servers (special computers) which communicate with other computers on global networks using a set of rules, known as the HyperText Transport Protocol (HTTP). Today there are estimated to be tens of thousands of servers around the globe, each one capable of storing thousands of digital files which can be viewed by using software browsers on computers linked to the servers through telecommunication networks. Multimedia information (text, graphics, images, video and sound) is readily presented and distributed via the Web. Information is published within discrete Web sites, using a language called Hypertext Markup Language (HTML). Sites are located by a specific address or Uniform Resource Locator (URL). URLs can be embedded as a hypertext link within the multi-media content permitting a user to jump from one Web page to another page which may be within the same site, or may be on another site in another country. Hence there is an infinite web of links to information stored in servers all over the world. This accounts for its meteoric rise in popularity of the Web as the new electronic publishing medium of the late twentieth century.

**WYSIWYG:** What You See Is What You Get describes a perfect match between what is displayed on a monitor and what is output to a printer or other output device.

**X, Y or Z modem:** Protocols or signalling languages used between modems to **XYZ** transfer data from one computer to another.

**YCC:** A colour space used by PCD image files stored on a PhotoCD. YCC is a variant of hte Hue, Saturation, Lightness (HSL/HSB) colour space.

**zoom:** A facility built into some operating systems and applications enabling automatic zooming of window size in a graphical user interface. MacOS has a zoom system called CloseView which permits zoom from x 2 to x16 of the full screen. Some image editing softwares have a zoom tool to facilitate detailed editing of individual pixels.

# Appendix I: Company contacts

Telephone directory for selected digital camera and hardware manufacturers, dealers and retailers, and software publishers

4-Sight International Ltd  Tel: 01202 764401
Adobe Systems UK Ltd  Tel: 01256 463344/0131 453 2211
Agfa-Gevaert Ltd  Tel: 0181 231 4200
Alps  Tel: 0800 973405
Apple Computer UK Ltd  Tel: 0181 569 1199
Bannerbridge plc  Tel: 01268 419101
Broderbund  Tel: 01429 855 048
BIT (UK) Ltd  Tel: 01420 83811
Canon (UK) Ltd, Photo Division  Tel: 0181 459 1266
Casio Electronics Co Ltd  Tel: 0181 450 9131
Channel Marketmakers  Tel: 01703 814142
Computers Unlimited  Tel: 0181 358 5857
Corel Photo-CD Europe  Tel: 01435 862748 or 865660
Digital Workshop  Tel: 01295 258335
Dixons  Tel: 0181 200 0200 or 08000 682868
Epson  Tel: 01442 227478
Fargo  Tel: 01268 419101
Fractal Design  Tel: 01756 704000
Fuji  Tel: 0171 722 4259
Fujifilm  Tel: 01234 245245
Graphics Unlimited  Tel: 01462 491563
Hewlett Packard  Tel: 0171 939 2345 or 0344 369222
IMC  Tel: 01344 872800
Imaging Associates  Tel: 01844 213790
Impact  Tel: 01483 797200
Iomega  Tel: 0800 973194
Jessop  Tel: 0116 232 0060
Johnsons Photopia  Tel: 01782 717100
Keybase Systems  Tel: 0117 9294555
Kodak  Tel: 0800 281487/01442 61122
Konica  Tel: 0181 751 6121
Kyocera Yashica  Tel: 01734 311919
La Cie  Tel: 0171 883 0009
Lexmark International  Tel: 01628 481500
Linotype-Hell  Tel: 01242 285000
Metacreations  Tel: 01756 704000

MGI Software  Tel: 0171 365 0034
MicroGraphx  Tel: 0191 510 0203/01483 47526
Microsoft  Tel: 0345 002000
Microtek  Tel: 0171 627 1000/0181 200 8282
Minolta  Tel: 01908 200400
Mitsubishi Electric Imaging Ltd  Tel: 01707 276 100
NBA Quality Systems  Tel: 01483 542100
Nikon  Tel: 0181 541 4440 or 0800 230220
Olympus  Tel: 0171 253 0513
Panasonic  Tel: 0500 404041
Pentax  Tel: 01753 792792
Plasmon  Tel: 01763 262963
PhotoDisc  Tel: 0181 2552900
Polaroid  Tel: 0800 010119/01582 632000
Principal  Tel: 01756 704444
Ricoh  Tel: 0181 751 6611
Samsung  Tel: 0181 862 9311
Sanyo  Tel: 01923 225672
Sharp  Tel: 0161 205 2333
Softkey  Tel: 01923 208400
Sony  Tel: 0990 381122
Spaceward Graphics  Tel: 01954 261333
Syquest  Tel: 0131 339 2022
TDS  Tel: 01254 676921
Tektronix  Tel: 01628 403300
Umax  Tel: 01344 871329
Vivitar  Tel: 01793 544814
Wacom  Tel: 0181 200 8282/0171 928 7551
Wright Technologies  Tel: 01582 455471

# Appendix II: Useful organisations in the UK

Arts Council
14 Great Peter Street
London SW1P 3NQ
Tel: 0171 973 6474

Association of Photographers
9-10 Domingo Street
London EC1Y 0TA
Tel: 0171 608 1441

British Association of Picture Libraries & Agencies
18 Vine Hill
London EC1R 5DX
Tel: 0171 713 1780

British Institute of Professional Photographers
Amwell End
Ware
Hertfordshire SG12 9HN
Tel: 01920 464011

Bureau of Freelance Photographers
Focus House
497 Green Lanes
London N13 4BP
Tel: 0181 882 3315

Guild of Wedding Photographers UK
13 Market Street
Altringham
Chesire WA14 1QS
Tel: 0161 928 3716 or 0161 926 9367

Master Photographers Association
Hallmark House
2 Beaumont Street
Darlington
Co Durham DL1 5SZ
01325 356555

Photo '98
The Year of Photography & Electronic Imaging
Kirklees Media Centre
7 Northumberland Street
Huddersfield HD1 1AL
Tel: 01484 531201

Photo Marketing Association International (UK) Ltd
Peel Place
50 Carver Street
Birmingham B1 3AS
Tel: 0121 2120299

Royal Photographic Society
The Octagon
Milsom Street
Bath BA1 1DN
Tel: 01225 462841

Society of Wedding & Portrait Photographers
5 Liverpool Road
Ashton Cross
Wigan WN4 0YT
Tel: 01942 711763

A number of the organisations listed above organise photography competitions and include a category/categories for digital images. Competitions are also organised by a number of leading manufacturers including Adobe (Tel: 0181 606 4006), Agfa in conjunction with BJP (Tel: 0181 560 4435), Fuji (Tel: 0171 586 5900) and Kodak (Tel: 01925 246519).

# Appendix III: UK digital imaging services

The following companies have multiple outlets, please contact the Head Office to locate the nearest branch:

CPL, Fircroft Way, Edenbridge, Kent TN8 6ET. Tel: 01732 862555 - eight outlets in southern England for the professional market.
The Jessop Group Ltd, Jessop House, 98 Scudamore Road, Leicester, Leics LE3 1TZ. Tel: 0116 232 0432 - 76 outlets in the UK for the consumer and professional market.
KJP, Promandis House, Bradbourne Drive, Tilbrook, Milton Keynes MK7 8AJ. Tel: 01908 366344 - 16 outlets in the UK serving the professional market.
Maxim London Limited, 22a Arlington Way, London EC1R 1UY. Tel: 0171 278 6706 - three outlets in London, Birmingham and Bristol for the professional market.
Tecno, Enterprise House, Maxted Road, Hemel Hempstead, Herts HP2 7BT. Tel: 01442 233 500 - 26 outlets in England for the consumer and professional market.

There is a good choice of independent companies, some with one or more outlets within the regions listed below:

East Anglia

Campkins Camera Centre Ltd, Cambridge.  Tel: 01223 364223
Digital Imaging Centre, Cambridge. Tel:  01223 361651
GGS Photo Graphics, Norwich. Tel:  01603 622500
Lab 7, Lincoln. Tel:  01522 544025
Reflections, Norwich. Tel:  01603 630081

London

Acorn Studios plc.  Tel:  0171 8378667
Action Graphics.  Tel:  0181 9400520
Altered Image.  Tel:  0171 8338334
Black 'n White n' Colour.  Tel:  0171 4050055
Ceta Imaging.  Tel:  0171 434 1235
Colour Company.  Tel:  0171 2511285
Contour Colour Services Ltd.  Tel:  0171 3231166
DP Photographic.  Tel:  0171 713 0723
Data Layout.  Tel:  0171 4038106
Davey Photo-Summit Ltd.  Tel:  0171 6362778
The Display Board Company Ltd.  Tel:  0171 2315433
Electro-Tech Colour Ltd.  Tel:  0171 6366677

Equator Photographic. Tel: 0171 8376111
Flash Phtoographics Ltd. Tel: 0171 7279881
Flashlight Photographic Services. Tel: 0171 5867272
Fleet Photos. Tel: 0171 3534610
Graphix Imaging. Tel: 0171 5382329
Harrow Photolabs Ltd. Tel: 0181 4279022
Howard Thomas Photographic Service Ltd. Tel: 0181 6592296/7
I C Video. Tel: 0181 2056687
Joe's Basement Ltd. Tel: 0171 4393210
John Wilson Ltd. Tel: 0171 4371057
Jones Bloom Imaging Ltd. Tel: 0171 636 0590
Jupiter Display Ltd. Tel: 07000 414414
Laserbureau. Tel: 0171 9359944
Leeds Photovisual. Tel: 0171 8331661
Lightbox Creative Services. Tel: 0171 5205100
McKenzie Clark Ltd. Tel: 0171 2316070
Metro Imaging Ltd. Tel: 0171 8650000/0171 490 8833
Mr Cad. Tel: 0181 6848282
Negs Photograhic Ltd. Tel: 0171 4371403
Ohio Imaging Ltd. Tel: 0181 6800590
Optikos Colour Studios. Tel: 0171 4908855
Professional Photographic Processing Ltd. Tel: 0181 7520040
Professional Sport International Ltd. Tel: 0171 4822311
Promises SCP. Tel: 0181 7492136
Quicksilver Ltd. Tel: 0171 8567420
Regent Vision Ltd. Tel: 0171 7349970
SPS Ltd. Tel: 0171 4958705
Sarner International Ltd. Tel: 0181 7431288
Service Visual Communications plc. Tel: 0181 8744152
Sky Photographic Services Ltd. Tel: 0171 4342266
Slide Project. Tel: 0171 6229577
Solo Digital Imaging Ltd. Tel: 0171 2430007
Stockpile. Tel: 0171 6100030
Tapestry. Tel: 0171 4371821
UPPA Ltd. Tel: 0171 4216000
Wace Group plc. Tel: 0171 2503055
Zeta Image to Print. Tel: 0171 7873993

Midlands

Astro Art, Birmingham. Tel: 0121 7771802
Colab Ltd, Birmingham. Tel: 0121 6326433
Dean & Smedley Ltd, Ashby. Tel: 01530 412735/411457
Dishly Exhibitions Ltd, Loughborough. Tel: 01509 646553
Dunn's Professional Imaging, Cradley Heath. Tel: 0138 4564770
Five Valleys Photography, Stroud. Tel: 01453 766660
Harvest Studios Creative Group Ltd, Northampton. Tel: 01604 24422
ICL Individual Colour Laboratories Ltd, Birmingham. Tel: 01214 726747

K & S Digital & Photographic Imaging, Leicester. Tel: 0116 2470270
Leeds Photovisual, Kirkstall. Tel: 0113 2759000
Mass Mitec Presentation Graphics, Lubenham. Tel: 01858 410366
Morris Colour Lab, Birmingham. Tel: 0121 3271832
Northampton Colour Processors, Northampton. Tel: 01604 768886
Pro-colour, Nottingham. Tel: 0115 9784527
Quick Imaging Centre Ltd, Bromsgrove. Tel: 01527 871648
School Pictures International, Mansfield. Tel: 01623 657777
Stoneleigh Photo Graphic Imaging, Leamington Spa. Tel: 01926 427030

North & North East

Beverley Camera Centre, Beverley. Tel: 01482 868243
CC Imaging, Leeds. Tel: 0113 2330024
Greatrex Professional Imaging, Bradford. Tel: 01274 308632
Pro Digital Imaging, Leeds. Tel: 0113 245 4848
Saville Group Ltd, York. Tel: 01904 782782
Saville Group Ltd, Hull. Tel: 01482 446107
Wood Visual Communications, Bradford. Tel: 01274 732362

North West

GBM Group plc, Manchester. Tel: 0161 2735562
HPS Colour, Knutsford. Tel: 01565 722669
Ness Visual Technology, Widnes. Tel: 0151 4240514
Norwyn Photographics, Preston. Tel: 01772 254214
Preston Professional Labs, Bamber Bridge. Tel: 01772 627677
Professional Colour Laboratories Ltd, Manchester. Tel: 0161 8325663
Summit Studios, Manchester. Tel: 0161 6435892
Swift Photographic, Manchester. Tel: 0161 8669007
Tang Repro, Romiley. Tel: 0161 4307858

Scotland

Aberdeen Imaging Centre, Dyce. Tel: 01224 770585
B & S Visual Technologies Ltd, Glasgow. Tel: 0141 2218283
Elena Mae Ltd, Inverness. Tel: 01463 2321293
Expocolour Ltd, Edinburgh. Tel: 0131 6619089
Guthrie Photography, Glasgow. Tel: 0141 3339196

South & South East

Alchemy Graphics Ltd, Reading. Tel: 0118 9760077
Allied Photolabs, Surrey. Tel: 01372 379933
Applied Image Technology Ltd, West Malling. Tel: 01732 875000
Banbury Colour Imaging, Banbury. Tel: 01295 250552
Chelmsford Colour Labs, Chelmsford. Tel: 01245 451262
Chorely & Handford Ltd, Wallington. Tel: 0181 6694900

Colchester Colour Imaging, Colchester. Tel: 01206 751241
Colorific Ltd, Slough. Tel: 01753 770303
Colour by Colour, Reigate. Tel: 01737 226600
Colour-Plus, Linford Wood. Tel: 01908 662588
Concept Colour, Bishop's Stortford. Tel: 01279758954
Desktop Solutions, Hitchin. Tel: 01462 438887
Digi Lab International Ltd, Morden. Tel: 0181 3306828
The Digital Camera Company, Guildford. Tel: 01483 452100
Digital Darkroom, Silsoe. Tel: 01525 862456
Dormans Photo Imaging Ltd, Dunstable. Tel: 01582 665515
Hadland Photonics Ltd, Tring. Tel: 01442 821500
Hammonds AVS Ltd, Watford. Tel: 01923 239733
Harbutt Graphics & Visual Comms, Welwyn Garden City. Tel: 01707 335258
Hayward Associates, Romsey. Tel: 01703 813881
The Imaging Division, Harlow. Tel: 01279 444929
Jadon Designs, Welwyn Garden City. Tel: 01707 393120
Ken Pharaoh Ltd, Dartford. Tel: 01322 626100
Light Stop Ltd, Marlow. Tel: 01628 483181
MBA Group, Isleworth. Tel: 0181 8473777
Memories (Maldon). Tel: 01621 858240
PRC Colour Processing Ltd, Hampshire. Tel: 01428 723838/722953
Photogenesis Ltd, Watford. Tel: 01923 249866
Photo-Me International plc, Bookham. Tel: 01372 453399
Prophoto Ltd, Hedge End. Tel: 01489 790088
Renker Ltd, Abingdon. Tel: 01235 555189
Rivermead Studios Reading. Tel: 01491 872354
SSDM Ltd Reading. Tel: 0118 9595711
Shutters, Reading. Tel: 01734 404774
Sienna Europe Ltd, Thatcham. Tel: 01635 865651
Slides For Business, Kingston Upon Thames. Tel: 0181 5491972
Supersine Duramark Ltd, Reading. Tel: 0118 9595711
Superfine Photovideo Ltd, Brighton. Tel: 01273 417553
Synopsys Technology Ltd, Saffron Walden. Tel: 01799 513628
Thames Valley Systems plc, Reading. Tel: 01734 503500
Windmill Photographic Advertising Studios, Purley. Tel: 0181 6609993
Wycombe Cameras, High Wycombe. Tel: 01494 441941

South West

Alan Cooper Colour Labs, Newton Abbot. Tel: 01626 362216
Ashley Colour Laboratories, Poole. Tel: 01202 742508
Aviation Photographs International, Swindon. Tel: 01793 497179
Baths Photographic, Barnstable. Tel: 01271 343941
Baths Photographic, Bideford. Tel: 01273 479331
GWR Computer Imaging, Kingsbridge. Tel: 01803 712217
LP & TS Publishing Services, Somerton. Tel: 01458 274528
Nashua Photo Ltd, Newton Abbot. Tel: 01626 322022
Photo Media Ltd, Falmouth. Tel: 01326 377300

Photo Press Defence Pictures, Plymouth. Tel: 01752 401800
Photoworld, Weston-Super-Mare. Tel: 01934 629868
Service Visual Communications plc, Salisbury. Tel: 01722 321736

Wales

ACT Reprographics Ltd , Cardiff. Tel: 01222 492211
Perry Visual Communication, Cardiff. Tel: 01222 486868

# Appendix IV: UK magazines

Digital photography and other relevant magazines in the UK

Amateur Photographer
IPC Magazines plc
King's Reach Tower
Stamford Street
London SE1 9LS
Tel: 0171 261 5100
Weekly magazine for amateurs including news, equipment reviews, and technique features mainly for silver halide enthusiasts, but with increasing coverage of digital photography.

British Journal of Photography
Timothy Benn Publishing Ltd
39 Earlham Street
Covent Garden
London WC2 H9LD
Tel: 0171 306 7000
Weekly magazine aimed at professional and student photographers featuring news, portfolios, individual and business profiles, reviews of conventional equipment, and digital hardware and software .

Computer Arts
Beaufort Court
30 Monmouth Street
Bath BA1 2BW
Tel: 01225 442244
Publisher: Future Publishing
A monthly publication for digital artists. Coverage includes image manipulation, digital video, 3D, computer generated graphics, graphic design, illustration, multimedia, Web design and new technology for Mac and PC users.

Creative Technology
St John Patrick Publishers Ltd
3rd Floor
New Hibernia House
Winchester Walk
London SE1 9AG
Tel: 0171 357 6161

This monthly magazine for professionals in the creative media showcases the latest technological developments, product news, portfolios and interviews for those interested in digital photography, graphic design, video and multi-media.

Digit
IDG Communications Ltd
99 Grays Inn Road
London WC1X 8UT
Tel: 0171 357 6161
This magazine covers the world of digital creativity from photography to graphic arts and design, the Web, multimedia, digital video and 3D modelling for professionals, and the latest product reviews.

Digital Photo FX
EMAP Apex Publications Ltd
Apex House
Oundle Road
Peterborough
PE2 9NP
Tel: 01733 898100
A monthly magazine for beginners and amateur digital photographers with news, reviews, product bench tests, detailed technical 'how to' features, a useful buyers' guide and more.

Digital Photographer
Top Events & Publications Ltd
First Floor
Davina House
137-149 Goswell Road
London EC1V 7ET
Tel: 0171 250 3944
Digital photographer newbies are catered for in this monthly magazine which includes news, product features, bench tests and a software buyers' guide.

Electronic Imaging
Market Link Publishing plc
The Mill
Bearwalden Business Park
Wendrens Ambo
Saffron Walden
Essex CB11 4JX
Tel: 01799 544200
Monthly magazine for technicians in the creative and publishing industries including professional photographers, graphic designers, imaging bureaux and printers. News, product reviews and bench tests plus an extensive buyers' listing of input, manipulation, storage and output hardware plus software.

HotShoe International
Datateam Publishing Ltd
Farimeadow
Maidstone
Kent ME14 1NG
Tel: 01622 687031
Digital photography for professionals and imaging bureaux with news, product reviews, and in-depth features on high-profile businesses and professionals.

Internet magazine
EMAP Apex
Priory Court
30-32 Farringdon Lane
London EC1R 3AU
Tel: 0171 309 2700
News, events, software and hardware product reviews, a digest of the best Web sites and a list of Internet Service Providers, is the typical fare from this monthly magazine.

Mac Format
Future Publishing Ltd
30 Monmouth Street
Bath BA1 2BW
Tel: 01225 442244
Comprehensive review of hardware and software products for Macs form the backbone of this monthly magazine together with a buyers' guide of past and present products.

MacUser
Dennis Publishing Ltd
19 Bolsover Street
London W1P 7HJ
Tel: 0171 631 1433
A monthly magazine for Mac enthusiasts covering product reviews, news, and a buyers guide. An annual Mac Sources book, covering a vast range of hardware and software, is produced quarterly by the same publisher.

Macworld
IDG Communications Ltd
99 Grays Inn Road
London WC1X 8UT
Tel: 0171 831 9252
Product news, reviews and features permit readers to make informed opinions about the Apple Mac and Mac compatible products in this monthly magazine.

.Net
Future Publishing Ltd
536 Kings Road
London SW10 0TE
Tel: 0171 447 3300
A monthly magazine for Internet and Web enthuisiasts offering news, features, product reviews and a regular update of the best Web sites.

PC Direct
Ziff-Davies UK Ltd
International House
1 St Katherine's Way
London E1 9UN
Tel: 0171 9036800
This monthly magazine aims to enable readers to make informed decisions on buying new PCs, peripherals and software.

Personal Computer World
VNU Business Publications Ltd
VNU House
32-34 Broadwick Street
London W1A 2HG
Tel: 0171 316 9000
Numerous computer, peripherals and software test reviews, group and long-term tests, and hands-on advice fill the pages of this 700 page monthly magazine for personal computer users.

Practical Photography
EMAP Apex Publications Ltd
Apex House
Oundle Road
Peterborough
PE2 9NP
Tel: 01733 898100
News, product reviews, 'how to' features, bench tests of conventional and digital photography products, and a buyers guide is the staple fare of this monthly magazine for amateur photographers.

What Digital Camera
Top Events & Publications Ltd
Events House
P O Box 1008
Chester
Cheshire CH3 1GF
Tel: 01829 770880
Low-end and mid-range camera reviews are complemented by how to features, software and hardware product tests and news items in this monthly magazine for amateur digital photographers.

# Appendix V: Digital cameras

This appendix gives a breakdown of popular sub-£1,200 digital cameras and assesses their image capture quality on the basis of the original capture resolution and file size,

**Digital cameras**

| Camera model | Capture resolution (pixels) | Capture file size (Kb) | Compressed file size at highest resolution (Kb) | Compression factor |
|---|---|---|---|---|
| Casio QV-11<br>Vivitar Vivicam 2500, 2700 | 320 x 240 | 922 | 21 to 51 | 4.5 to 11.0 |
| Agfa ePhoto<br>Apple QuickTake 200<br>Casio QV 200, 300, 770<br>Nikon Coolpix 300<br>Panasonic KXL-600A<br>Sanyo Digicam<br>Sony Mavica MVCFD5, FD7 | 640 x 480 | 922 | 56 to 83 | 11.1 to 16.5 |
| Fuji DX-5, DX-7<br>Panasonic NPV-DC1000<br>Samsung SDC 33<br>Sharp VE-LC1 | 640 x 480 | 922 | 89 to 133 | 6.9 to 10.4 |
| Canon Powershot 350<br>Konica Q-Mini<br>Minolta Dimage V<br>Olympus C-420<br>Ricoh RDC-300 & 300Z<br>Yashica KC-600 | 640 x 480 | 922 | 160 to 250 | 3.7 to 9.2 |
| Canon Powershot 600<br>Kodak DC50 zoom<br>Kodak DC210 zoom<br>Pentax E1-C90<br>Ricoh RDC-2E & 2L<br>Samsung SSC-410N<br>Sony DK-1 | Greater than 640 x 480 to less than 1,024 x 768 | 1,066 to 2,986 | 143 to 286 | 4.6 to 11.9 |
| Canon Powershot A5<br>Epson PhotoPC 600<br>Kodak DC120 zoom<br>Nikon Coolpix 600<br>Olympus C-820L<br>Sanyo DigiCam | 1,024 x 768 to less than 1.0 million pixels | 2,359 | 181 to 667 | 3.5 to 13.0 |
| Agfa ePhoto 1280<br>Fuji MX-700<br>HP PhotoSmart C20<br>Kodak DC 200, 220<br>Konica Q-M100<br>Nikon Coolpix 900<br>Olympus C-1400, C-840L<br>Pixera Pro<br>Polaroid PDC 2000/40<br>Polaroid PDC 2000/60 | megapixel cameras i.e. equal to or greater than 1.0 million pixels, up to 1,600 x 1,200 | 2,986 to 5,760 | 667 to 1,000 | 3.8 to 8.3 |

compressed file size and the compression factor. Cameras which capture at higher resolutions and use the minimum amount of compression generally offer the best possible image capture quality.

The compression factor can be calculated for any camera by dividing the capture file size (see Chapter 2) by the compressed file size taken at the highest resolution setting. A compression factor of equal to or less than 5 will generally produce better quality images than one with a compression factor of between 6 to 10 or higher. However, other factors may be equally or more important to the user, such as: the focal length of the lens (and whether there is a zoom); the ability to close focus; whether the camera will accept a PC card storage to enable storage of more images; the shutter speed range; the presence of a built-in flash; an exposure compensation facility; an LCD screen for combined image previewer and viewfinder; the weight; and the overall ease of use.

Refer to Tables 2.1 and 2.2 (see pages 11 and 12, Chapter 2) to get a general idea of the type of output which can be generated using the capture file sizes quoted below. Even quite small files can be output as photo-realistic prints using software interpolation to boost the total number of pixels but a capture resolution of equal to or in excess of 1,024 x 768 pixels is needed to produce photo-realistic prints equal to or greater than 7 x 5 inches.

# Appendix VI: Scanners

### Film scanners

A resolution of between 2,400 dpi and 2,700 dpi is regarded as equivalent to the capture resolution of photographic film. Scanners which capture at less than 2,400 dpi use interpolation to boost the resolution and hence file size. Typically interpolation factors range from a factor of x2 to x8. It is best to use a scanner that does not apply high interpolation factors in order to produce better quality scans.

**35mm and APS scanners**

| Price range (£) | Model | Optical capture resolution (dpi) |
|---|---|---|
| Sub-£500 | Epson FilmScan 200* | 1,200 x 2,400 |
| | Fujifilm AS-1** | 835 |
| | Minolta Dimage Scan Dual* | 2,438 |
| | Olympus ES-10 * | 1,770 |
| £501 to sub-£1,000 | Canon CanoScan 2700F* | 2,720 |
| | Minolta Quickscan 35 | 2,720 |
| | Microteck Scanmaker 35T Plus | 2,820 |
| | Nikon CoolScan II and LS-1000 | 2,700 |
| | Polaroid SprintScan 35LE | 1,950 |

Notes:
*35mm plus APS film format scanners
**APS film format only

### Flatbed scanners

There is a diverse range of flatbed scanners to suit different capture resolution requirements and budgets. Typically the better quality scanners use interpolation factors of between x8 to x32 and the low-end scanners between x64 to x128. Interpolation enables prints to be output at larger sizes than would otherwise be possible, but can lead to a reduce sharpness and introduce unwanted artefacts to the image. Some popular models are listed overleaf.

**Flatbed scanners**

| Price range (£) | Model | Optical capture resolution (dpi) |
| --- | --- | --- |
| Sub-£150 | Agfa SnapScan 310 | 300 x600 |
| | Microtek Scanmaker E3 | 300 x 600 |
| | Umax Astra 600 | 300 x 600 |
| | Vivitar ViviScan Ultra Photo | 400 x 600 |
| | Vivitar VSF-300 | 300 x 600 |
| £151 to sub-£500 | Agfa SnapScan 600 | 600 x 1,200 |
| | Agfa SnapScan 600 Artline | 600 x 1200 |
| | Canon Canoscan 300 | 300 x 600 |
| | Epson GT5000 | 300 x 600 |
| | Epson GT8500 | 400 x 800 |
| | Epson GT9500 | 600 x 2,400 |
| | Fuji CS-1 | 300 |
| | Hewlett Packard Scanjet 5p | 300 |
| | Linotype-Hell Jade 2 | 600 x 1,200 |
| | Microtek Scnmaker E6 | 600 x 1,200 |
| | Nikon ScanTouch | 300 x 600 |
| | Umax Astra 1200 | 600 x 1,200 |

# Appendix VII: Printers

The sub-£200 printers listed here are fine for outputting images on plain paper for general purposes but if photo-realistic prints are required then a sub-£500 printer is really the minimum specification that will achieve this standard. The actual quality

**Printers**

| Price range (£) Output paper size | Model | Resolution (dpi) | Type |
|---|---|---|---|
| Sub-£200, A6* | Vivitar ViviPrint 5000 | 640 x 480 | Cylithographic |
| Sub-£200, A4** | Canon BJC4300 | 720 x 360 | Inkjet (bubblejet) |
| | Epson Stylus Color 300, 400 | 720 x 720 | Inkjet |
| | Hewlett Packard Deskjet 6900 | 600 x 600 | Inkjet |
| | Hewlett Packard 820 cxi | 600 | Inkjet |
| | Lexmark 1020 | 600 x 600 | Inkjet |
| | Lexmark 2030, 2050, 3000 | 600 x 600 | Inkjet |
| Sub-£500, A6 | Casio DP-8000 | 446 x 297 | Sub-thermal |
| | Fargo FotoFun | 203 | Dye-sub & wax |
| | Fuji NC-3D | 720 x 480 | Thermo-autochrome |
| | Mitsubishi CP-D1E | 720 x 480 | Dye-sub |
| | Olympus P300 E | 1,376 x 1,024 | Dye-sub |
| | Ricoh RXP 10 | 700 x 480 | Dye-sub |
| Sub-£500, A4 | Alps MD-1000, 1200 | 1,200 x 600 | Micro-dry |
| | Alps MD-2010 | 600 x 600 | Micro-dry |
| | Canon BJC620 | 720 x 720 | Inkjet (bubblejet) |
| | Canon BJC4550 | 720 x 360 | Inkjet (bubblejet) |
| | Canon BJC7000 | 1,200 x 600 | Inkjet (bubblejet) |
| | Citizen Printiva 700, 1700C | 600 x 600 | Inkjet |
| | Epson Stylus Color 800 | 1,440 x 720 | Inkjet |
| | Epson Stylus Photo | 720 x 720 | Inkjet |
| | Epson Stylus Photo EX | 1,440 x 720 | Inkjet |
| | Hewlett Packard PhotoSmart | 600 x 600 | Inkjet |
| | Lexmark 5700, 7000, 7200 | 1,200 x 1,200 | Inkjet |

Notes:
*A6= 148mm x 105mm, approx. 6 x 4 inch
**A4 = 296 x 210mm, approx. 11.5 x 8 inch

of the photo-realism achieved varies according to the printing process, the original file size (and whether any software interpolation is applied) and the type of paper.

Generally glossy, semi-gloss or matt photo finish type papers give much better prints that plain paper.

Non-inkjet printers capable of producing photo-realistic A6 prints are the best option if a dedicated photographic printer is required. However, inkjet printers are more versatile being capable of producing both photo-realistic prints and high quality graphics and text on paper up to A4 size and larger.

# Index